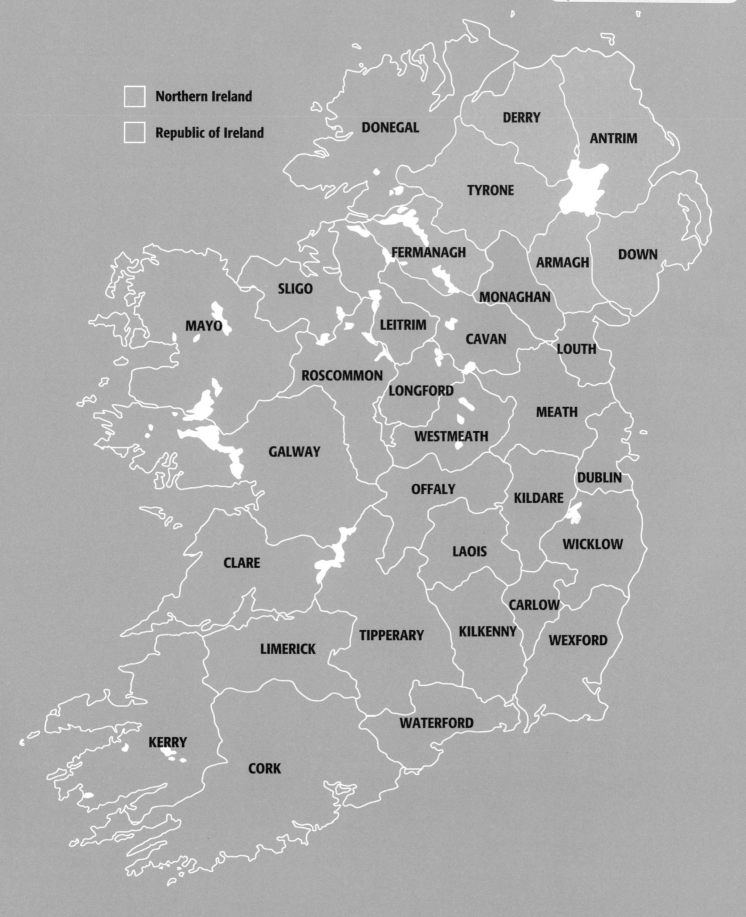

W9-AVS-928

Northern Ireland

Republic of Ireland

DONEGAL

DERRY

ANTRIM

TYRONE

FERMANAGH

ARMAGH

DOWN

SLIGO

MONAGHAN

MAYO

LEITRIM

CAVAN

LOUTH

ROSCOMMON

LONGFORD

MEATH

WESTMEATH

GALWAY

OFFALY

DUBLIN

KILDARE

WICKLOW

LAOIS

CLARE

CARLOW

LIMERICK

TIPPERARY

KILKENNY

WEXFORD

WATERFORD

KERRY

CORK

IRELAND
A LUMINOUS BEAUTY

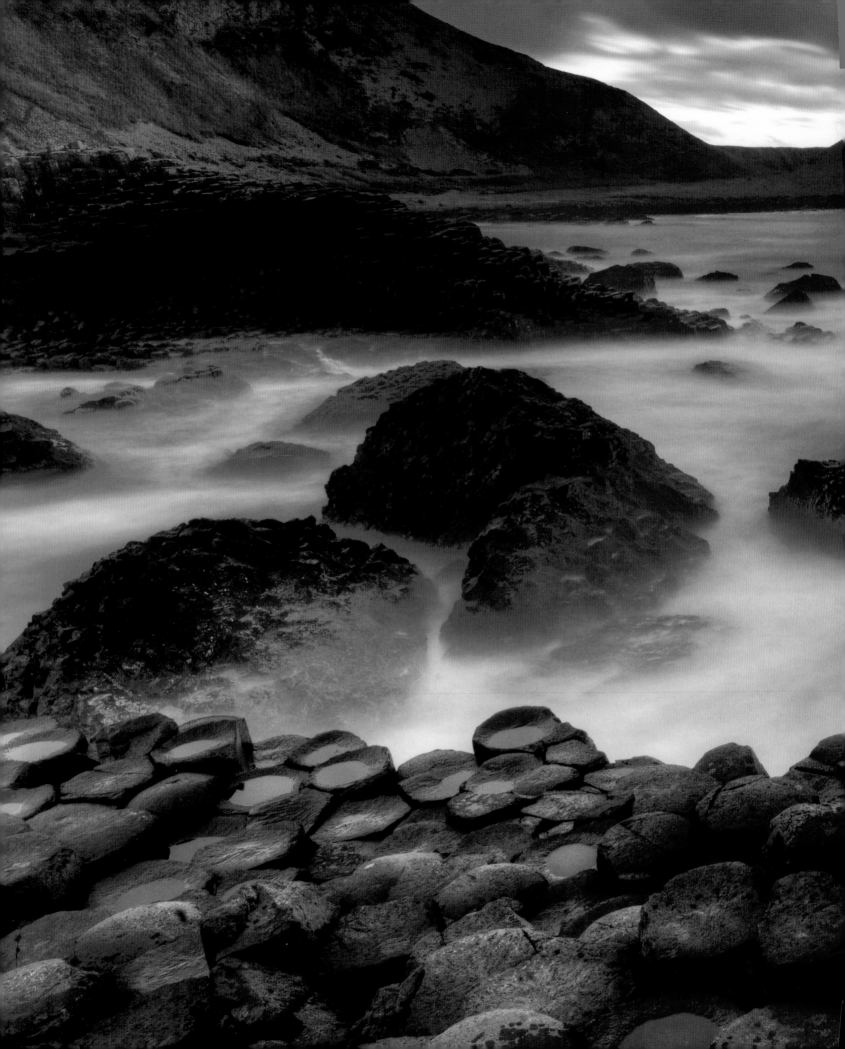

IRELAND
A LUMINOUS BEAUTY

PETER HARBISON & LESLIE CONRON CAROLA
PHOTOGRAPHY BY CHRIS HILL · CARSTEN KRIEGER · GEORGE MUNDAY AND OTHERS

Thomas Dunne Books
St. Martin's Press
New York

THOMAS DUNNE BOOKS.
An imprint of St. Martin's Press.

IRELAND: A LUMINOUS BEAUTY. Copyright © 2014 by Arena Books Associates, LLC. All rights
reserved. Printed in China. For information, address St. Martin's Press,
175 Fifth Avenue, New York, N.Y. 10010.
www.thomasdunnebooks.com
www.stmartins.com

Project Creator and Photo Researcher: Leslie C. Carola, Arena Books Associates, LLC
www.arenabooksassociates.com
Book Design: Elizabeth Johnsboen, Johnsboen Design
Cover Design: Kerri Resnick and Elizabeth Johnsboen
Production Manager: Adriana Coada

Library of Congress Cataloging-in-Publication Data
Harbison, Peter.
 Ireland : a luminous beauty / by Peter Harbison and Leslie Conron Carola. -- First edition.
 p. cm
 ISBN 978-1-250-05659-7 (hardcover)
 ISBN 978-1-4668-6039-1 (e-book)
 1. Ireland--Pictorial works. I. Carola, Leslie. II. Title.
 DA982.H368 2014
 914.150022'2--dc23
 2014013008

 To discover more and plan your Ireland vacation
visit www.Ireland.com today.

Photo Credits: CHRIS HILL/Scenic Ireland: Pages ii-iii, iv, v middle, vi, vii, viii-ix, x, 5, 7, 20-21, 23, 26-27, 31,
32-33, 36-37, 39, 40-41, 44, 45, 46-47, 54-55, 62, 63, 66-67, 69, 72-73, 74, 75, 88, 90, 91, 92-93, 96, 97, 100, 101, 102-
103, 105, 106, 107, 108-109, 110-111, 112, 113, 114-115, 117, 118, 121, 122-123, 124,125, 126-127, 128-129, 132 top
left, bottom left and right, 133, 134-135, 135, 136, 138-139, 140 top, 142, 143, 144, 145, 147, 150
CARSTEN KRIEGER: Pages v top, 9, 34, 34-35, 42-43, 43, 53, 56, 58-59, 64-65, 68, 70, 71, 78-79, 80, 81, 82, 83,
84-85, 86, 86-87, 89, 104, 119, 132 top right, 137
GEORGE MUNDAY: Pages 16-17, 18-19, 22, 25, 29, 30, 48-49, 50-51, 60-61, 94-95, 98-99, 116-117, 120, 130-131, 146
JILL JENNINGS/Scenic Ireland: Pages 52, 76-77, 107
PAUL LINDSAY/Scenic Ireland: Page 140 bottom
BRIAN MORRISON/Tourism Ireland: Page 38
DUNBRODY HOUSE: Page 141
KEVIN O'DWYER: Page 149
MONUMENTS SERVICE, Dept of Arts, Heritage, & the Gaeltacht: Pages i, 1, 2, 3, 4, 8, 24, 28, 149 bottom
NATIONAL MUSEUM OF IRELAND: Pages 6, 10, 11
TRINITY COLLEGE, Dublin: Pages: 12, 13, 14, 15
WOLFSONIAN-FLORIDA UNIVERSITY: Page 148
PHOTOS: Page i: Tara's green hills, County Meath; Pages ii-iii: Giant's Causeway, County Antrim; Page iv: Slem-
ish Mountain, County Antrim; Page v top: Poulnabrone Dolmen, County Clare; Page v middle: County Wicklow;
Page v bottom: Clifden Castle, County Galway.

Thank you to Tourism Ireland, especially Ruth Moran, New York, Jenny Jensma, Dublin, Patrick Lennon, Col-
eraine,Northern Ireland; Maeve Sikora and Finbarr Connolly, National Museum of Ireland; Sharon Sutton, Trin-
ity College, Dublin; Tony Roche, National Monuments Service, Dept of Arts, Heritage, and the Gaeltacht.

Without St. Martin's Press this book would not be: a million thank yous to Tom Dunne, Peter Joseph, Melanie
Fried, Steve Snider, Kerri Resnick, and to Sally Richardson.

St. Martin's Press books may be purchased for educational, business, or promotional use. For information on bulk
purchases, please contact Macmillan Corporate and Premium Sales Department at 1-800-221-7945, extension 5442,
or write specialmarkets@macmillan.com.

First Edition: October 2014
10 9 8 7 6

Printed in China

CONTENTS

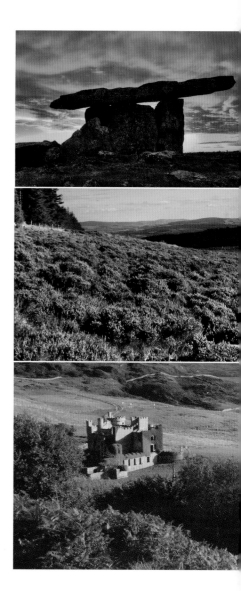

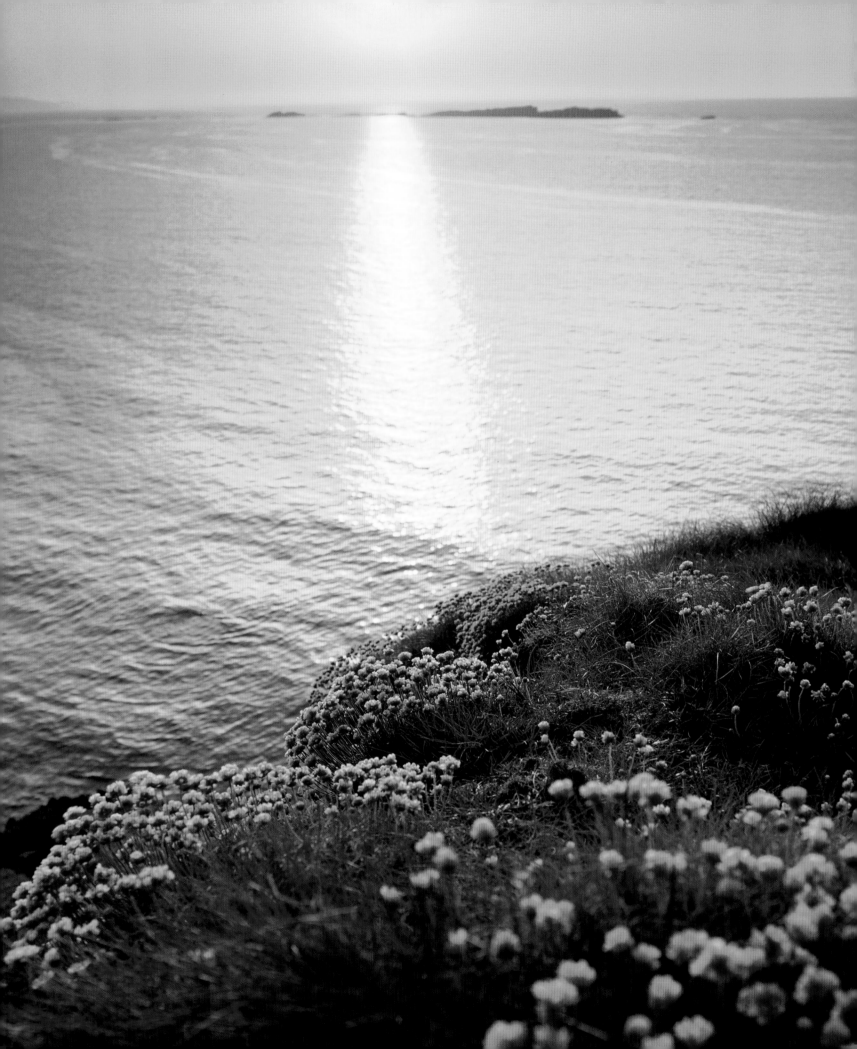

INTRODUCTION

Island light is magical, and none more so than Ireland's. Ireland's light, a theme of this book, lures the senses with a restless presence, flooding the landscape from all directions. The water surrounding and carving through the island reflects back to us the ever-changing movement of the clouds, the wind, the light, and the color.

Ireland's sky is full of motion and color. The motion is the result of the wind sculpting and sweeping masses of clouds across the landscape. The clean air above and around the island (well situated in the north Atlantic, without a lot of dust and pollution) means we experience the dazzling colors, from deep, rich blues to pink-purples and fiery red-oranges, that accompany the spectacular sunsets.

Many of the landscapes—sun-drenched, rain-filled, or cloud-brushed—have been captured in the photographer's golden hour, the hushed first light of morning or the end of day when the sun streams down to the sea. Lady Augusta Gregory's comment that "Ireland is a land of mists and mythic shadows, of weird silences in the lonely hills, and fitful skies of deepest gloom alternating with gorgeous sunsets" expresses the luminous drama of Ireland's wind-swept skies.

From the icons and artifacts of the ancient world to the dramatic landscapes of the natural world and the enduring sense of place of the cultivated world, this fascinating island with its magical light is rich with imagination and style. That spirit is everywhere. It moves our souls.

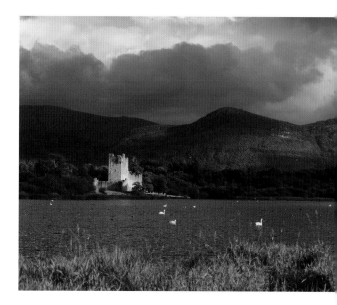

ABOVE: *Ross Castle, built in the fifteenth century on the banks of Lough Leane in County Kerry by O'Donoghue Mor, one of the Irish chieftains, was the last stronghold against Cromwell. Legend says that O'Donoghue still sleeps under the water of the lake and on the first of May every seven years he rises from the depths and circles the lake on his glorious white horse. It is said that anyone seeing the figure would have good luck for the rest of his or her life.*

OPPOSITE: *Wild flowers—sea pinks—on a cliff at the edge of the Atlantic, along the west coast, at sunset.*

FOLLOWING SPREAD: *Morning mist on Maigue River, County Limerick.*

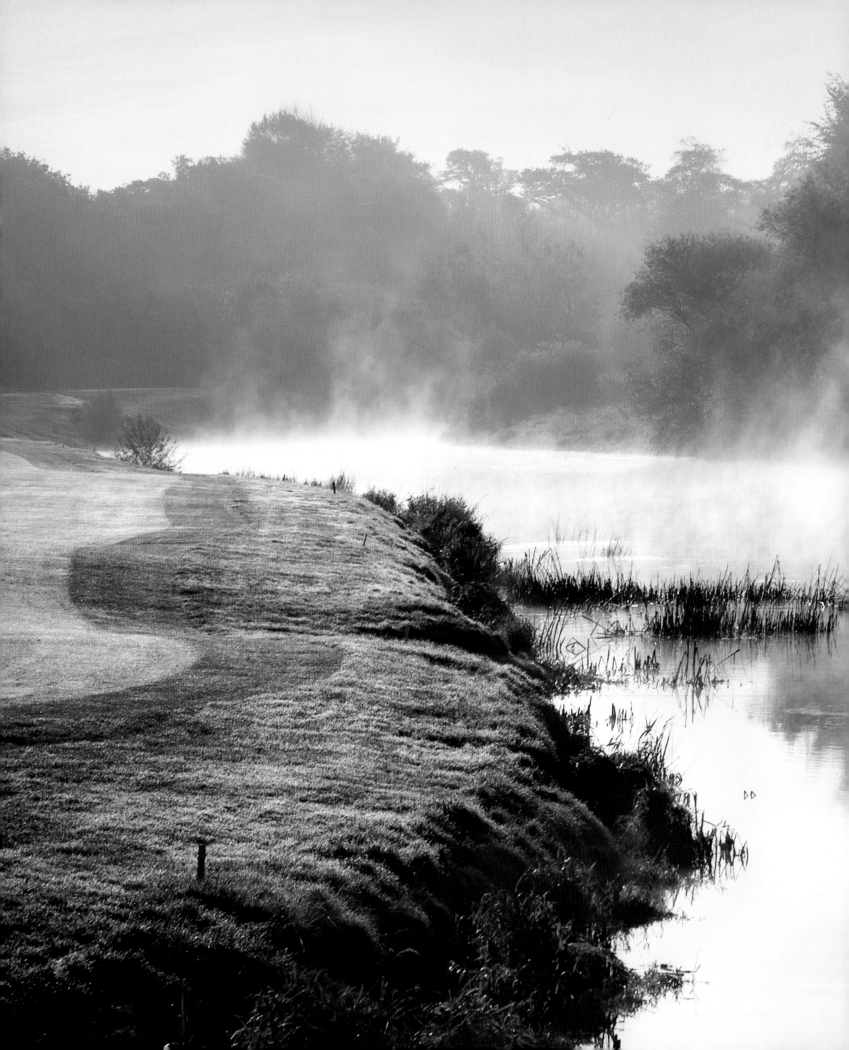

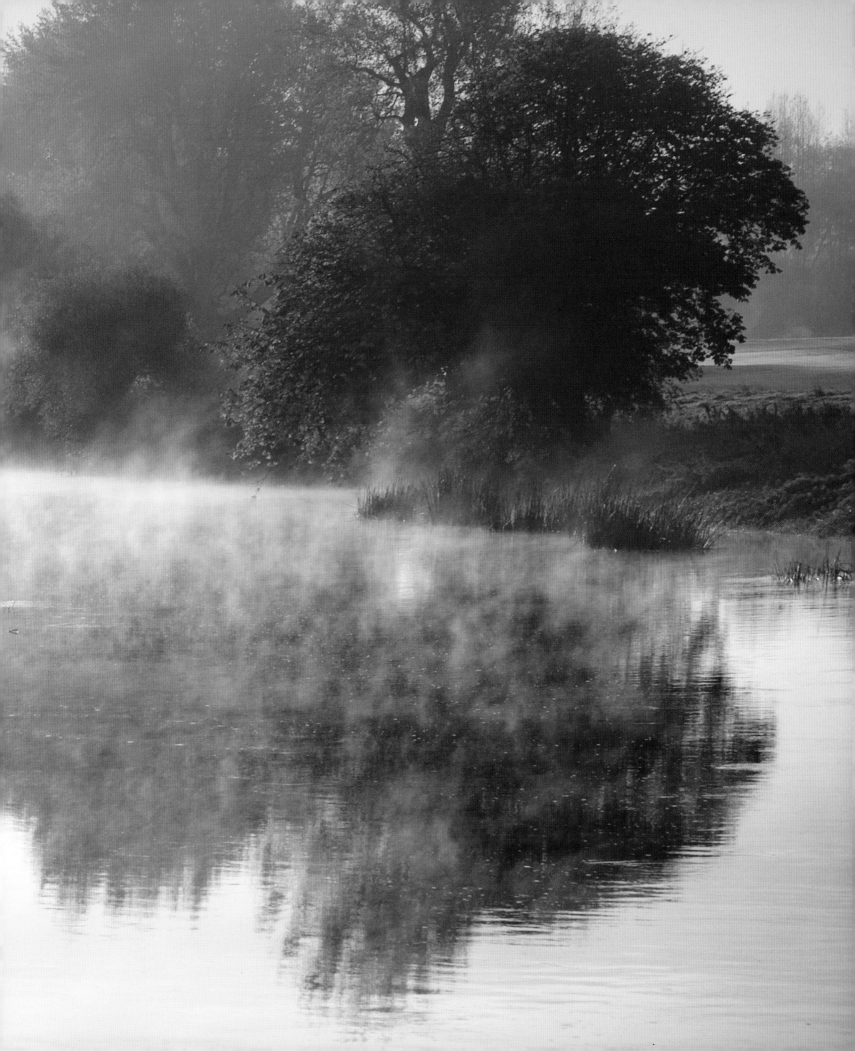

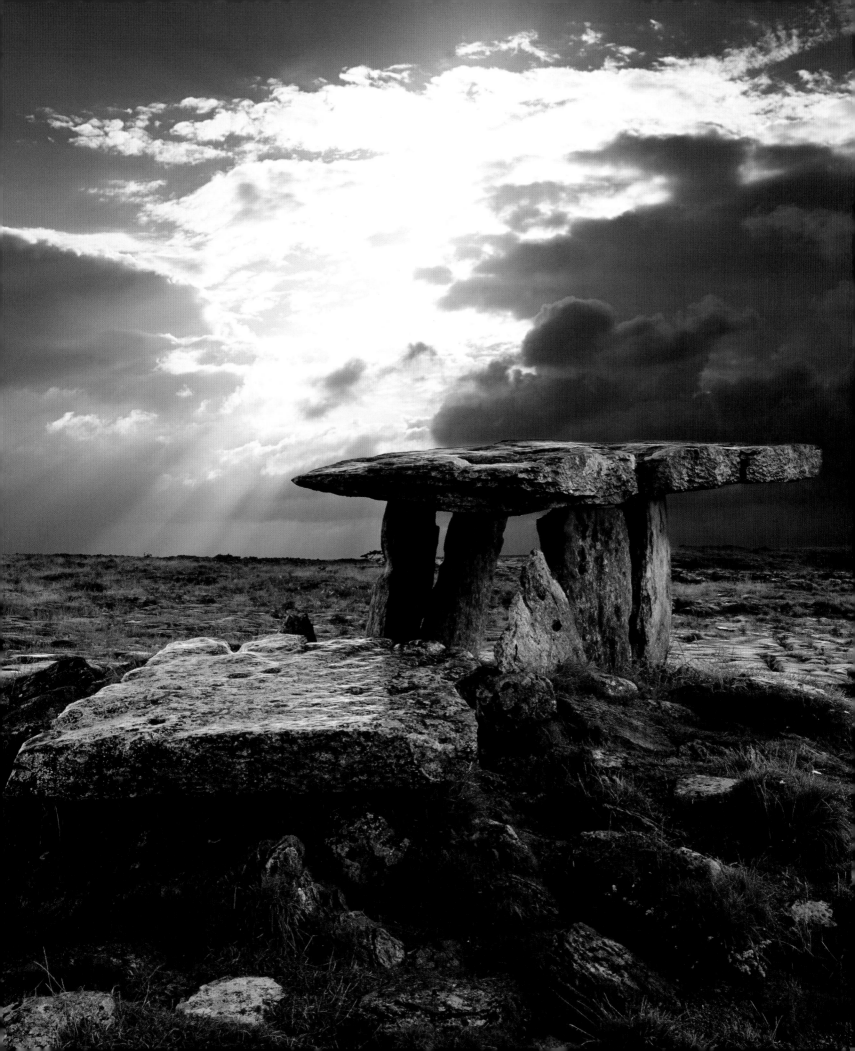

THE ANCIENT WORLD
ICONS AND ARTIFACTS

It is, perhaps more than anything, the use of stone that forms the link between Ireland's past and present. It is the impressive ancient stone still present in the landscape in the form of dolmens, passage-tombs, stone circles, high crosses, round towers, forts, and, eventually, castles and monasteries, that informs our sense of the past. Other structures, presumably made of wood, have long since vanished.

The Stone Age hunter-gatherers who took up two-fifths of the time that mankind has been inhabiting the island—from about 8000 to 4000 BC—have left little for us to admire, simply because they spent most of their time foraging for food. But their immediate successors of the late Stone Age respected their dead so much that they cared far less for the abodes of the living than for those of the dead, building great stone tombs to house and commemorate the departed. These tombs were often set on heights so their visibility was assured from miles away, and with such large stones that we should see their builders as giants in genius, if not in stature.

Of all the Stone Age megalithic (great stone) tombs of Ireland, the dolmens, for their size, are the most dramatic and graceful. They have been dubbed the earliest public sculptures in Europe. The word "dolmen" comes from two Breton words meaning "stone table." Dolmens consist of between three and seven uprights, which support a massive capstone (possibly weighing up to one hundred tons), usually tilting toward the entrance, where a large stone sometimes acted as a door. Some observers have imagined the dolmens to be druids' altars, but folklore sees them as the beds of the legendary fleeing lovers Diarmuid and Gráinne. Excavations have unearthed human bones within, indicating they are burial sites. The most remarkable characteristic of dolmens is the almost

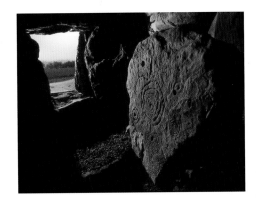

ABOVE: *When excavated in the 1950s, the Mound of the Hostages on the Hill of Tara was found to contain burials, most from the Bronze Age. When these were cleared out, one of the stones revealed ornaments of circles with central ring marks, a kind normally associated with the Bronze Age rather than the Stone Age and different from the spirals at Newgrange (see page 3). It would seem, therefore, that the Mound of the Hostages came probably centuries after those in the Boyne Valley, including Newgrange and Knowth.*

OPPOSITE: *Utilizing the wrinkly limestone of the Burren region in northern County Clare, Stone Age builders, over five thousand years ago, constructed a stunningly dramatic monument to their dead. The four stone legs of the dolmen known as Poulnabrone, the hole of the sorrows, carry a capstone stretched like a bird about to take flight to explore eternity in the skies.*

weightless way they carry their capstones, which must have required considerable skill and manpower to raise into position.

Dolmens may be the most dramatic and graceful of the megalithic tombs, but the passage-tomb is the most dominant, although not necessarily the earliest type. The passage-tomb has a stone-lined pathway leading from the rim of a usually circular mound to a burial chamber roughly at its center. Certainly built by a people bent on making a permanent mark on the landscape, these burial places were frequently set on eminences that could be seen for miles. Among the most visible are Queen Maeve's Grave on top of Knocknarea, which offers a spectacular panorama over Sligo Bay, and the Mound of the Hostages on the Hill of Tara in County Meath, from which it is said that seven counties of Ireland can be seen on a clear day. But the most famous passage-tombs in Ireland are the three in the Boyne Valley, on a prominent ridge overlooking the river Boyne—Newgrange, Knowth, and Dowth. These three great monuments can be taken as the high point of megalithic construction in Ireland, not only because of the sophisticated techniques required for their construction and the masterly decoration, but also because they seem to be the culmination of a series of tombs stretching back many hundreds of years.

Newgrange, the largest of the three great mounds, is roughly heart-shaped, rising to a height of about thirty-six feet and measuring about three hundred feet in diameter. Made with a mixture of earth, turves, and stones layered neatly one above the other, it occupies the top and part of the slopes of the ridge on which the three tombs are set. The orientation of its main passage toward the rising sun at the winter's solstice on December 21 (and a few days on either side of it) has created worldwide interest in the tomb. A slim ray of sunlight enters the mound through an opening above the entrance door (the "roof box") on the shortest day of the year, bringing a seventeen-minute show of light into the darkest recesses of the tomb. The sun's rays bringing light to the darkness of the tomb send the simple message that there is life after death, as the sun brings life to the depths of winter. The imaginative opening for the sun's rays to enter the mound, the ingenious corbel construction of the burial chamber roof that keeps the interior still bone dry after five thousand years, and the marvelous decoration inside and outside the tomb show that this monument was built by a sophisticated people. One of the world's first great pieces of architecture, Newgrange may predate Egypt's pyramids by more than five hundred years.

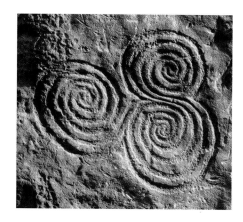

ABOVE: *Imagine a human being five thousand years ago using a wooden mallet to hammer the end of a pointed stone to peck out this lovely triple spiral onto the carefully prepared surface of a flat stone. He certainly wasn't just doodling, for his decoration was placed in the deepest part of Newgrange, one of Ireland's greatest Stone Age sanctuaries. Perhaps the swirling Ss were to be understood as shedding a special light on those buried beneath. The artist must have realized that he was working in the service of his god, the sun, and creating a symbol that had deep meaning for those who came to worship the sun in its presence. The way the third spiral, on the left, emerges from the other two could represent two beings creating a third, epitomizing the story of human life.*

OPPOSITE: *Newgrange passage-tomb, Ireland's best-known Stone Age tomb, built on the bend of the river Boyne about five thousand years ago.*

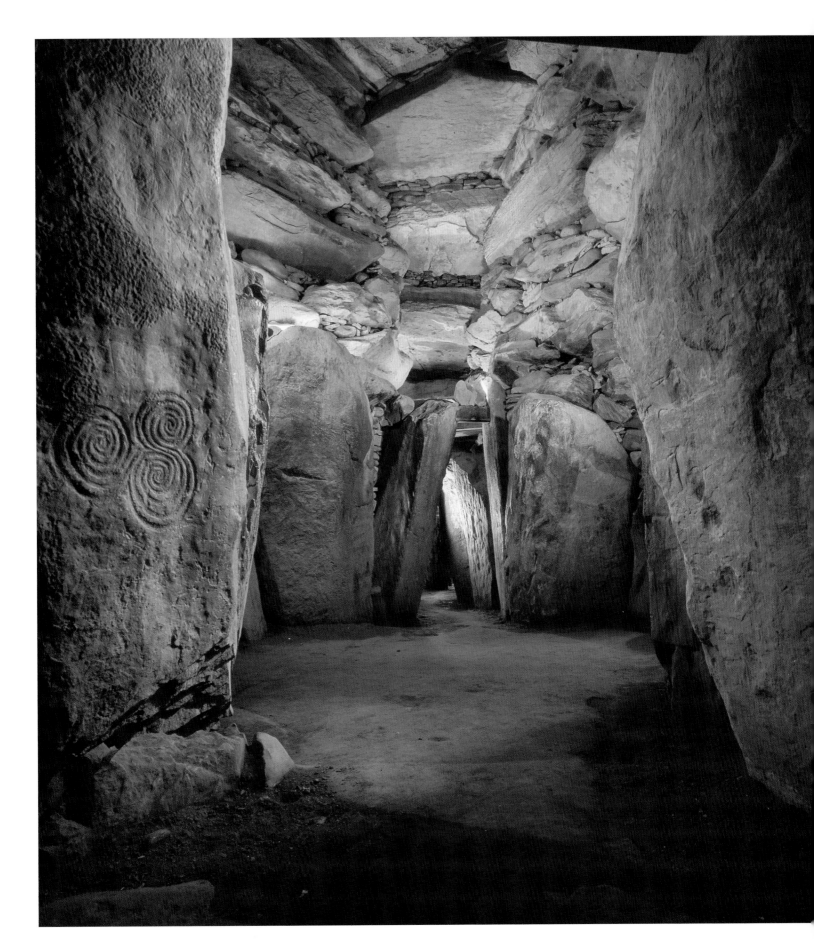

For those standing in awe in the Newgrange tomb five thousand years ago, it must have been a magical moment when the sun climbed over the horizon on a midwinter's day to shine through an aperture above the door and creep silently upward along the passage until it reached the burial chamber. This was the culmination of the year's long and expectant wait. For seventeen minutes, the rays of the celestial orb sent their life-giving light through to those inside paying homage to their ancestral dead.

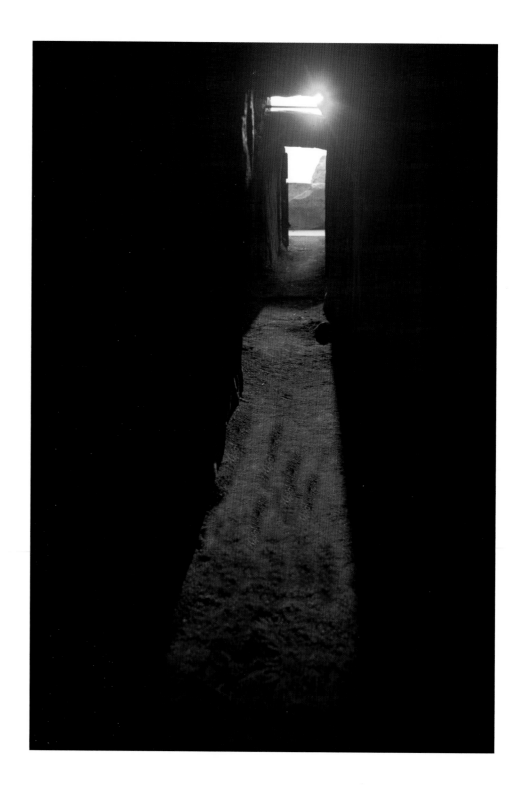

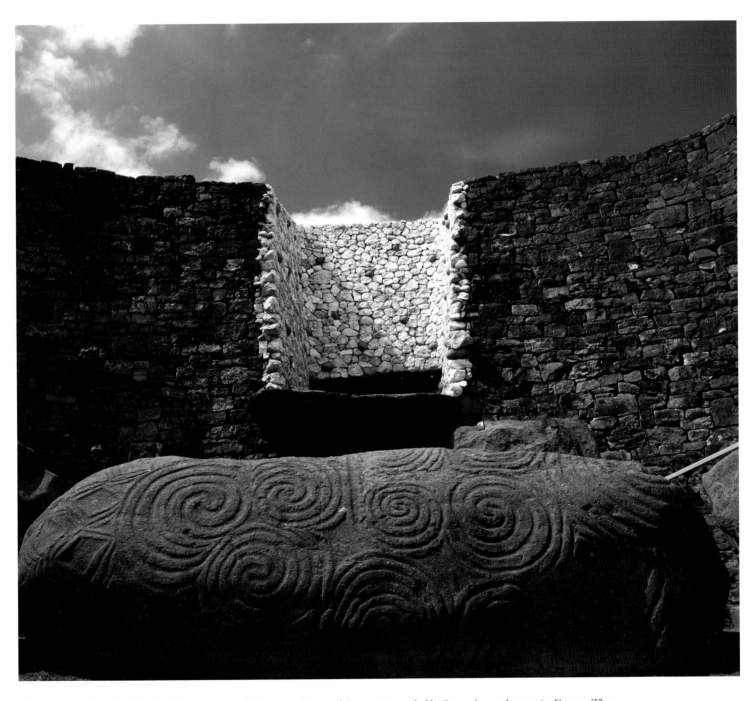

The stone standing (or lying) at the entrance to Newgrange is one of the most remarkable Stone Age sculptures in Europe. The groove falling from the center of the upper edge surely points the way to the tomb-entrance behind it. To the left, as we look at it, we recognize the same triple spiral as that in the inner chamber, flanked on the left by a pair of diamond-shaped designs. The tomb was closed by the large stone seen now to the right of the entrance, while above the doorway there is a small aperture (surrounded by a modernly constructed white quartz frame) inserted at a high-enough level to allow the sun to penetrate to the very center of the tomb for just over a quarter of an hour in the dawning midwinter light.

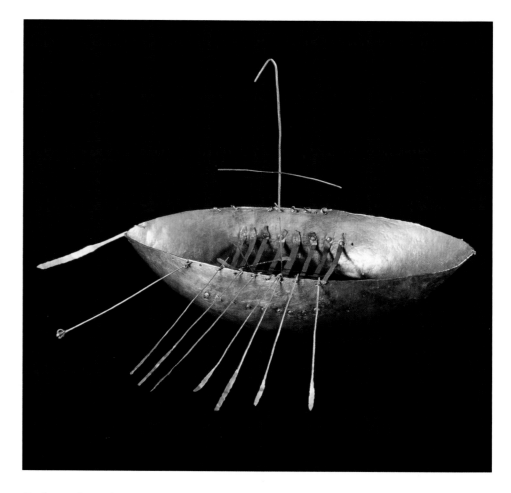

Modeled on a wood-and-canvas craft some forty feet long, with seats, mast, and eighteen oars, this miniature gold boat was found at Broighter, County Derry, in one of the most remarkable Iron Age finds. Now in the National Museum in Dublin, it is probably the earliest known representation of a sailing boat from Britain or Ireland. The miniature boat, from the first century BC, may have been offered as a sacrifice to the sea god Manannan Mac Lir over whose waves its mariners navigated. This image is reproduced with the kind permission of the National Museum of Ireland.

Perhaps the subsequent Bronze Age is an archaeological misnomer, because this period—from 2000 to 500 BC—is distinguished by the quantity of gold ornaments it produced. The "Great Clare Find" discovered during the making of the West Clare Railway in 1854 is among the largest hoards of gold objects ever discovered in Europe. Ireland's richness in prehistoric gold, such as the Broighter boat and others, makes the National Museum's collection one of international importance. Two of the most remarkable masterpieces of the Irish gold-and silversmith's art are among the museum's greatest treasures from hoards found at Ardagh, County Limerick, and Derrynaflan in neighboring County Tipperary. The Ardagh chalice (page 11) is one of the most perfect of its kind, glittering with gold, silver, bronze, and glass, all fitted together exquisitely to form a container for distributing wine during Mass. The Tara Brooch (page 10), is another masterpiece of the gold-and silversmith's wizardry. It would be difficult to find one equal to it, let alone better, anywhere in the first Christian millennium. Like the Book of Kells (page 12) also from the same period in the eighth or ninth century, its mastery can be seen in the minute scale of its ornamentation, each detail executed to a perfection that even contemporary jewellers find inspiring.

The Book of Kells, too, is a masterpiece, its pages glowing with still-vivid colors that paint pictures of Christ and his apostles, and pages of purely geometrical configuration and texts enlivened by little animals masquerading as the initial letters of words or lines.

All of the chalices, brooches, and manuscripts are the prodigious products of a cultural flowering emanating from the Christian monasteries that came to enrich the surface of Ireland from the fifth century until the twelfth. Their monks were not just master metalworkers but illuminators of manuscripts, keepers of historical records, and deeply learned students of the Bible. They produced iconic monuments that made a unique contribution to the

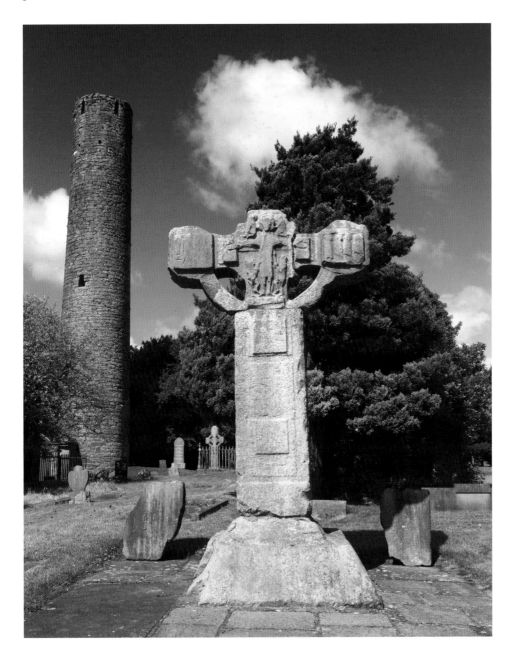

This unfinished stone cross at the monastery at Kells shows us the various stages involved in carving a cross. What was virtually completed is the figure of the crucified Christ at the center of the head, his arms outstretched on a cross seen (unusually) in the background, but the blocks from which his hands were carved have not actually been chiseled away. Equally, the sculptor had not yet even started on the flat blocks standing out from the surface, and the removal of one halfway up the shaft may have been a mistake that caused the cross to be left unfinished. The more traditional story as to why the cross is incomplete is that the Vikings arrived and killed the sculptor before he could finish his job. Given that the decoration on the surface of half of the ring (partially visible here) was completed, it seems likely that there were two men at work on the cross—one doing the purely ornamental decoration, the other the human figures.

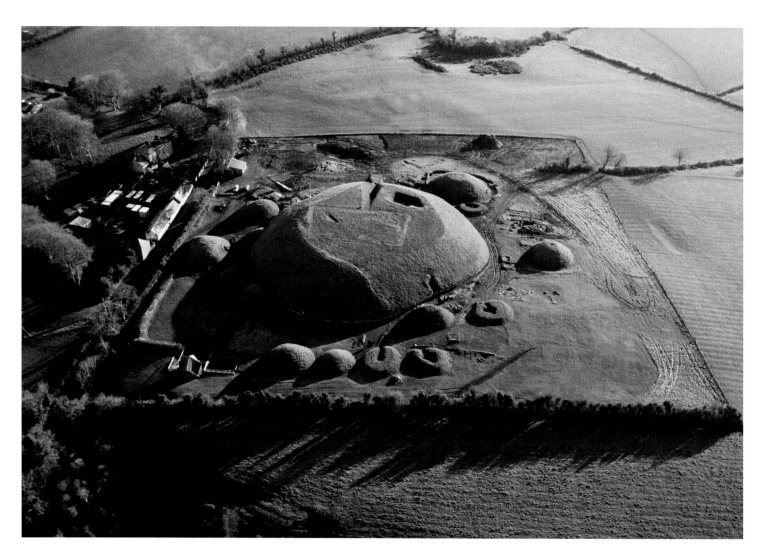

The extraordinary trio of passage-tombs in the Boyne Valley—Knowth, Dowth, and Newgrange—dominate the landscape. Knowth offers a great passage-tomb with a number of smaller "satellites" clustering like chickens around the mother hen, perhaps containing the bones of additional family members or other families buried within the mound. In the 1960s, two impressive passage-graves were found back-to-back within the mound at Knowth, thereby raising the possibility that Newgrange may also have a second tomb within its mound. The stones within the tombs and marking the outer edge of the mound are decorated with the greatest concentration of Stone Age art in Europe.

sculpture of Europe in the form of great stone high crosses, bearing panels of figures representing events narrated in the Old and New Testaments, and even taller round towers to be ever closer to heaven! Many stone crosses have a ring that serves to help prevent the heavy stone arms from snapping off, while offering a cosmic symbolism in relation to the Crucifixion of Christ. But what makes the Irish crosses so unusual is the richness of their narrative scenes from the Old and New Testaments. These scenes are typically enclosed in rectangular panels framed by a roll molding separating each panel. Generally the Old Testament is on the east face, beneath the Last Judgment at the center of the head, and the other side is filled with scenes illustrating the New Testament beneath the figure of the crucified Christ at the center of the head.

High crosses and round towers are Ireland's noblest monuments dating from the great days of Irish monastic civilization in the first millennium AD. They are also Ireland's most important contribution to the sculpture and architecture of early medieval Europe and, as such, are certainly worthy

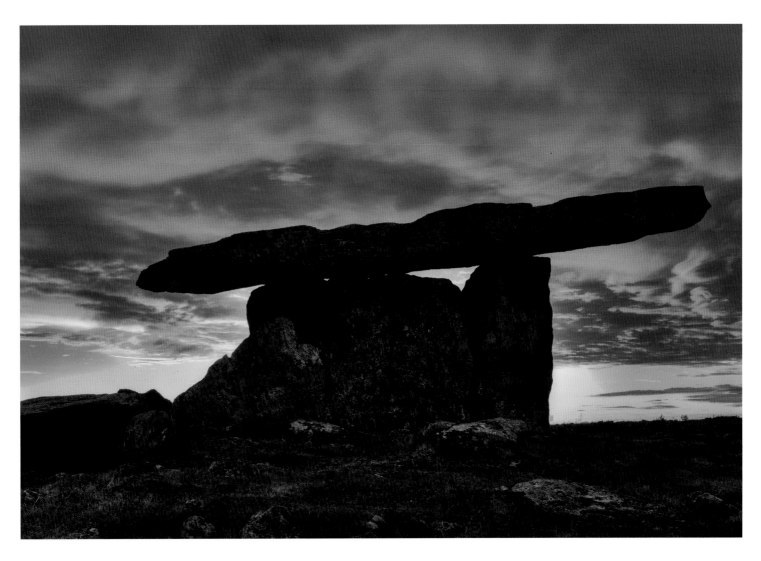

to be mentioned almost in the same breath as the Book of Kells.

The Vikings raided the treasure-filled monasteries in the ninth and tenth centuries, some more than once, with the goal to bring the gold and silver objects back home. But perhaps they are given too much credit for the decline of the Irish monasteries around the tenth century. The monasteries continued to exist, perhaps not with the same vibrancy, although there was an important revival of monastic art in the twelfth century.

Round towers are Ireland's monuments closest to the sun, like trees in the forest striving to get the maximum of heavenly light. They make their mark on the Irish landscape by rising to one hundred feet above it, looking like a pared pencil, as the beacon announcing the old monastery they adorn, and beckoning the pilgrim to come. Rather than being put up as a defense against the nasty Vikings, as every Irish schoolchild used to be taught, they were most likely built between the ninth and twelfth centuries as bell towers and treasuries where the monastery's relics and reliquaries could be stored safely.

Many of the ancient structures beg to be seen at opposite ends of the day—at the first light of dawn and at the glorious splash of sunset. The magnificent fiery light at sunset provides a dramatic backdrop to this most famous of Irish dolmens (Poulnabrone), located in the Burren, County Clare, appearing as if it were a lasting statuesque survivor as the world goes down in Armageddon's cataclysmic flames. And lasting the dolmen certainly is—it is one of Ireland's oldest datable tombs, built around 3800 BC, and still standing in its elegant simplicity. It is a worthy memorial to the more than thirty individuals whose remains have been discovered there.

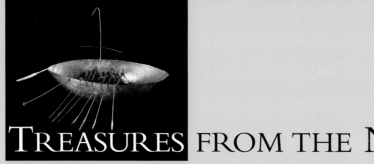

TREASURES FROM THE NATIONAL MUSEUM

The National Museum's collections include some of the most important Celtic and pre-Celtic artifacts in the world.

RIGHT: *The Tara Brooch, one of the greatest treasures of the museum, must surely be considered one of the most wonderfully intricate pieces of jewelry ever made. Found beside a beach at Bettystown in County Meath, it gets its name from a jeweller who bought it thinking it would sell at a greater profit with the name of the site of old Irish kingship. It is circular in shape, with a pin added to join two parts of a cloak together.*

Even if some of the panels have been lost, almost every surface is decorated on an incredibly miniscule scale. The diameter of the whole brooch is only a little over four inches, and the sub-triangular panel bearing a contorting animal made of twisted gold wire is scarcely the size of a fingernail. Gold wire is also used to create spiral decoration and animal interlace, while dragonlike heads protrude from the rim at various places. Further ornament is supplied by the addition of half-round glass studs, which could be interpreted as forming a cross at the center of the upright section of the extended half-moon shape at the bottom. Much of the same kind of decoration can be found on the triangular head of the pin, where a rather stylized bovine head looks down on the stem of the pin.

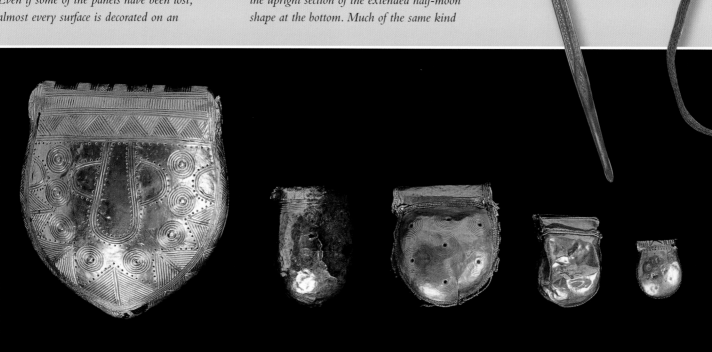

ABOVE: *Found in 1868 by a boy hunting rabbits in a rath or ringfort at Ardagh in County Limerick, this chalice is one of the finest pieces of religious metalwork in the National Museum, dating from the greatest artistic period of the old Irish monasteries in the eighth or ninth century. With handles of a kind found in Byzantium, the chalice has a bowl and foot made of silver, but is decorated with panels of gold wire at the constriction of the neck and in a frieze below the rim. Not easily visible, the names of Christ's apostles are inscribed beneath the frieze. They flank a circular medallion filled with gold panels*

decorated with spirals made of twisted wire and forming a "cross of arcs" of a kind found on many pilgrimage sites in Ireland. This suggests that the chalice may have been venerated as a relic or reliquary, though actually used for administering the wine to Mass-goers. At the center of the medallion is a stud with a silver pattern framing red and blue glass panels. A similar system is used in slightly larger studs beneath the handles.

OPPOSITE: *Bulla is a Latin word describing an amulet or charm against evil, and is used to describe these gold ornaments. They are*

loosely heart-shaped, filled with clay or lead, and were probably meant to be worn around the neck. The largest example, on the left, was found in the Bog of Allen and has been compared to a feline face or a helmet of ancient Greek style with a noseguard extending down the center between two eyes, which could indicate that it was intended to protect against injury.

Images on pages 10 and 11 are reproduced with the kind permission of the National Museum of Ireland.

THE BOOK OF KELLS

The Book of Kells is a collection of superlatives—pages of fantasy, imagination, brilliancy, color, and with the Christian message in a script that is as readable today as it was when written some twelve hundred years ago. A manuscript book of the four Gospels of the New Testament, it is now preserved in the Library of Trinity College, Dublin, where its artistic genius is appreciated by the half a million visitors who come annually to see it. The first historical reference we have to the existence of the book comes from *The Annals of Ulster* under the year 1007, in which the book was called "the most precious object of the Western World" after it had been stolen from the church in Kells in County Meath. We are told that it was recovered after two months and twenty nights, but with the cover of its shrine stripped of its gold. It was written within the precincts of a monastery associated with St. Colmcille (or Columba), who died on the Hebridean island of Iona around 597, but art historians have been at loggerheads for years as to whether it was written there or in the monastery at Kells, which had been founded by monks from Iona. Discussions rage, too, over when the manuscript came

into being, but there is now wide agreement that it may be dated to within a decade or two on either side of the year 800, also the period when the great Frankish emperor Charlemagne reigned on the European continent. A case could thus be made for seeing the Book of Kells as an "insular" response to the beautifully illuminated codices produced in Charlemagne's imperial workshops before his death in 814. It is also widely acknowledged that more than one scribe and artist were involved in the book's production.

RIGHT: *The most amazing of all the book's pages is folio 34 recto, the Chi Rho page, where the name of Christ is first mentioned in the Gospels. The intricacies of all the decora-*

tion are not very easy to take in at a first glance. The overall design presents us with the first three letters of Christ's name in Greek, XPI, the X looking like the modern letter P, and the PI being interlinked in the lower center of the page. The curl of the P ends in what is most likely Christ's head, which is also reproduced at the very top of the page. Pairs of beard-pulling men are framed at the top of an inverted L-shaped panel on the bottom right and book-bearing angels ride on the back stem of the X, but much of the rest is given over to an incredible assemblage of spirals and animals interlace (often purposely asymmetrical to catch the eye). This is all supremely executed and painted at such a small scale that one wonders how the illuminator's eyes survived the strain.

In the midst of this ocean of decoration, cats and mice cavort near the bottom of the page, perhaps inspired by the animal frolics the monks saw on the scriptorium floor.

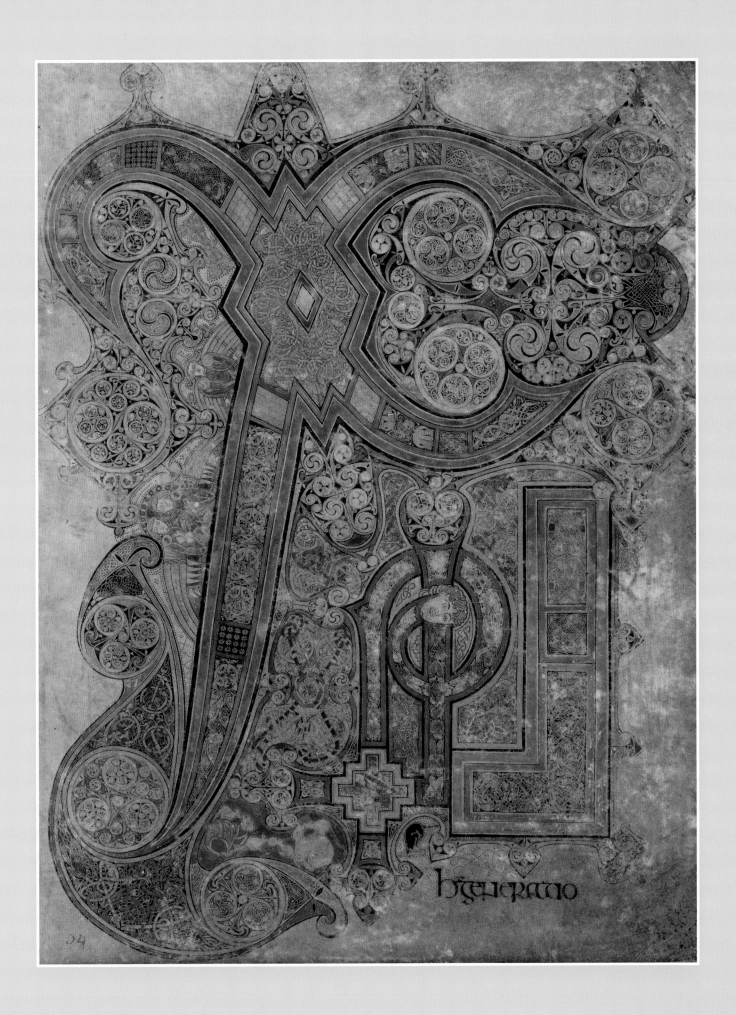

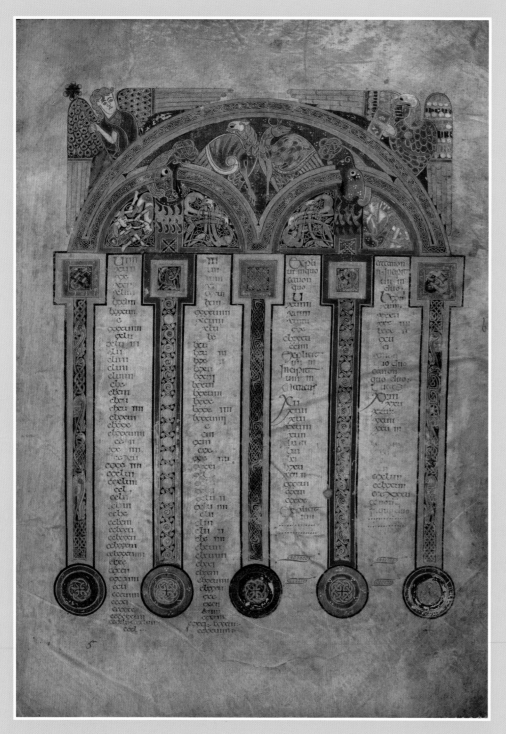

numbers, while the square capitals at the top carry a pair of arches gripped by animal jaws containing acrobatic humans. One arch encloses a charming winged lion and calf, symbols of the evangelists Mark and Luke, while at the outer corners are a man and an eagle, both winged and representing Matthew and John, respectively. All of this decoration is painted in lively and well-preserved colors, creating a most visually satisfying presentation with varied designs, painted by a master who never put a hand wrong.

OPPOSITE: *The same cat and mouse (or is it a rat?) that we found on folio 34r reoccur at the top of folio 48r while, further down the page, we see a hound hunting a hare. Such animals, and others more fanciful, fill the script pages of the Book of Kells, enlivening them with fantastic and imaginative contortions in a way found in no other manuscripts.*

The script is the beautifully rounded majuscule, which is much easier to read than it was to write. It is reckoned that it may have taken the expert scribe only about an hour and a half to write his page of text, but the artist would have taken longer to paint his playful animals. However, to complete a page like the Chi Rho may have taken a month or more. The Latin Gospel text is largely that of the Vulgate, as translated from the Greek and Hebrew by St. Jerome, though there are also parts of the Old Latin version that the Vulgate was commisioned to replace.

Images on pages 12-15 reproduced with permission of The Board of Trinity College, Dublin.

ABOVE: *Certain events in the life of Christ are told in some of the Gospels but not in others so, in an effort to indicate where the same happening is described in the various Gospels, a fourth-century bishop named Eusebius of Caesarea devised a system of determining which gospels carried the same account and where. This was developed into what are known as canon tables, where each relevant Gospel gets a column to itself, in which the numbers of the corresponding passages are listed. The details are not always accurate in the Book of Kells., but the tables are made into a delightfully designed and colored composition with bases and variously decorated columns separating the list of*

mittatis margaritas uestras ante porcos

ne forte conculcent eas pedibus suis &

conuersi dirumpant uos

Petite & dabitur uobis querite &

inuenietis pulsate & aperietur uo

bis omnis enim qui petit accipit

& qui querit inuenit & pulsanti ap

eritur

Aut quis est ex uobis homo quem si

petierit filius suus panem numquid

lapidem porriget ei Aut si piscem

petierit numquid serpentem porri

get ei Si ergo uos cum sitis mali nostis

bona dare filiis uestris quanto magis

pater uester qui in caelis est dabit

bona petentibus se

Omnia quaecumque uultis bona

48

Wonderful shadowy light and dark cloud effects in the evening sky look like a window opening to another world as the setting sun winks its way through the stones of this impressive dolmen at Knockeen near Tramore in County Waterford, Ireland's sunny southeast.

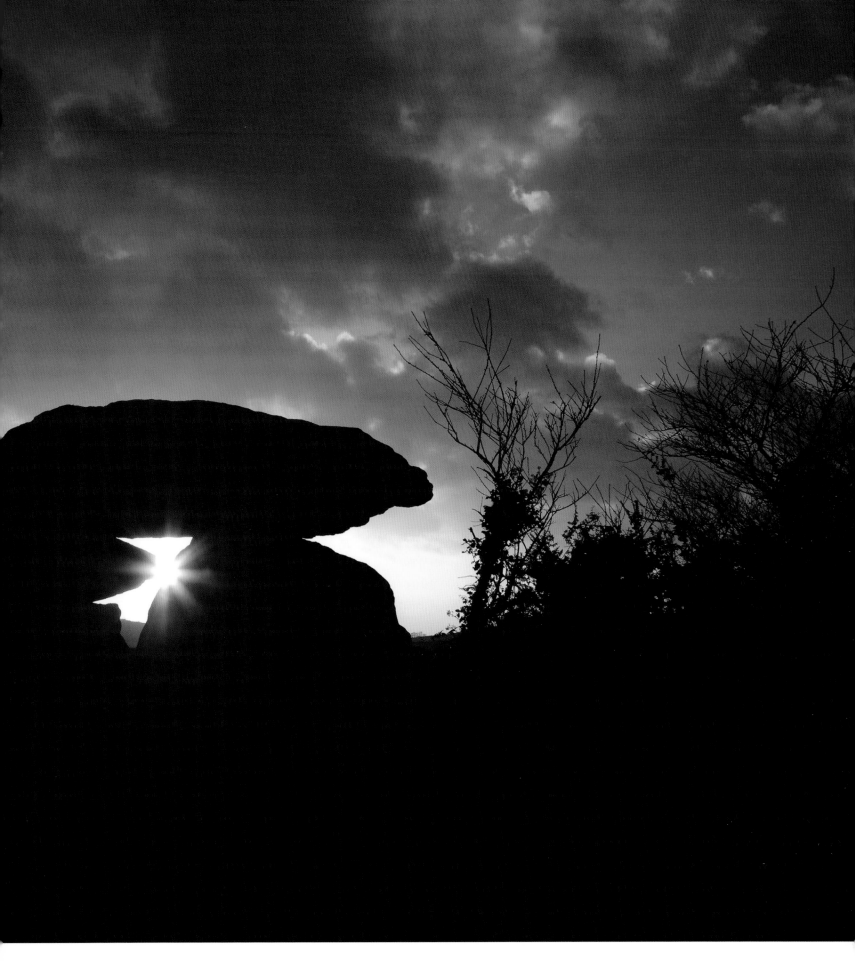

THE ANCIENT WORLD 17

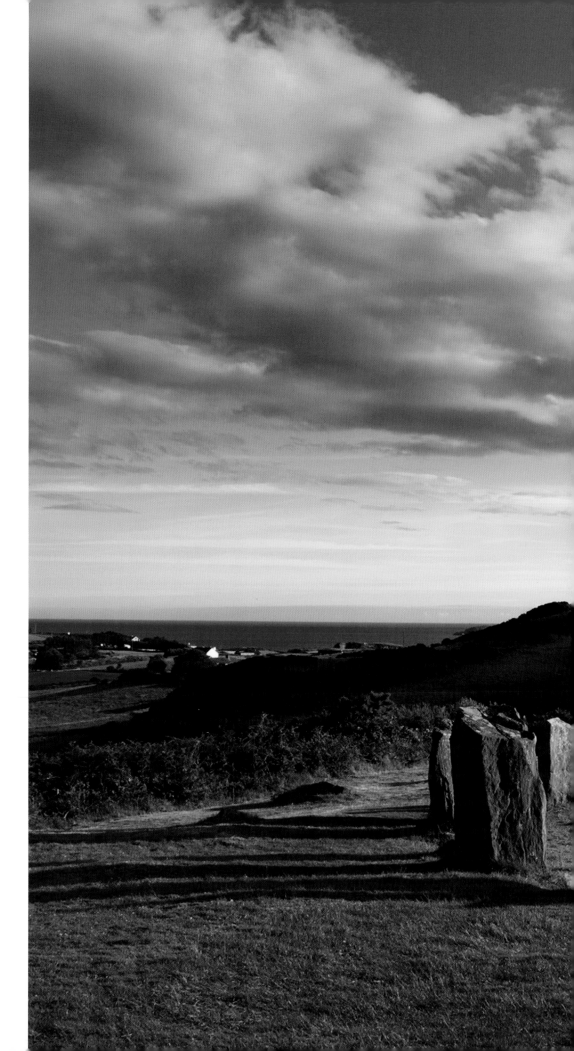

Stone circles, found in many parts of Ireland and dating mainly from the Bronze Age some three or four thousand years ago, are enigmatic. Modern Calvinistic folklore interpreted them as people in a circle who were turned into stone because they dared to dance on the Sabbath. Ancient myth stays silent about them. The very shape of the circles links them to the orb of the sun, and some circles have two particular stones which, when lined up, point to a spot on the horizon where the sun either rises or sets on some significant day of the year. Just imagine prehistoric Irish people celebrating—yes, probably dancing—and bowing toward the sun, their god and giver of life, in the midst of these glorious green fields.

Drombeg, one of the best-known and -loved stone circles, looks down to the Atlantic Ocean in the distance. It lies near the southern tip of the province of Munster in County Cork, which probably has the greatest concentration of stone circles anywhere in the country. Like many others of its kind, the two tallest stones in the foreground frame an entrance, opposite which is an axial or recumbent stone (just glimpsed in the background to the left of the right-hand entrance stone). Extending this sight line from the entrance beyond the axial stone leads to a point on the horizon where the sun sets on the winter solstice to enable ancestral Cork farmers to set their seasonal "clocks," as it were. They, too, may have had celebrations and ceremonies within the circle which only fantasy can imagine.

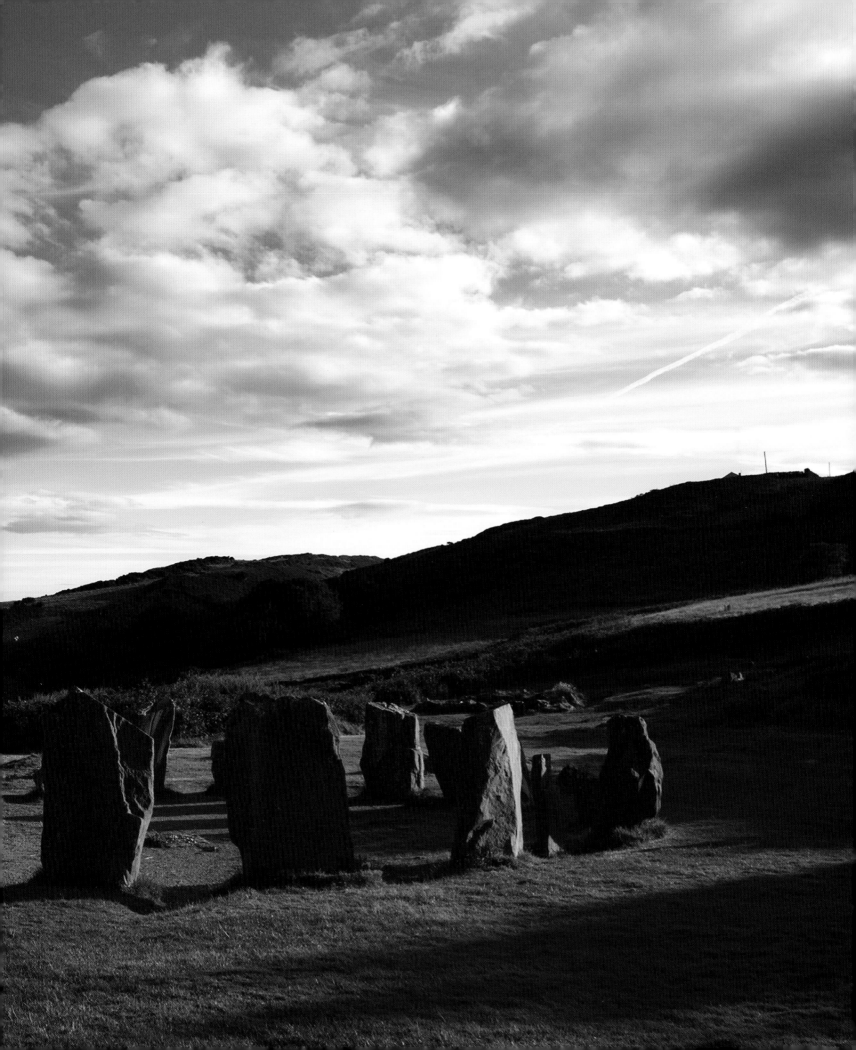

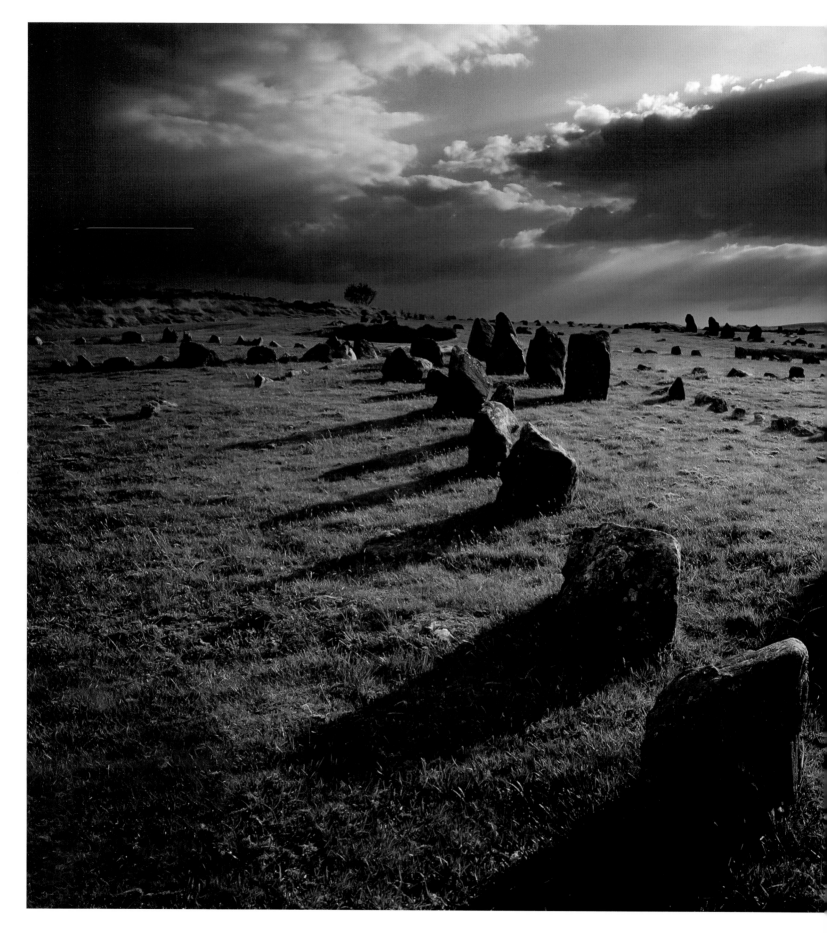

IRELAND: A LUMINOUS BEAUTY

Today's discussions about climate change are nothing new, and the Irish—great weather-talkers—must have had a lot to say on the subject four thousand years ago, even if we don't know what language they spoke. For it was around then that rain and cold temperatures became more common, and, as a result, many parts of the country began to be covered in peat-bog. One of the Bronze Age sites that it came to cover was Beaghmore in County Tyrone, where a series of stone circles and alignments that had been constructed not long after the shivering squalls had started were uncovered in the last century. It has even been argued that the stone circles may have been constructed to appease the weather gods. Beaghmore has four pairs of stone circles, and four of its alignments have been shown to point toward the midsummer sunrise on the horizon. Perhaps the circle shape is modeled on the orb of the sun, suggesting that the Bronze Age population may have worshipped the sun, as their predecessors are likely to have done at Newgrange.

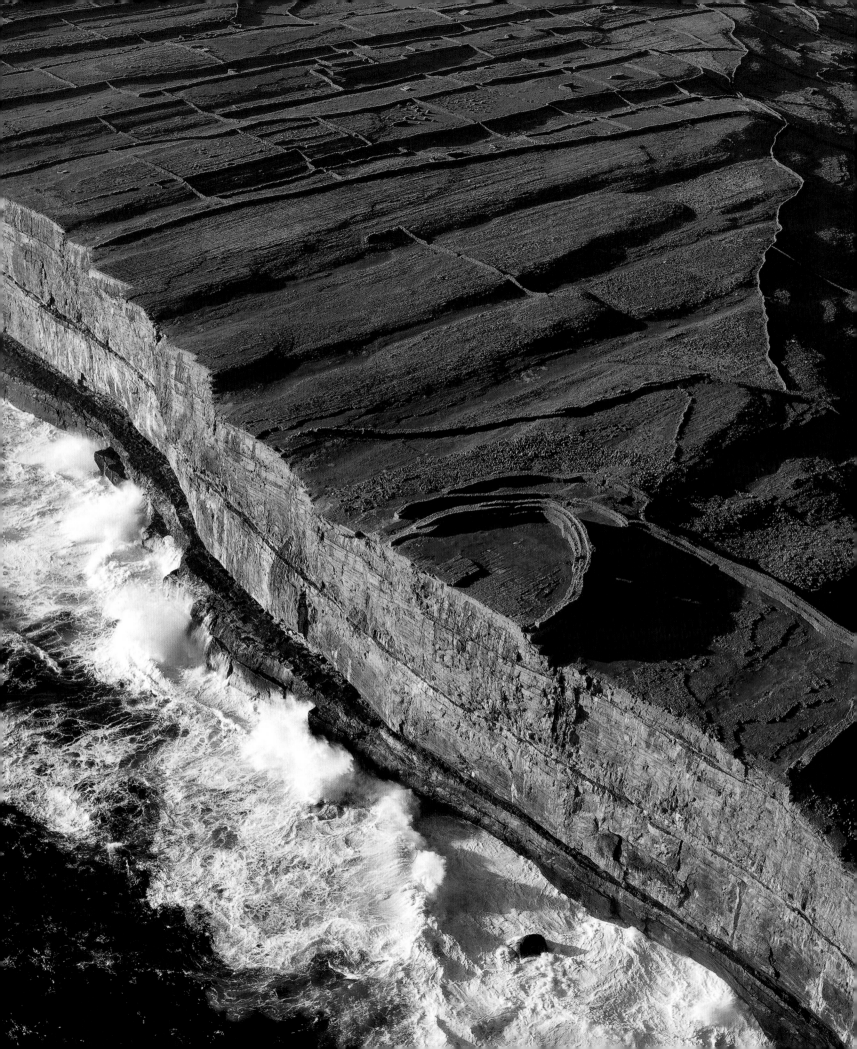

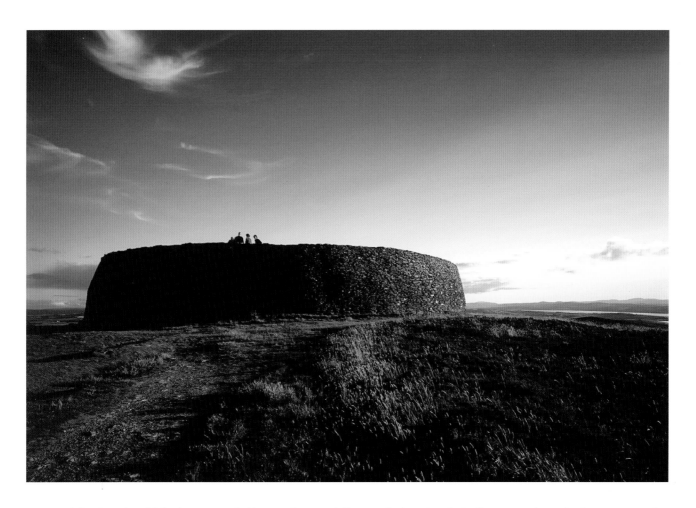

ABOVE: *The Grianán of Aileach is a remarkable stone fort on a hilltop overlooking Lough Swilly, just a mile inside County Donegal close to its border with County Derry. The word Grianán means "a sunny place." Tradition ascribes its erection to the Tuatha De Danann, a prehistoric people whose coming to Ireland preceded that of the "Celtic" Milesians, but trying to put dates on such long-ago events is difficult. Being an impressive stronghold, the fort was perhaps the Regia, mentioned by the second-century AD Greek geographer Ptolemy, and its builders would have been the northern Uí Néill (O'Neill) kings who ruled parts of counties Donegal, Derry, and Tyrone in the early centuries of Christianity, and for whom it served as the royal seat. It is said that St. Patrick came here and blessed the inhabitants as well as a flat stone on which the future kings and princes would be inaugurated.*

OPPOSITE: *Situated on a cliff-edge dropping precipitately to the raging Atlantic waves almost two hundred feet below, Dun Aengus (which has many spellings) is one of the supremely heroic monuments of ancient Ireland. Located on Inishmore, the largest of the three Aran Islands in Galway Bay ("o'er which the sun goes down," according to song), it gets its name from Aengus, a chief of the Fir Bolg, "vassal tribes" who were pushed westward in Ireland until they could go no farther, facing the choice of either defending themselves or falling over the cliff into the sea. This impressive fortification—a series of walls extending out in onion-like layers from the central half-circular defense—was erected toward the end of the Bronze Age, perhaps around eight hundred years before the Christian era. What looks like an altar at the very center, beside the cliff-edge, could suggest an additional ceremonial purpose, but a band of hundreds of sharp pieces of limestone set upright in the ground (chevaux-de-frise) beyond an outer wall suggests fortification as the primary purpose of the complex, as they help to impede access.*

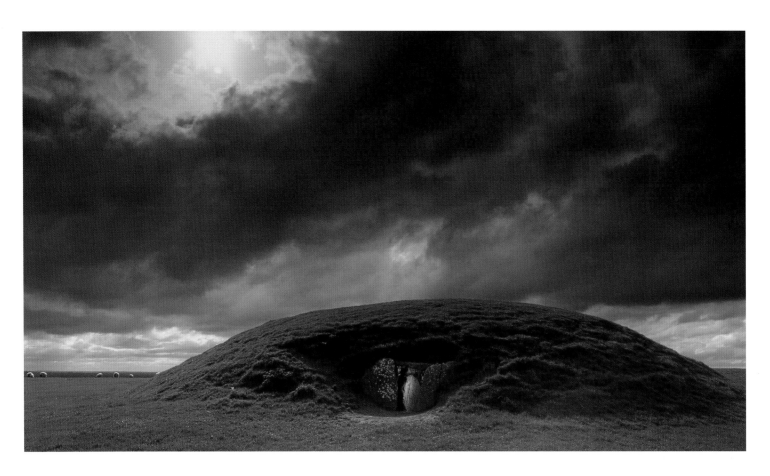

Tara, in County Meath, the most sacred site in Ireland for millennia, the symbolic seat of the High Kings, includes a Stone Age passage-grave. All the old (presumably wooden) buildings have long since disappeared, causing some disappointment to visitors, but this is where imagination and a knowledge of the site's history comes into play, for the earthworks we see today must have teemed with life centuries ago.

ABOVE: The oldest visible monument on the Hill of Tara today is the Mound of the Hostages, a passage-grave dating perhaps from not long before 2000 BC. Tara was a place of sacred kingship in the early medieval period, and where people may have invoked their ancestors buried in the Mound of the Hostages in order to justify their claim to the surrounding land.

OPPOSITE: Today, the hilltop is surrounded by an oval wall enclosing two ring-forts in the center and the pimple-like Mound of the Hostages to the left. Over centuries, kings fought to claim the prestigious title of "King of Tara," though Maelsechlainn I (846-862) may have been the first to claim jurisdiction over other parts of Ireland and extend the title legitimately to "King of Ireland." In 1022, the real importance of Tara waned, after which the city of Dublin became the prize to win. Tara is associated with another king, uncrowned but of regal status in the community: the great Liberator, Daniel O'Connell, who held a "Monster Meeting" (attended by close to half a million people) on the Hill in 1843 in a sadly unsuccessful attempt to repeal the Act of Union, which had made Ireland subservient to the British Parliament in Westminster in 1801.

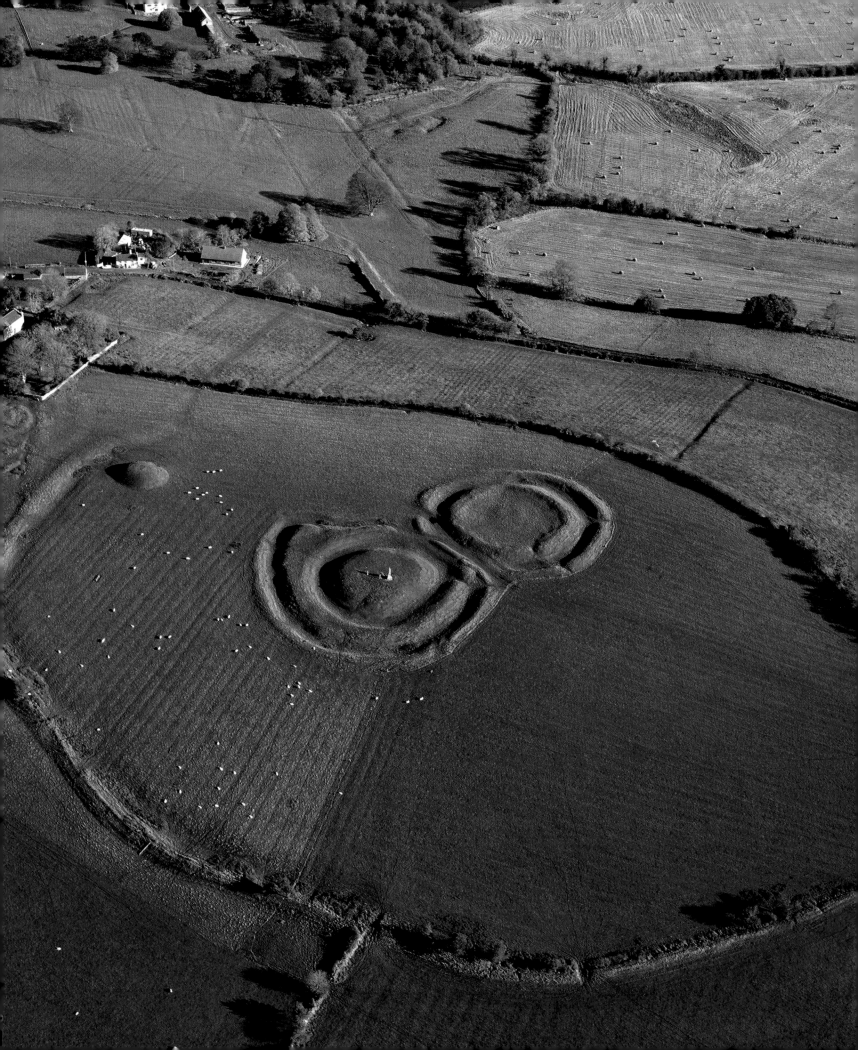

Navan Fort, "Emain Macha" in Gaelic, two miles away from Armagh, is, in a way, Northern Ireland's Tara in that it follows a similar pattern of Stone Age origin, Bronze Age use, Iron Age ritual, heroic kings' presence, and eventual abandonment. But there the similarities fade. Within a large circular bank and ditch, there are a large mound and a small mound, the former (almost twenty feet high and two hundred feet in diameter) arguably the most spectacular and important monument in Northern Ireland. It was around this extraordinary place that the medieval tales of King Conor MacNessa and the great Irish hero Cuchulain were woven, reflecting a heathen Iron Age society, which waned around the fourth century AD when St. Patrick founded his church on the hill of Armagh. The Christian Armagh then took over from the pagan.

Macha was a goddess who once must have been venerated in Navan Fort and whose name is closely associated with its origins. Before the mound was erected in 95 BC (a precision achieved through tree-ring dating), a house had been rebuilt eleven times on the same spot; one of these houses would have offered a perch for a Barbary ape, probably brought from North Africa as a diplomatic gift in the second century BC.

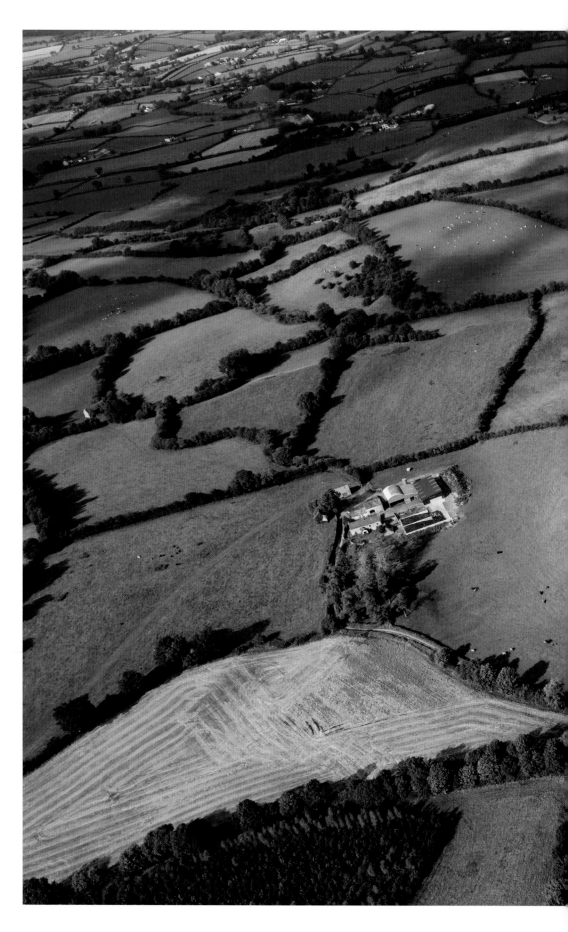

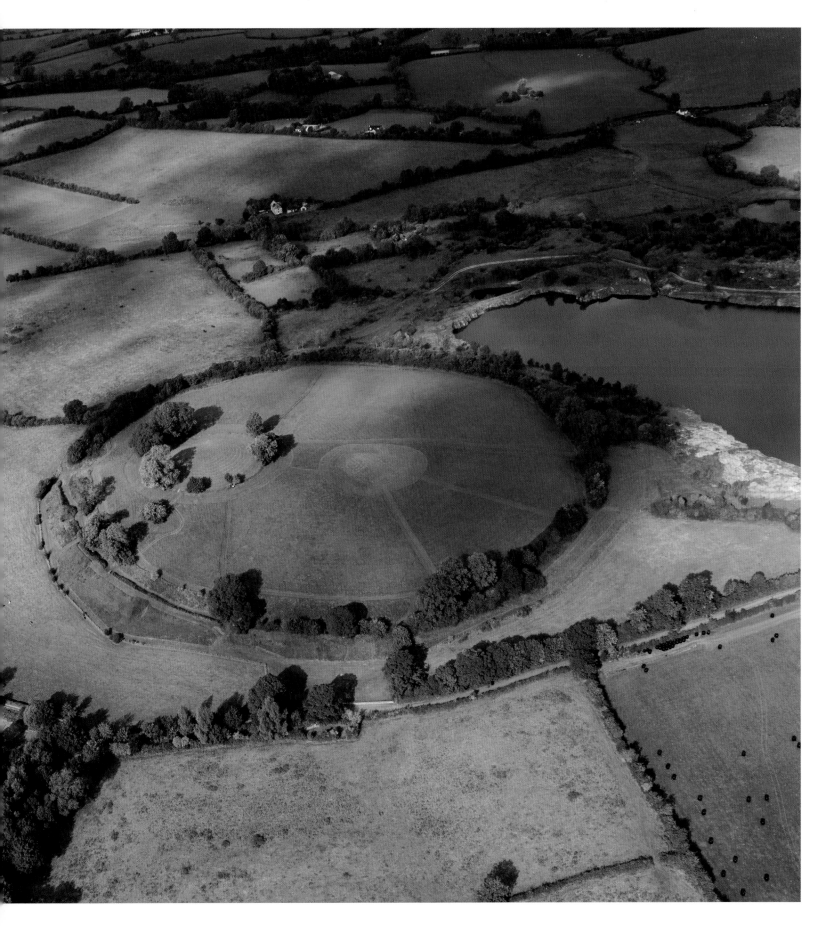

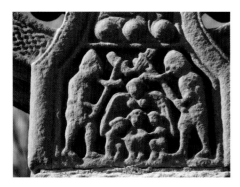

The head of the West Cross at Monasterboice is one of the finest and best-preserved pieces of high cross carving, dating from the late ninth century, as exemplified by this panel, which represents the biblical tale of what is commonly known as "The Three Children in the Fiery Furnace," from the third chapter of the Old Testament book of Daniel.

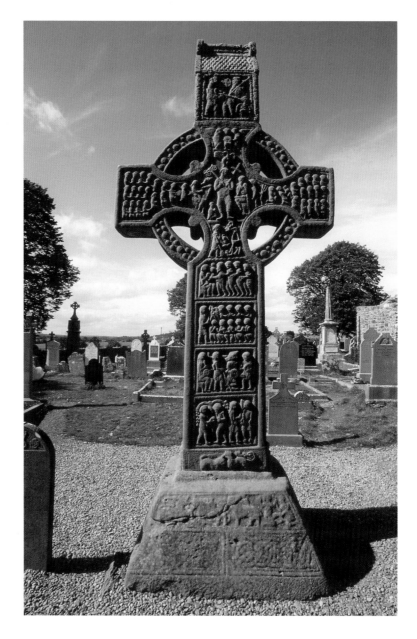

There are over sixty—whole or fragmentary—Irish high crosses bearing biblical sculpture, but few are as masterly or well preserved as the stone cross at Monasterboice in County Louth. An abbot named Muiredach commissioned this cross at the end of the ninth century. Above the base, we find three panels from the Old Testament: Adam and Eve with their children, David slaying Goliath, and Moses getting water from the rock to save the Israelites in the desert. Then a switch to the New Testament with a panel showing the Virgin and Child and four Magi just beneath the ring, the head. At the center of the head, is one of the oldest representations of the Last Judgment, with Christ flanked by the good souls on his right and the bad souls sent to eternal damnation on his left. Beneath is a comic view of St. Michael weighing souls as he overcomes the devil on the Day of Judgment, showing a sense of humor seen also in the two animals playing with one another at the bottom of the shaft.

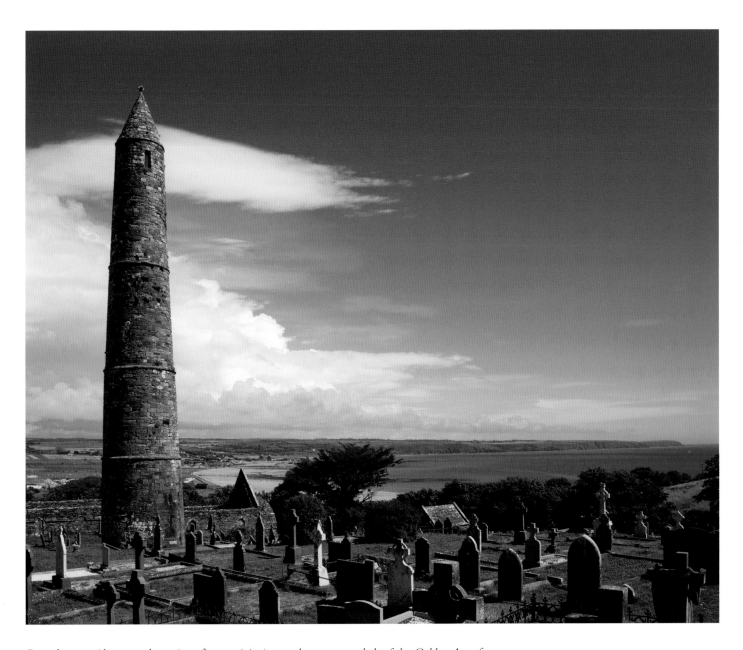

Round towers (there are about sixty-five surviving) were the status symbols of the Golden Age of monastic Ireland, between 950 and 1200 AD. Literally "The Great Height" in Gaelic, Ardmore stands in a dominating position, looking towards Tramore and Waterford out over what is known today as "The Celtic Sea," but which is really a part of the Atlantic Ocean. Here an ancient monastery was founded by St. Declan allegedly before St. Patrick began his mission to Ireland. The graceful round tower, preserved right up to its conical roof, rises ninety-five feet above ground—a great height. It thins out as it rises over three stringcourses which provide a horizontal contrast to the almost pencil-like height. The long, low building behind the round tower is the twelfth-century Ardmore cathedral, its west gable decorated with a series of small sculptures.

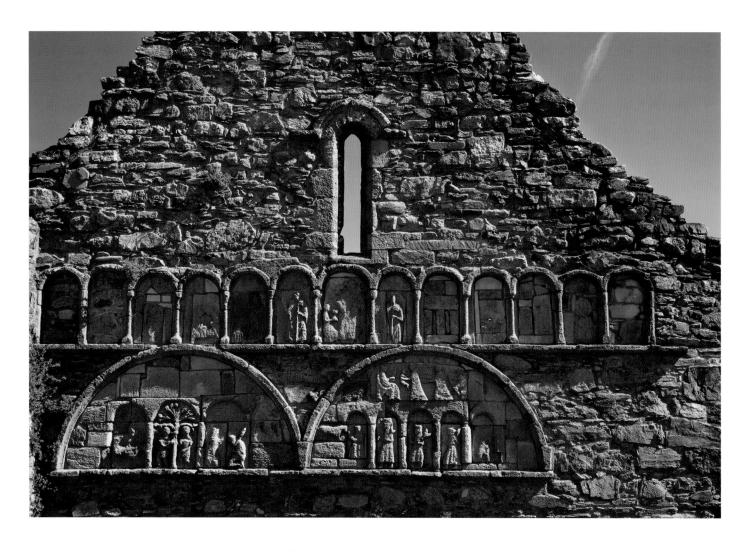

One may take with a grain of salt the story which declares St. Declan of Ardmore one of the four saints in Ireland before St. Patrick. But, true or false, his monastery overlooking the Celtic Sea at Ardmore is arguably the most important early Christian site in County Waterford. The main religious center is the cathedral, which we know was completed by 1203. Its most surprising element is the collection of twelfth-century sculptures placed asymmetrically in two large lunettes surmounted by an arcade on the gable. (The long, low remains of the cathedral are seen in the preceding photograph of Ardmore.) The sculptures are not in their original position, having probably been taken from an earlier building. Some of the disjointed sculpted panels may, appropriately, have something to do with the building of Solomon's Temple, but the only scenes we can reasonably identify are Adam and Eve under a tree near the center of the left-hand lunette, and the Judgment of Solomon on the upper part of its counterpart to the right. The rest, alas, have to be left to conjecture.

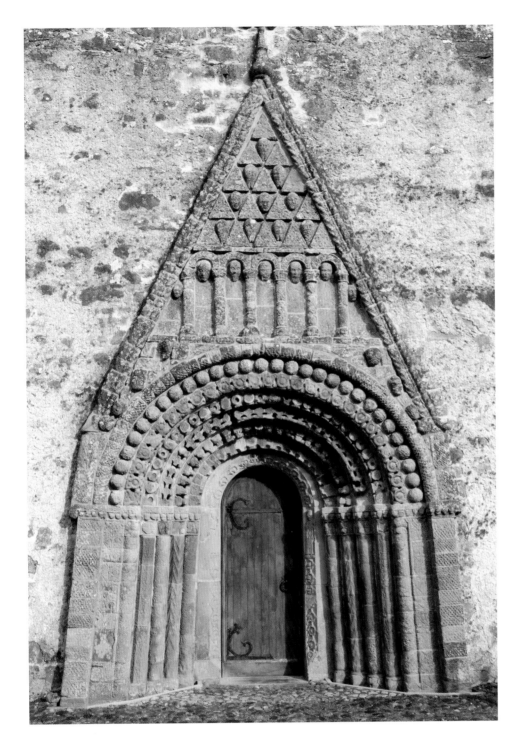

Clonfert Cathedral, not far from the Galway bank of the river Shannon, is the burial place of one of Ireland's most famous—and most traveled—saints, Brendan the Navigator. Born in Ardfert, County Kerry, around the 480s, he is best known as the central figure of the Navigatio Brendani, a narrative of his travels written in Latin in the ninth century and later translated into so many languages that it became what may be Europe's most celebrated travelogue of the Early Middle Ages. With a dozen disciples, Brendan set off from his native county in southwest Ireland in what would have been a currach, or canvas-covered boat, the kind still used along Ireland's west coast today. Aiming to find the Land of Promise, he had a number of adventures along the way, including saying Mass on the back of a whale that began to shiver and sink when his disciples lit a fire to cook a meal on it. The voyage, which took over a year to complete, brought the captain and his crew to various islands, some of which can be identified with probability. In Iceland a giant throws burning coals at the boat (reflecting an active volcano), while an encounter with a crystal pillar suggests the icebergs of Greenland. A great bird bringing a branch with grapes led to the suggestion that St. Brendan may have reached the east coast of North America long before Leif Ericson or Christopher Columbus, a tantalizing possibility that still awaits proof. His burial here must be the reason why Clonfert Cathedral has the most decorative Romanesque-style doorway in Ireland, the work of one master craftsman.

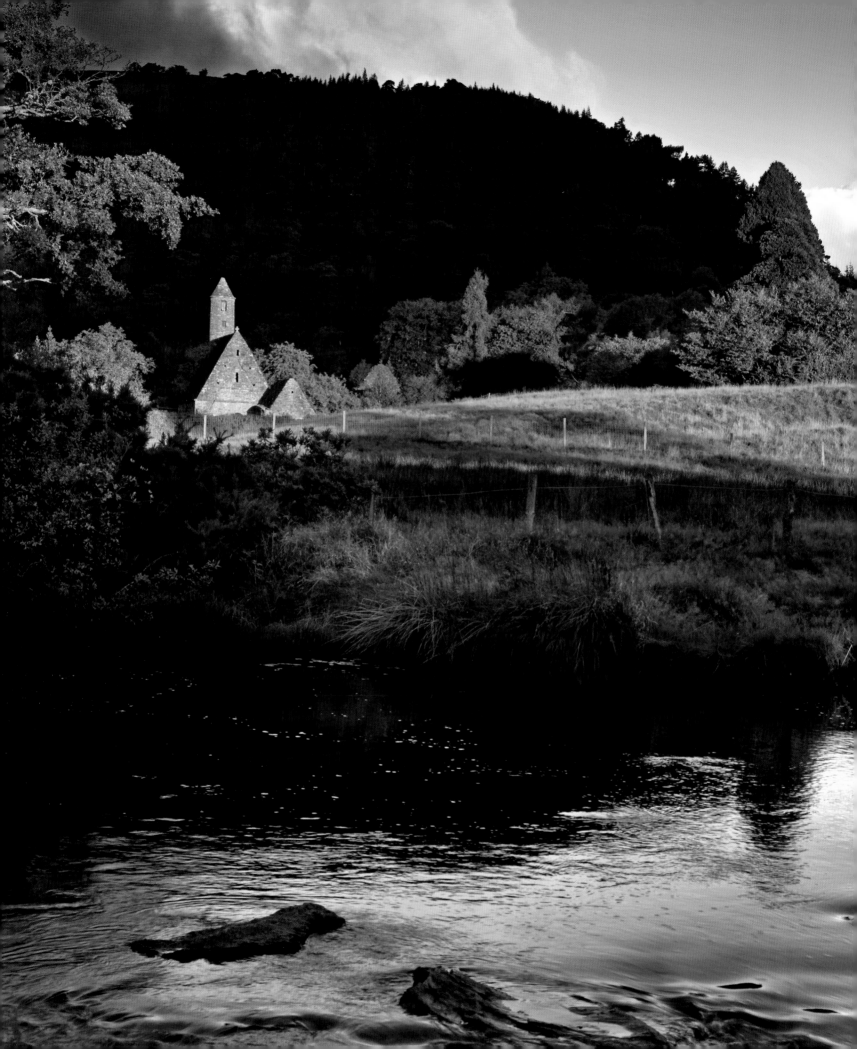

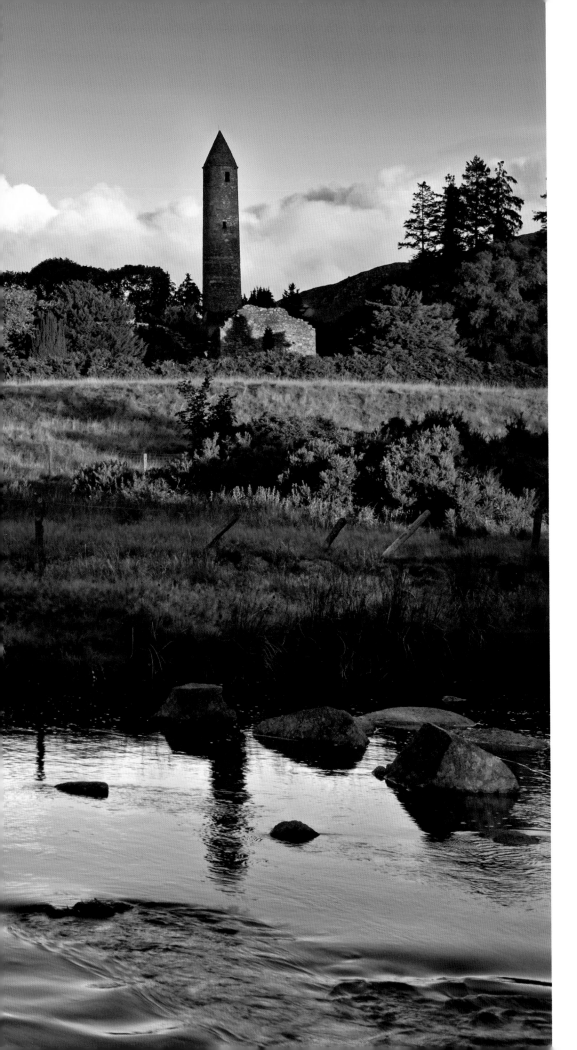

The scarcely moving water of the Glendasan stream is emblematic of the peace to be found in the County Wicklow valley of Glendalough through which it flows. The full foliage, the lushness of the gently curving green field, and the nobility of the stone monuments make this a place to still the mind and quiet the soul. This Glendalough is the serene hermitage sought out by St. Kevin in the sixth century, a place where he could cut himself off from the world and live an ascetic life devoting himself to God. The very first sight for the modern visitor approaching Glendalough is the top of the round tower, rising almost one hundred feet above ground level. The conical cap is made of its original stones, which were reset in 1876 after they had caved in years or even centuries earlier. This suggests that one of the purposes of round towers in the Middle Ages was to act as a beacon to pilgrims coming to venerate a saint's relics, showing the way and encouraging tired legs for the last few miles of the journey.

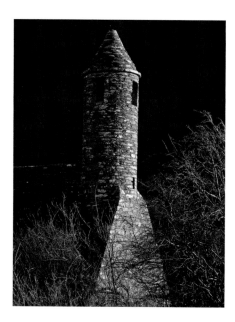

ABOVE: *A round tower was essential for any monastery wanting to be taken seriously. Most Irish monasteries possessed one. Glendalough has one and a half. In addition to a hundred-foot round tower, a mini version adorns St. Kevin's church, which goes by the name of "Kevin's Kitchen" because the round tower resembles a chimney rising from the roof. The tower, however, was not part of the original plan but most likely added during the twelfth century. It reaches out of a stone roof, a uniquely Irish contribution to the architecture of medieval Europe.*

RIGHT: *Glendalough—the "Valley of Two Lakes"—is tucked away in the Wicklow Mountains south of Dublin. Because of the valley's steep sides, the sun sets comparatively early there, sometimes creating a sense of melancholy from midafternoon on. As such, it was an ideal place for St. Kevin to find solitude away from "the madding crowd's ignoble strife," and to pray and commune with his Maker in what became a hermitage near the upper of the two lakes in the valley.*

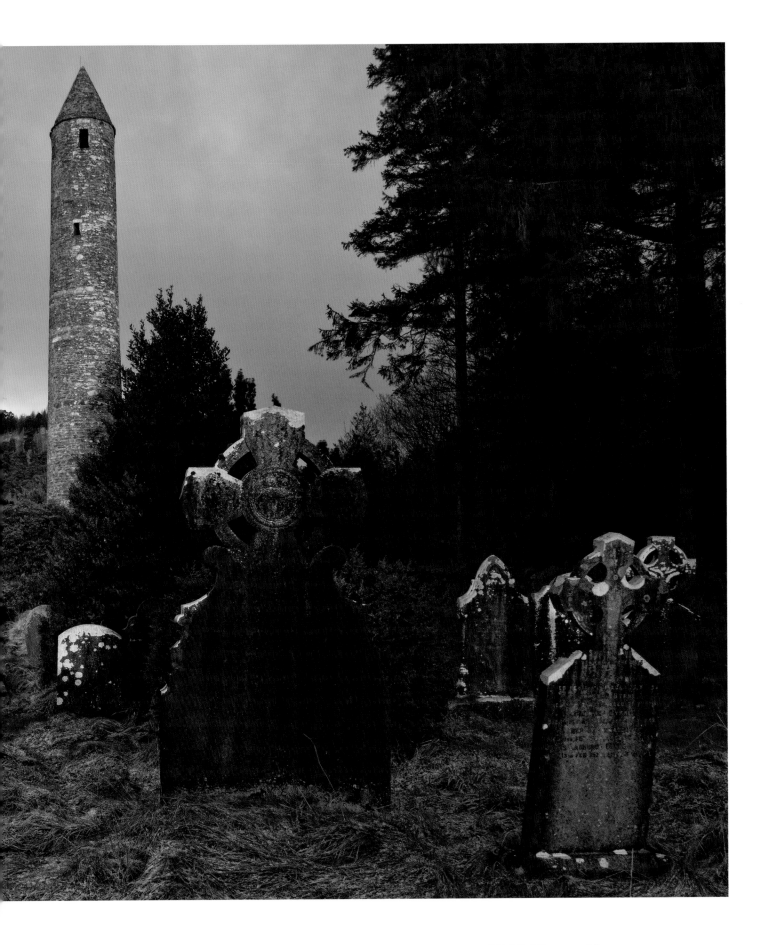

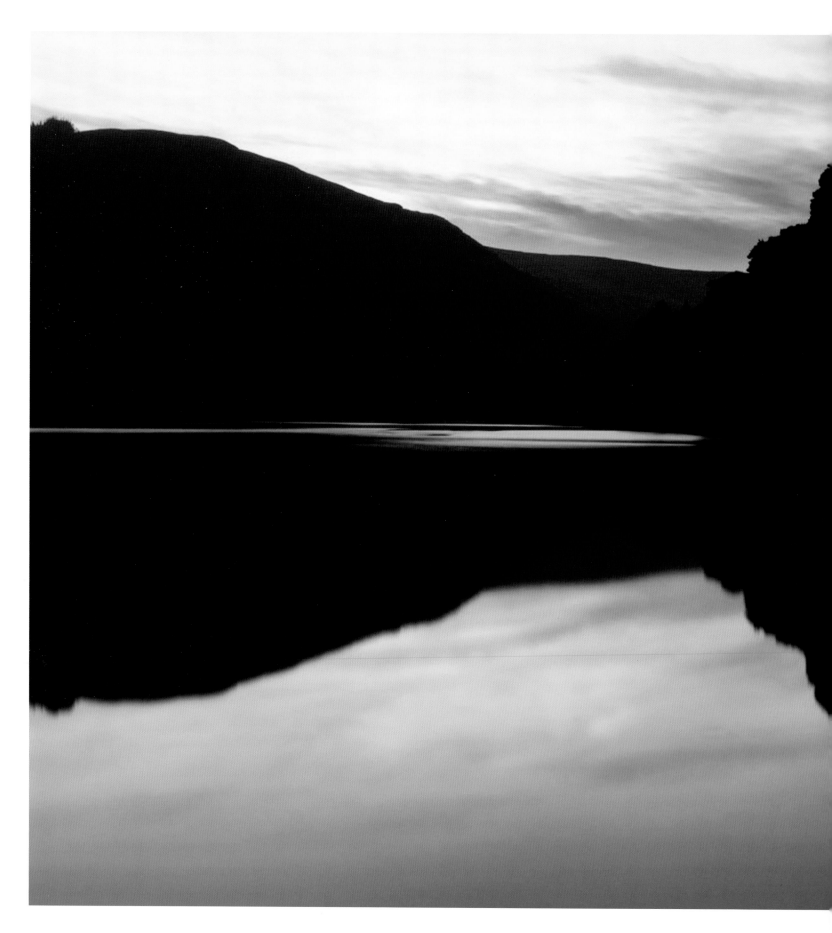

The upper of the two lakes in Glendalough is the area where St. Kevin probably settled when he first came to the valley in the sixth century. Often with colorful yellow gorse around its banks, it is surrounded by tall hills that provide wonderful views of the valley below and a very stimulating and energetic walk. There are two churches flanking the upper lake (not visible in this picture)—one, Temple Na Skellig, reachable only by boat, the other easily accessible on foot. This is Reefert Church, within whose walls sleep many Leinster kings, surrounded by a gentle scattering of trees. The stillness of this shadowy early evening image reflects the tranquility of the lakes.

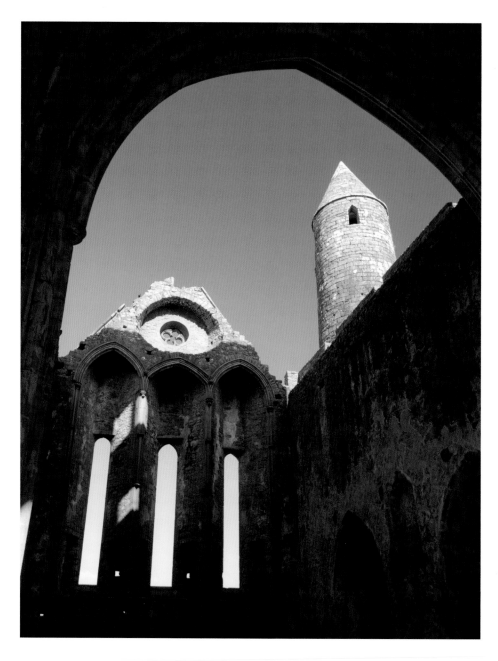

ABOVE: *Two periods in the architectural history of the Rock of Cashel are visible in this photograph. The older is evident in the ninety-two-foot-high round tower, representing a church presence on the Rock before it was formally handed over to the church in its entirety in 1101. The second period is apparent in the later thirteenth-century north transept of the cathedral, probably built by archbishop David Mac Cerbaill (1254-1289). Typical of the period are the tall, thin lancet windows, with the central one reduced in height to allow for a rose window, itself later reduced in size to become the smaller oculus we see today. This north transept was part of a second building phase of the cathedral, which would have intended to complete the nave—but never did. Instead, the nave was foreshortened, with bishops deciding to build a fortress for themselves at the western end of the cathedral, showing just how insecure they must have felt on their lofty medieval perch.*

OPPOSITE: *The cluster of great stone monuments atop a three hundred-foot-high rock rising imperiously above the plain of the "Golden Vale" in Cashel, County Tipperary, is an arresting sight from any direction. Cashel ("stone ringfort," akin to the Latin word* castellum*), was an obvious place for a fortress, and here St. Patrick is said to have come to baptize the local king, Aengus. During the ceremony, St. Patrick accidentally put his crozier through the royal foot and, on noticing what he had done, asked the king why he had borne it so stoically without complaint—to which the king replied he thought that this was part of the ritual!*

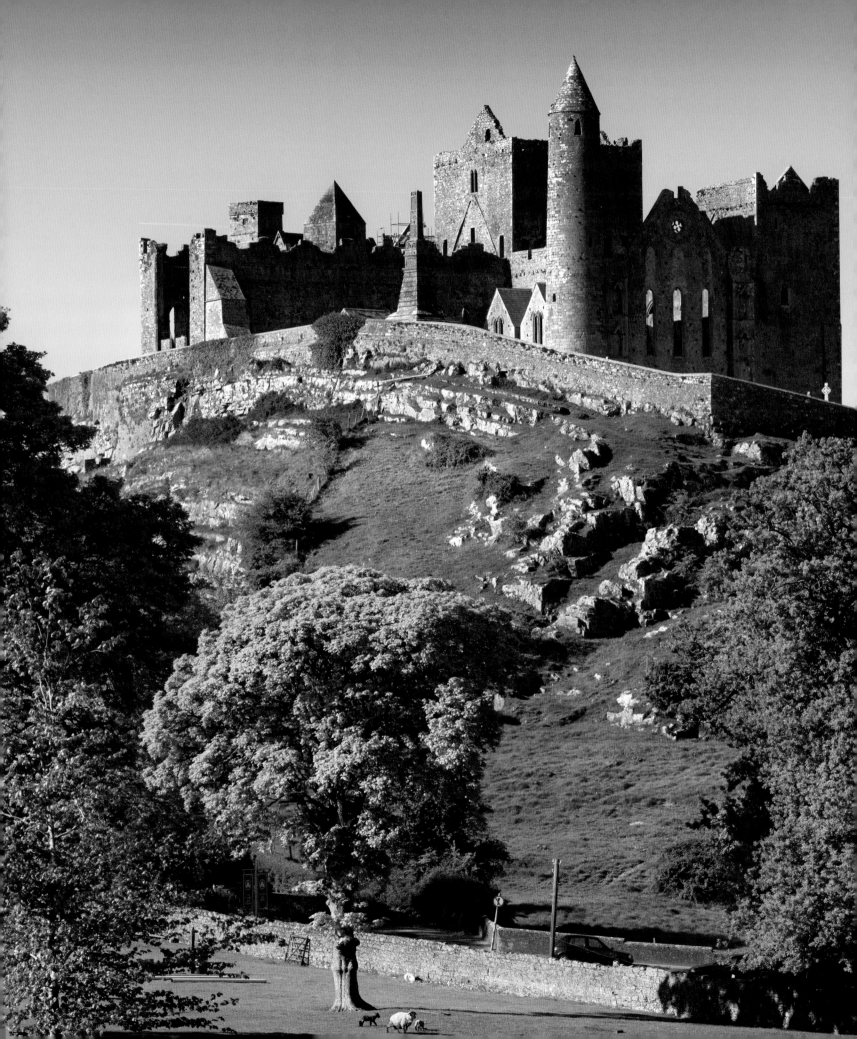

*Originally founded by the Benedictine order in 1266, Hore Abbey was given to the Cistercian
monks from Mellifont Abbey in 1272 by David Mac Cerbaill, archbishop of nearby Cashel.
Tradition says that Mac Cerbaill expelled the Benedictine monks who were then at Hore Abbey*

after he had a dream that they were about to kill him. The abbey was the last pre-Reformation
Cistercian foundation in Ireland. It was never prosperous; at the time of the Dissolution the annual
income of the abbey was valued at just £21.

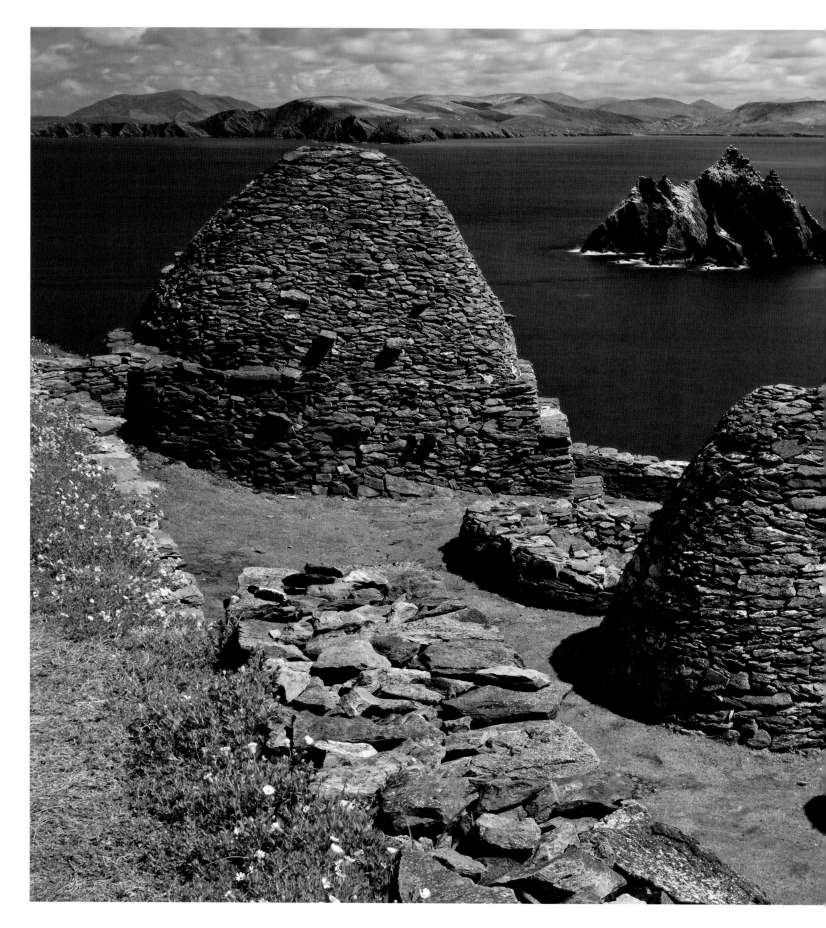

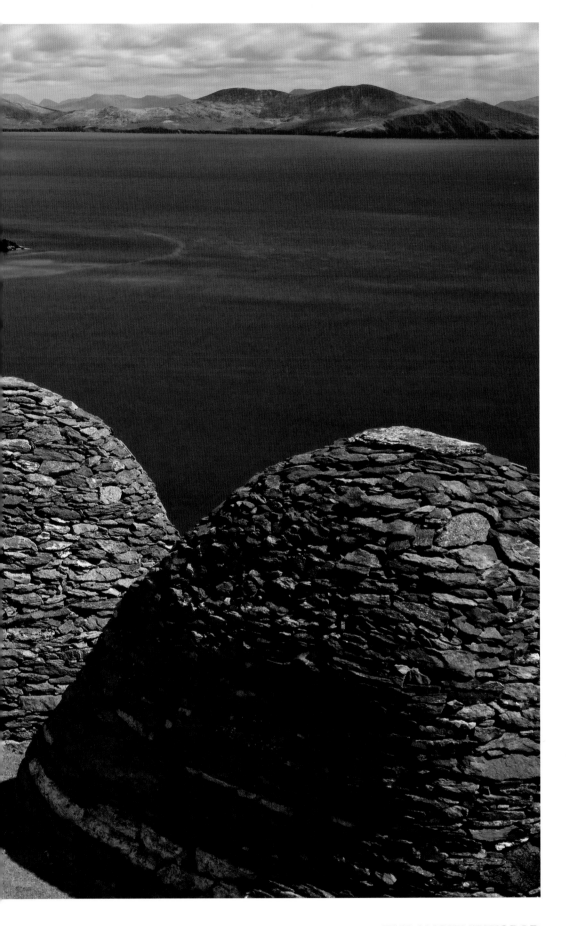

LEFT: *The island of Skellig Michael, County Kerry, nine miles out in the Atlantic off the southwest coast of Ireland, is perhaps the most amazing monastic site anywhere in northern Europe. The island is small and steep, reaching 715 feet above sea level, and its fame rests on the monastery, built on a terrace, at a height of 550 feet overlooking the sea. It may have been founded by a St. Finan around the sixth century, but it is really not known when the monks first came to enjoy the view of the mainland beyond the Lesser Skellig (a notable bird sanctuary). It was probably around the eighth or ninth century that work would have begun on the terraces, built on the island's steep slopes to enable the erection of the beehive huts, remarkable dwellings created with the corbel technique of circles of stones piled on top of one another, decreasing in width all the time until closed by a single stone at the top. Their builders were master masons, carefully choosing their stones to make a smooth outer circular wall, though square inside, and having stones jutting out externally to act as steps during the course of construction. A visit to the site, after an often difficult sea-trip over swell and waves, is a moving and exhilarating experience. What a lonely, difficult life the monks must have had on the island, isolated from the mainland possibly for months at a time due to trying weather conditions. Still, the view on a fine day is spectacular.*

BELOW: *Gallarus Oratory on the Dingle Peninsula in County Kerry was built using the same corbel construction technique, producing a modified shape.*

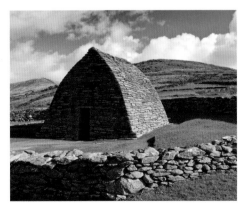

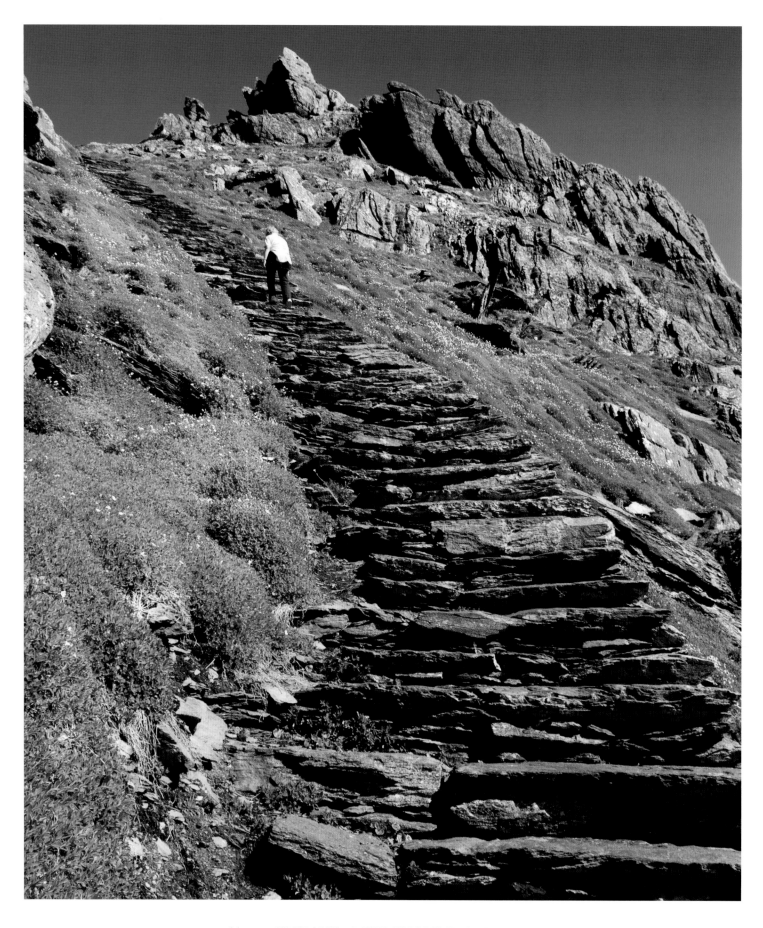

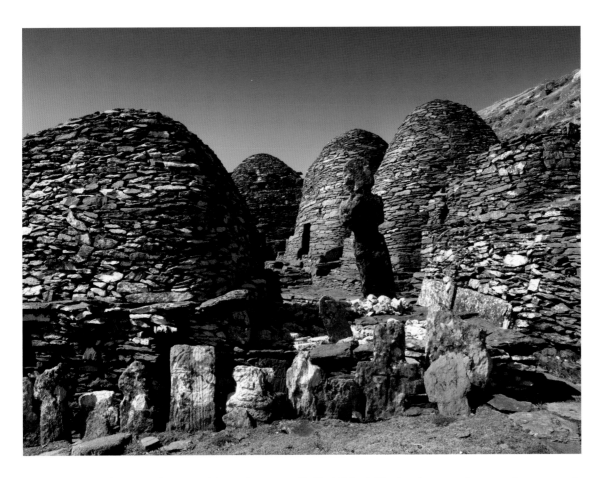

ABOVE: *This small graveyard is part of the settlement on Skellig Michael. The last interment known to have occurred here was in the nineteenth century, when one of the lighthouse keeper's children was laid to rest in the small chapel dedicated to St. Michael. The archangel Michael is the patron saint of high places. The name of St. Michael is first associated with Skellig in 1044, but we do not know to whom the monastery was dedicated before that (St. Finan?). In 844, we hear, Vikings raided the island, carrying off one of the monks.*

OPPOSITE: *Evoking images of Jacob's Ladder ascending to heaven, the more than five hundred steps on the island of Skellig Michael lead the visitor up to the monastery on the terrace above. The stairs in this photograph are only one of several sets leading from various landing-places on the island, necessary due to variables like the swell and the wind direction. The extensive terrace works would not really have been necessary for what was most likely a small community that perhaps increased in number during the summer. So these difficult operations must have been undertaken, at least in part, with visitors in mind, who would essentially have been pilgrims. It may have been for them, too, that some of the beehive huts were constructed, offering overnight accommodation when the wind and sea were adverse to passage back to the mainland. Thus, Skellig Michael would have served the double purpose of monastery and pilgrim hostel.*

Most people think of Skellig as an island
with a monastery of beehive huts on a terrace
550 feet above the Atlantic waves. But not
many know about—and, for safety reasons,
even fewer have access to—a much more
ascetic spot on the island. It is located just
below the southernmost, taller of the two
peaks, about 715 feet high. It is reachable by
rock-cut steps, through the perilous "Needle's
Eye" and up a further steep climb partially
using steps carved out by the monks of old.
All of this leads to three separate small
terraces, one of which has a little corbelled
oratory less than eight feet long, and basins
for holding water, while, nearby, is an open-air
altar. The choice of such a location, so
precipitous and difficult to access, makes one
wonder to what lengths the monks, or really
hermits, up there facing wind and rain from all
directions, were prepared to go to demonstrate
their love of God.

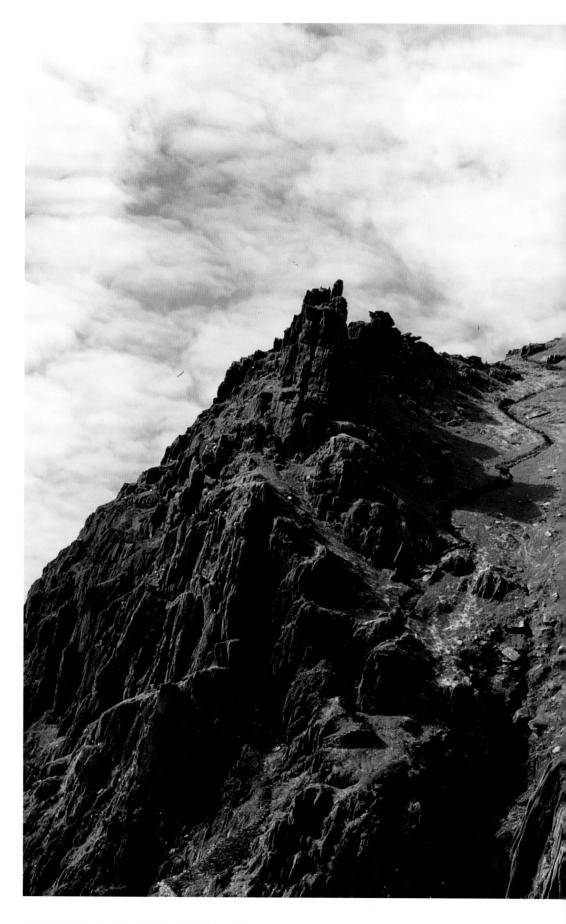

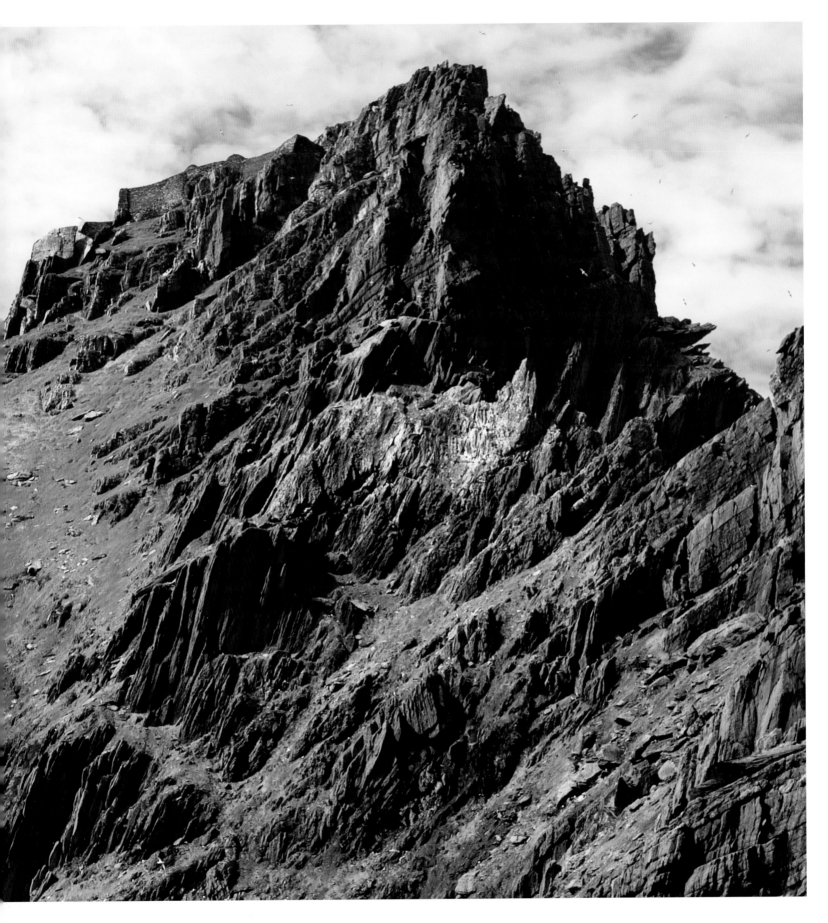

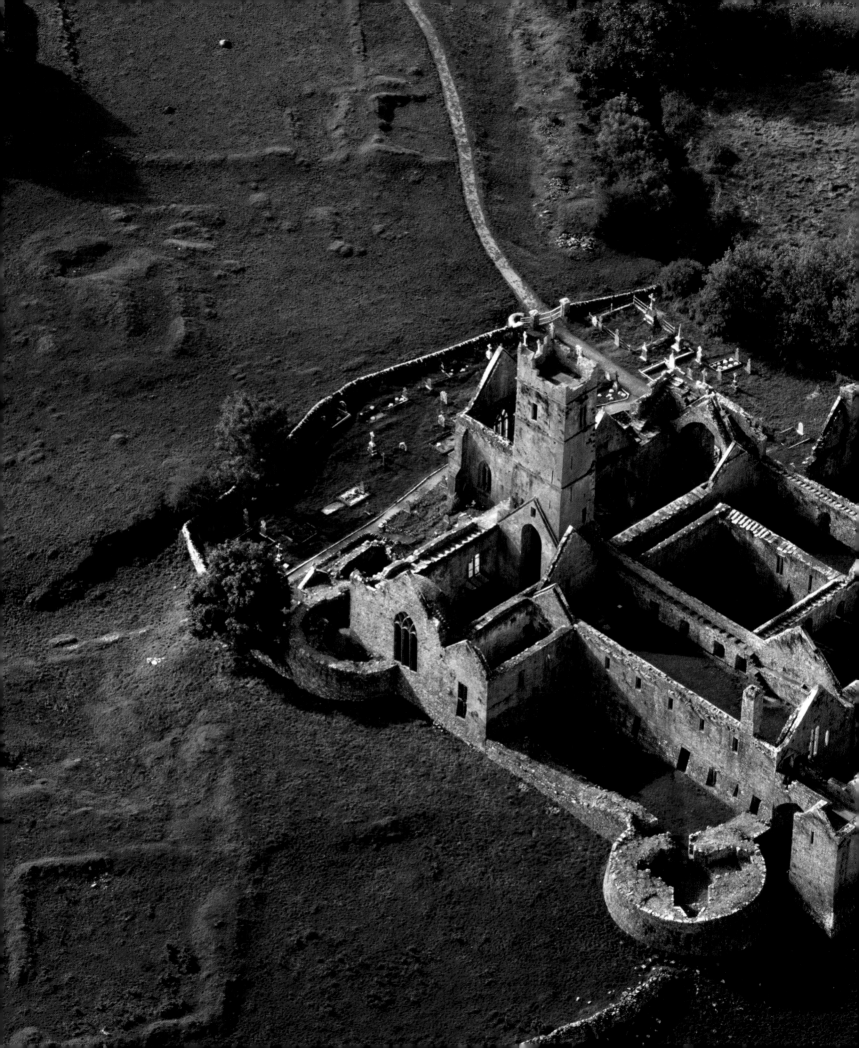

The midday sun lights up wonderfully the
footprint and details of the medieval Franciscan
friary at Quin which, in an unexpected way,
symbolizes the triumph of peace over aggression.
It certainly sits calmly in the luscious green
pastures of County Clare. The complex contains
a long church with a graceful tower in the middle
of its length, and a two-storey cloister where the
friars would have walked in quiet meditation.
But where does aggression come in? The round
feature at the bottom of the photograph and
another on the left near the east window are two
of the four bastions of a square castle built by
the invading Norman family of de Clare in
1278. But the Irish defeated them forty years
later at the Battle of Dysert O'Dea and
demolished their castle down to the basement of
the corner towers. The Irish placed their friary
four-square on top of the ruins of the castle,
which had been built in vain to intimidate them,
and so the friary became a symbol of peace, like
a phoenix rising out of the ashes of war.

An aerial view of the gently undulating lush, green Mayo countryside ineluctably draws the eye down to the friary of Rosserk located on the banks of Killala Bay on the estuary of the river Moy. It was founded around 1441 for the Third Order of Franciscans, and is the best-preserved example of their architecture in Ireland. Unlike the friars of the First Order and the nuns of the Second, who were full-time religious, the Third Order had permanent members as well as laymen who lived at home. Rosserk was operational for a century and a half before it was burned in 1570 by Richard Bingham, Queen Elizabeth I's governor of Connacht, but its walls—of high-quality masonry—still stand, roofless, today. The church is a long rectangle surmounted in the middle by a tall and slender tower, and an attractive two-storey cloister is located to the north. There is a simple, pointed doorway in the west gable, and a finely wrought window in the east wall. The unique feature of the friary, however, is a piscina (for draining away the unused water and wine from the Mass), which has one pillar decorated with a small carving of an old, Irish-style, round tower.

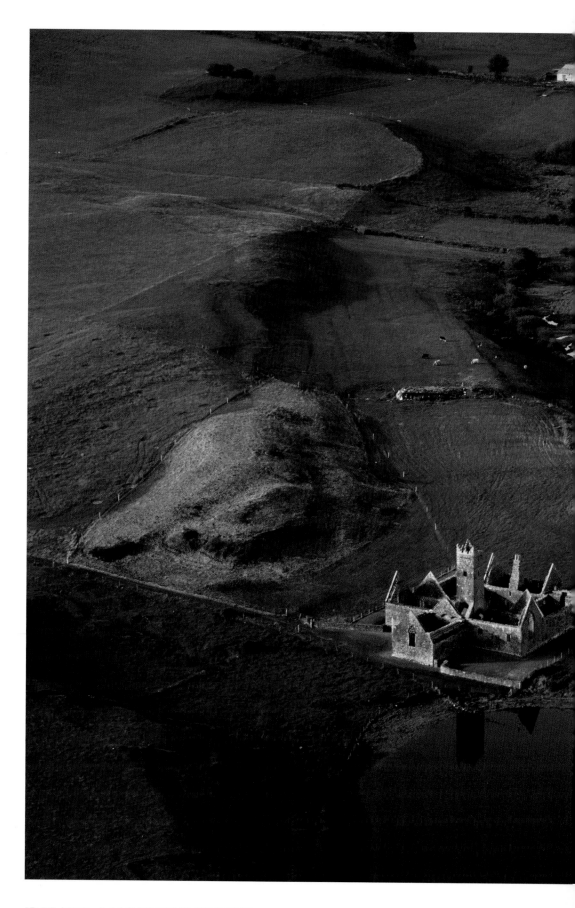

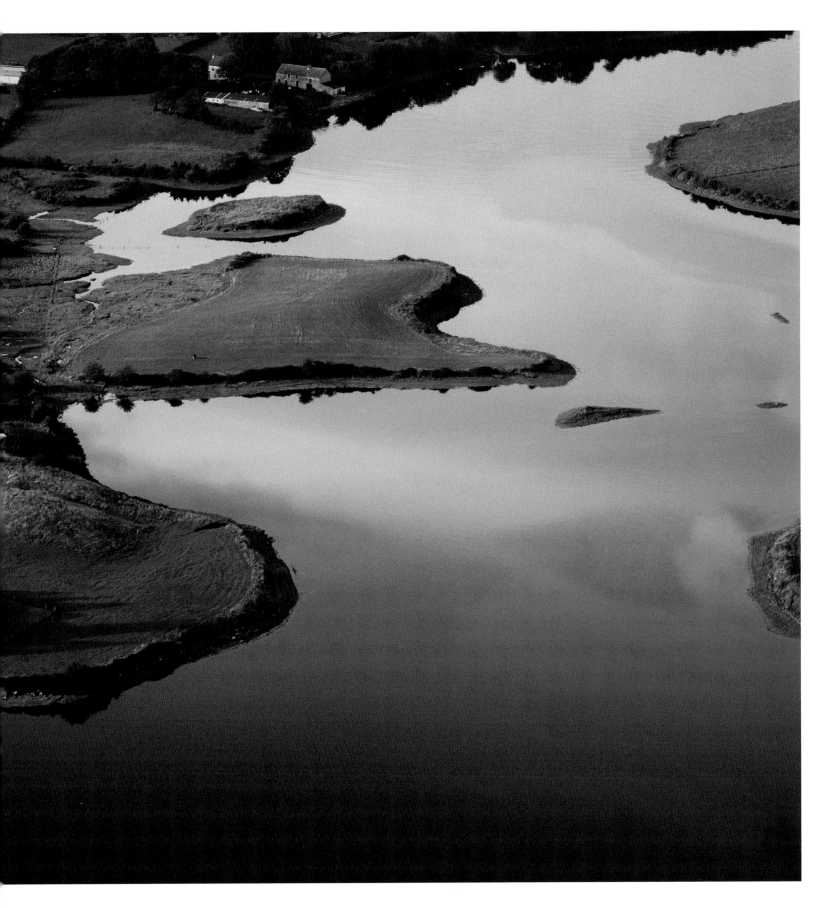

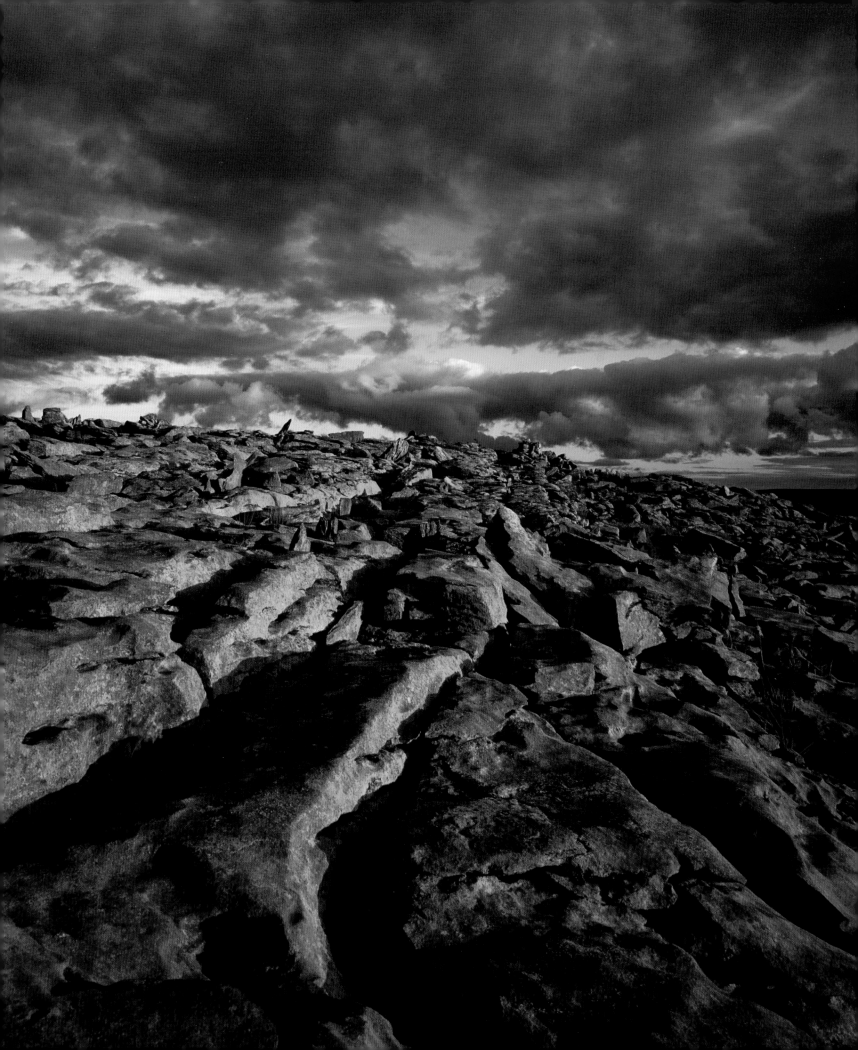

THE NATURAL WORLD
A LAND OF CONTRASTS

Ireland is certainly a land of contrasts: water and rock, light and shadow, stillness and motion, harsh and gentle, howl and murmur. What is it that draws us to the amazing interplay of light and water surrounding and winding through the island? Respect, fear, and awe for the savage power of the ocean? The peace engendered by the almost silent lake ripples mildly lapping the surface? The stillness of the lakes reflecting the movement of the clouds and the colors of the sunset or the rising morning mist? The quick rush of river water tumbling over rocks on its urgent path to the sea? Or just a break from the humdrum to acknowledge nature's glorious presence? Whatever it is that draws our attention, we are not disappointed.

Ireland is a small island country—about the size of the American state of Indiana—on the northwestern edge of Europe. Its position in the north Atlantic, on the same latitude as Newfoundland and Hudson Bay, would have us expect a cold, icy climate. Instead, the Gulf Stream running along the western coast warms the climate so that Ireland rarely gets frost or snow, and when it does it is an event. The mean temperature in winter is mild, approximately 41°F (5°C), and it has a cool summer of approximately 60°F (15°C).

The low-lying central plain of the country is surrounded by a rim of mountains—sandstone, limestone, granite, and basalt, which, in turn, is surrounded by ocean and sea. All of this gives Ireland much of its beautiful scenery: the mesmerizing water, the Mournes and Donegal Highlands in the north, Connemara and the Twelve Bens in the west, the Kerry peaks and lakes, and the Dublin and Wicklow hills.

Among the many stunning natural wonders we include here are the Giant's Causeway, the Cliffs of Moher, and the Burren, three of the

ABOVE: *Stone of all kinds, shapes, and sizes is prevalent in Ireland, to which the ever-present stone walls bear testament. No mortar, just rocks at the best angle with occasional space between to allow the wind to whistle through.*

OPPOSITE: *Like a lunar landscape, the Burren (from* Boireann *meaning "rocky place") in County Clare is a fascinating area of limestone-covered hills, located at the bottom of a tropical ocean over three hundred million years ago.*

Looking like a series of children's building blocks piled one atop another, these stones are made of basalt, which, when it cooled some 6.5 million years ago, formed these (usually) octagonal steps known as the Giant's Causeway in County Antrim. When seen from above, the surface is something like the shape of a honeycomb, with pillars of slightly different heights, facilitating easy hopping from one to another. We are lucky that the pounding waves of the Atlantic have not succeeded in wearing away what is such a unique geological phenomenon.

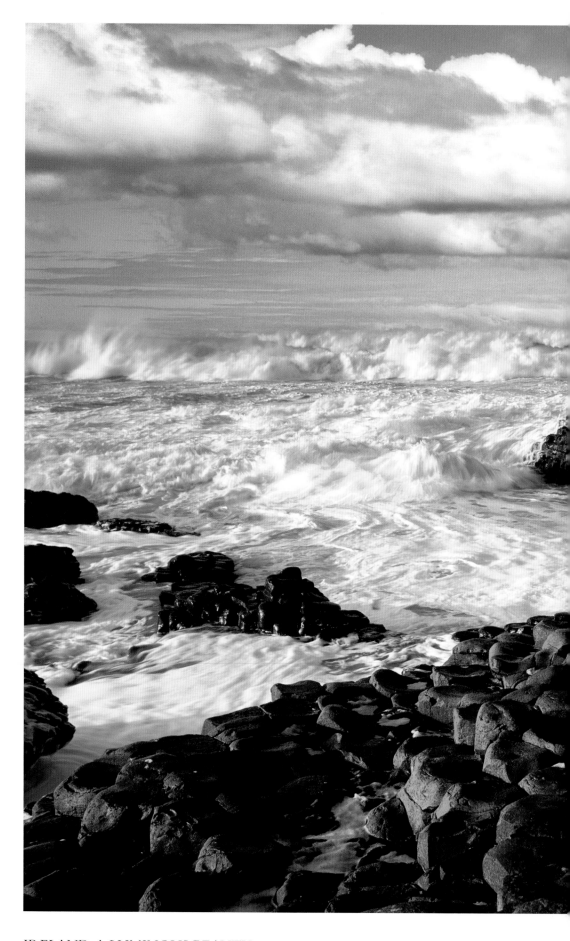

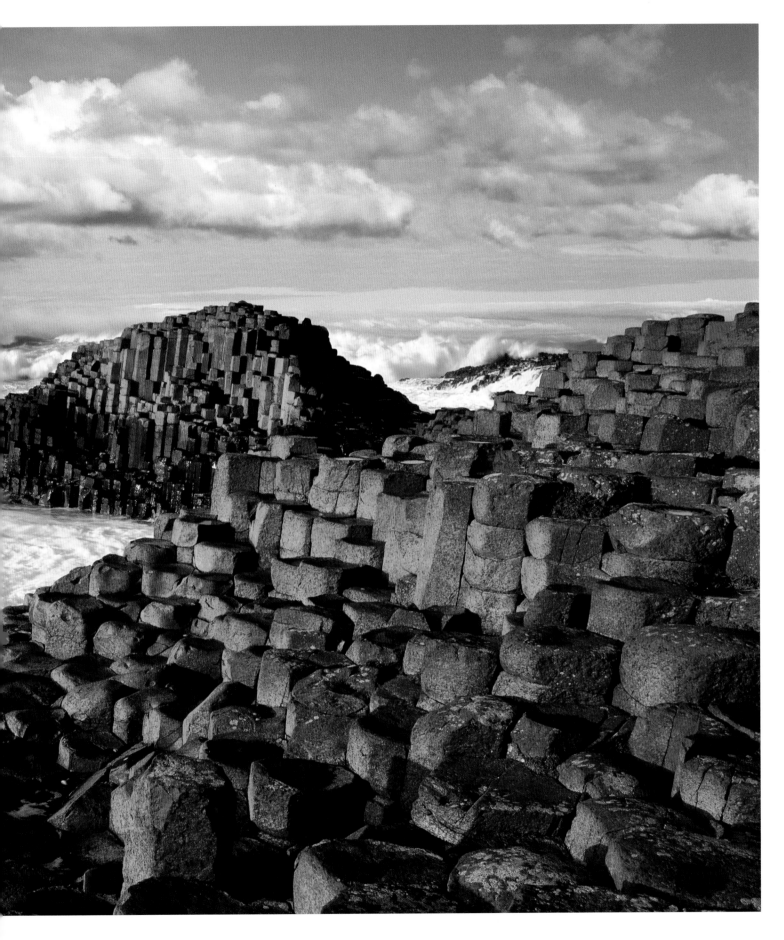

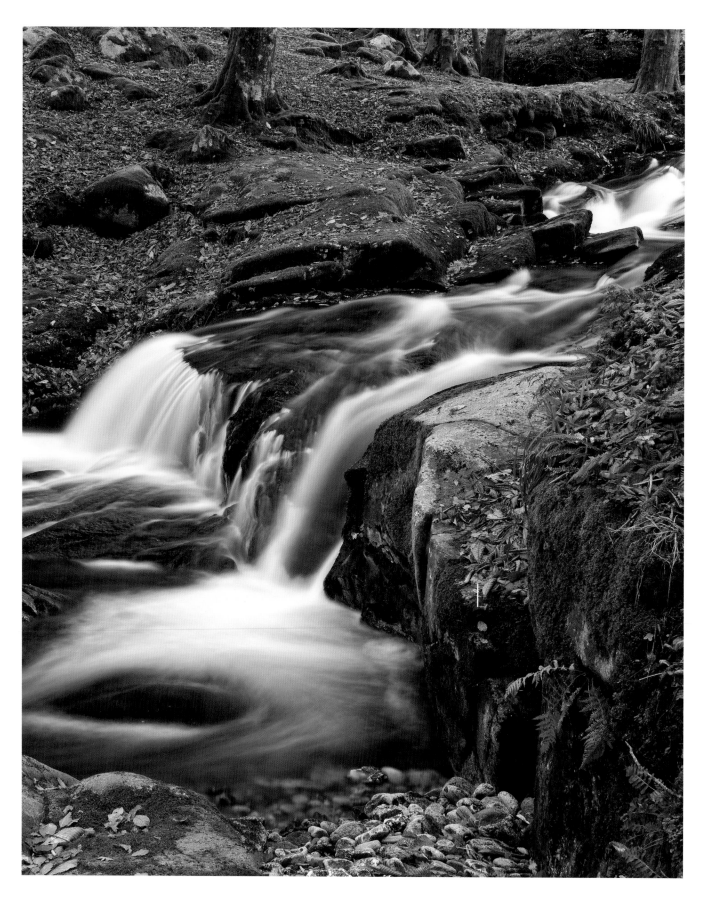

most visited sites in the country. The phenomenal Giant's Causeway along the rugged north coast of Antrim has been dubbed the "Eighth Wonder of the World," and is one of three UNESCO World Heritage Sites in Ireland, joined by Brú na Bóinne (the Boyne Valley passage-tombs) and Skellig Michael. One of nature's great wonders, the Giant's Causeway is an octagonal web of forty thousand bare basalt columns, some as much as thirty-nine feet (twelve meters). Science tells us that these columns were formed by an ancient volcanic eruption, but Irish legend tells us much more fancifully that these stepping stones leading from the foot of the cliffs into the sea were built by Finn McCool, hero of the Fianna, who wanted to build a link to Scotland. From morning to evening, the mood on the Giant's Causeway can change from utterly magical and mysterious to almost melancholy, with the tops of the basalt columns spreading like lilies in a pond, providing the onlooker with a grandstand seat to the dramatic play.

The Burren in County Clare, the rockiest part of Ireland, is bounded by the Atlantic on the west and Galway Bay on the north. Renowned for its remarkable collection of plants and animals, the Burren is home to three-quarters of the types of flowers found in Ireland as well as twenty-six of the thirty-three species of butterflies. Grykes (crevices) in the surface of the limestone provide moist shelter for a wide range of plants and shrubs, unexplainable combinations of arctic and alpine plants that would not grow together elsewhere. When the limestone pavement is covered with a thin layer of soil, patches of grass grow, interspersed with plants like the spring gentian (the symbol of the Burren) and orchids. The eerie beauty of these remains of a limestone seabed formed millions of years ago is compelling.

The Cliffs of Moher are another geological wonder: a five-mile stretch of a series of undulating headlands almost seven hundred feet high on the wild Atlantic coast of County Clare. The massive stone cliffs battered by the wind and relentless pounding of the ocean waves are the most visited natural site in the Republic of Ireland. The views from the top of the cliffs on the edge of the Atlantic are spectacular. On a clear day, one can see the Aran Islands, Galway Bay, and Connemara's Twelve Bens mountains.

Each of our senses is indulged by the natural environment of Ireland: the ever-changing light from dawn to dusk; mysterious shadows; the rocky coastline; the roar of the ocean challenging the ancient cliffs; stretches of golden sand; ancient patterns traced by perfectly angled grey stone walls and hedgerows through the lushest green fields; steely rivers carving through rich river banks; the sweet smell of flowers and salt air; fields of heather under a sunny summer sky complete with puffs of white cloud; mountains in shadowy silhouette providing the artistic background for a gentle world. It's all here.

OPPOSITE: *An autumnal woodland scene in the province of Leinster has the moss spreading almost unnoticed on the rocks, as small ferns make a valiant effort to gain a foothold in the fissures. Only the leaves falling on the water are carried away, as the stream descends to sweep them up and create its own miniwaterfall.*

FOLLOWING SPREAD: *In the peaceful rustic landscape of the Mourne Mountains in the south of County Down, mottled granite is the main rock-type. The stones cleared from the fields make solid walls typical of what is known as "The Kingdom of Mourne." Overlooked by the bald peaks where, on the other side, "The Mountains of Mourne sweep down to the sea" (in songwriter Percy French's words), the widely spaced farms are ideal for raising cattle and sheep, which abound in the shadow of the hills. Plentiful rain, sunshine, and general temperate weather provide an abundance of sweet green grass on which the livestock feed. The Mountains of Mourne provided inspiration for the setting of C. S. Lewis's magical land of Narnia in* The Chronicles of Narnia *and the spectacular world of* Game of Thrones.

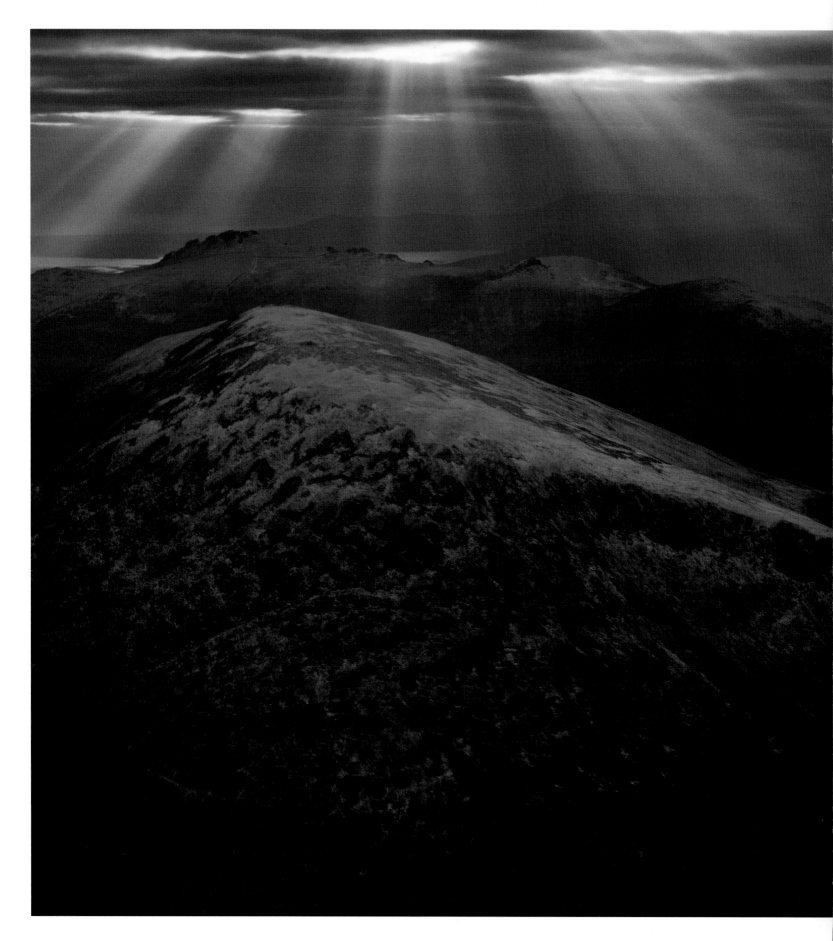

The appealing Mourne Mountains can turn icy and unwelcoming in winter, which is, perhaps, not surprising, since a dozen Mourne peaks rise over two thousand feet and get an annual sprinkling of snow. They are among the youngest of Ireland's mountain ranges, emerging when a heavy layer of shale above them eroded millions of years ago.

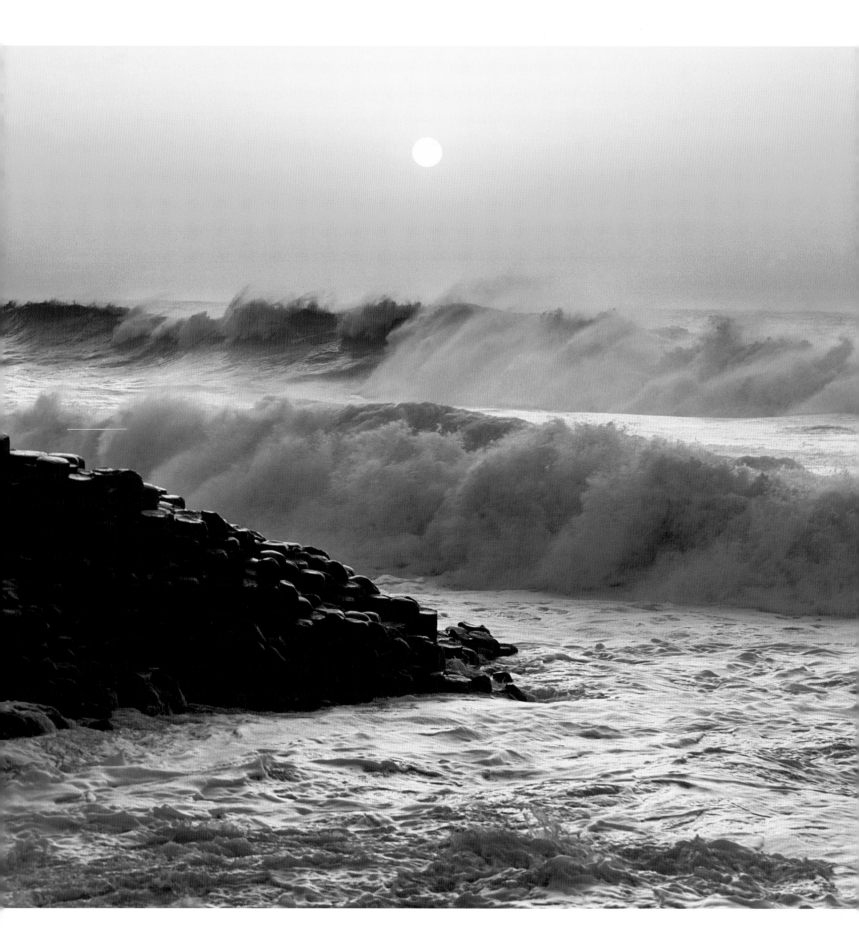

The closest parallel for the hugely distinctive geological formation of the Giant's Causeway is the organ-pipe-like folds at the mouth of Fingal's Cave on the Hebridean Island of Staffa, made famous by Mendelssohn's overture. The Giant's Causeway and Fingal's Cave, although about fifty miles apart, are linked by folklore: the Fingal of the cave is the same as Finn McCool, the mythical Irish hero and warrior (and womanizer) who, in Irish legend, was also the man who built the Giant's Causeway.

FOLLOWING SPREAD: *The final rays of the setting sun at the Giant's Causeway.*

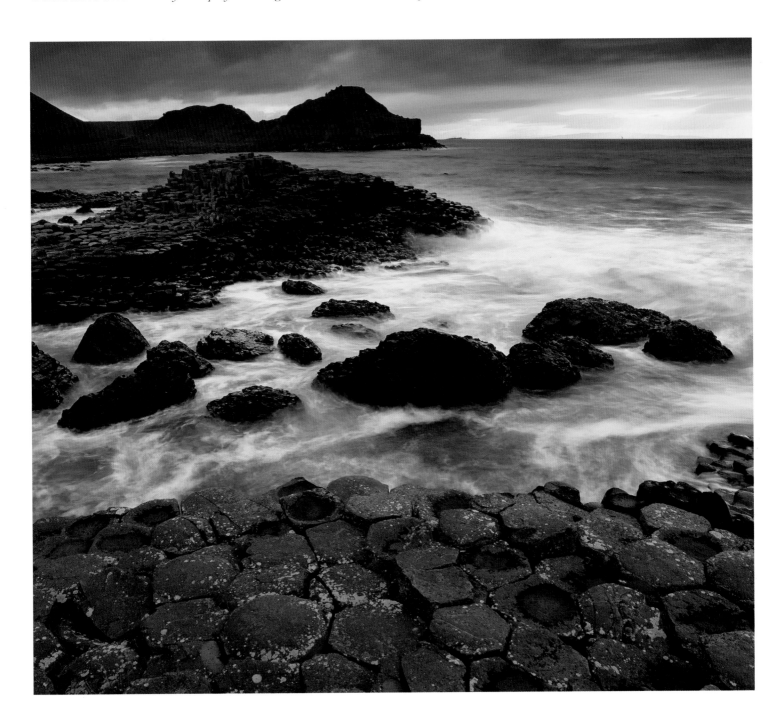

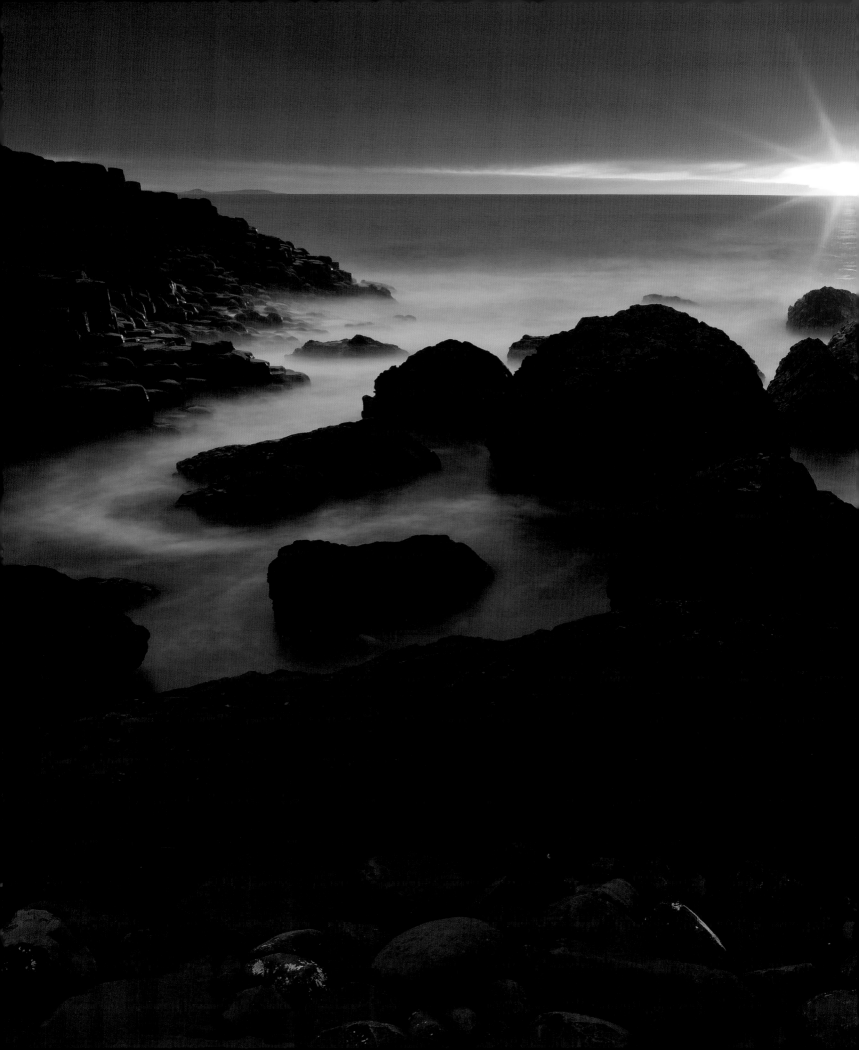

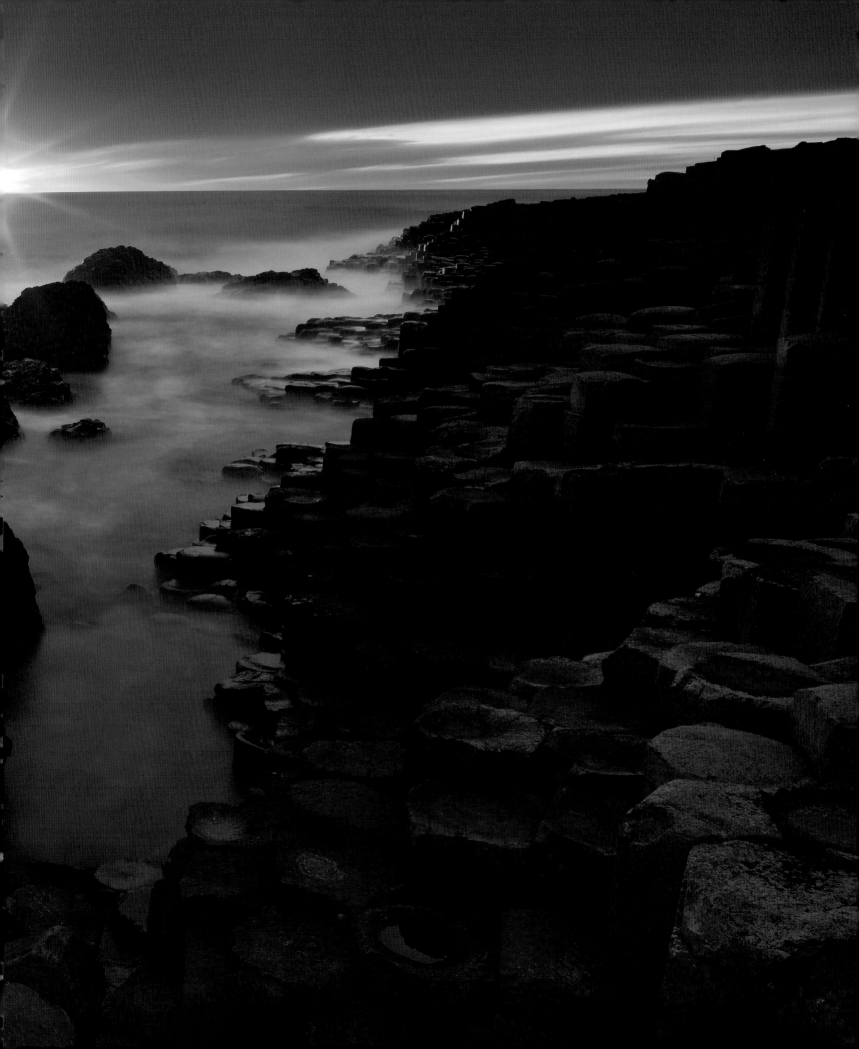

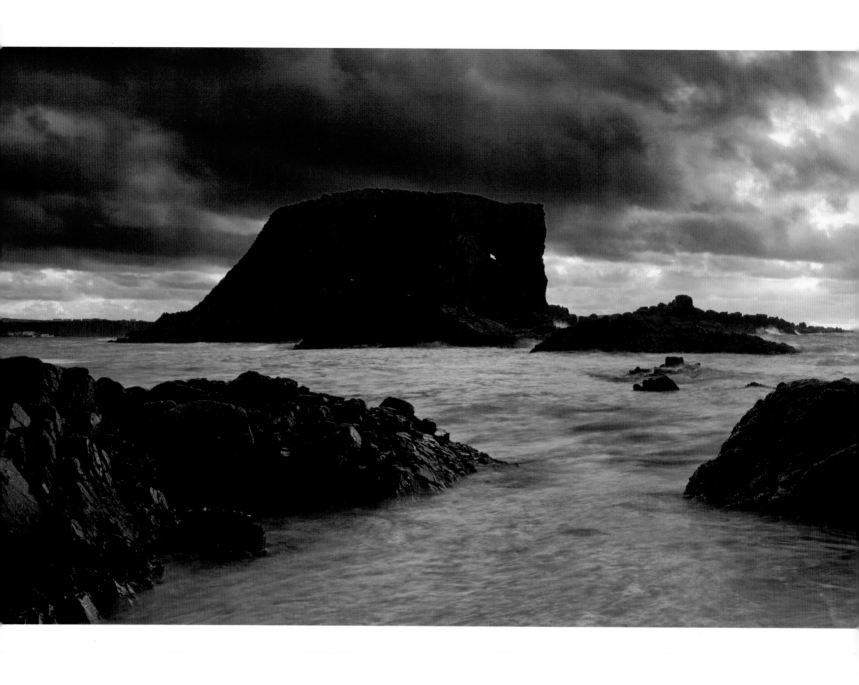

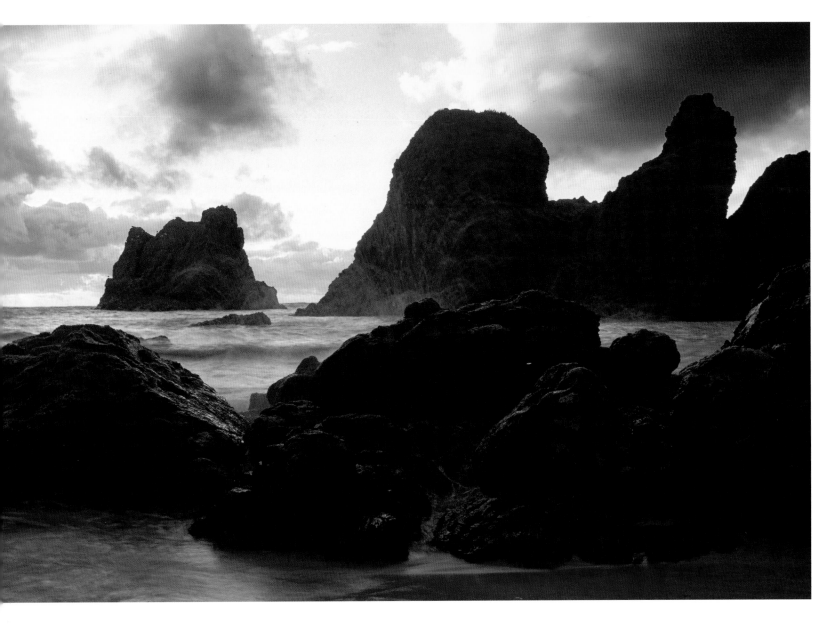

A dramatic, softly colored, light-filled display of imposing black basalt islands at Ballintoy, along the picturesque Causeway Coastal Route in County Antrim between the Giant's Causeway and the Carrick-a-Rede Rope Bridge, adds mythical intrigue to the shoreline of Northern Ireland. The shapes—sometimes merely massive and other times richly architectural—look every bit the part of the landscape they share with crumbling castles and towers. There is never a want of material to stimulate imagination and fantasy in the Irish landscape or seascape. Mystery, magic, and a sense of the Otherworld—a realm beyond the senses—abound.

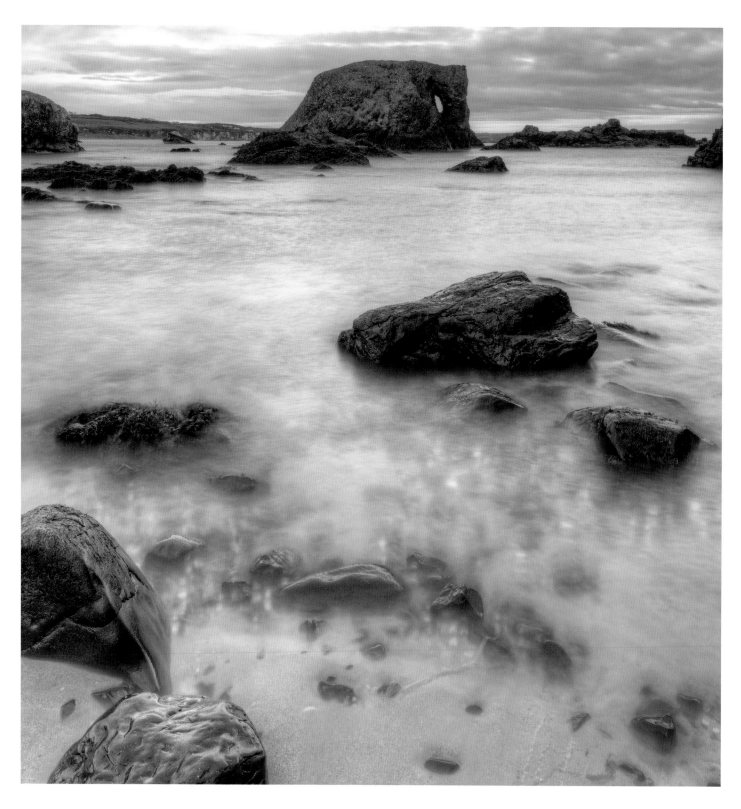

Light makes a difference. The mythical intrigue of the imposing structures in the evening light on the previous page extends to this elephantine shape in dawn's light—one of the same rocks. Nature plays erosion tricks to create the "Elephant Rock," far larger than its living equivalents as it wallows in the waves, a stoic giant in dawn's soft light. The wind would have helped to carve this piece of natural sculpture rivaling a Henry Moore work, though taking far more time to complete.

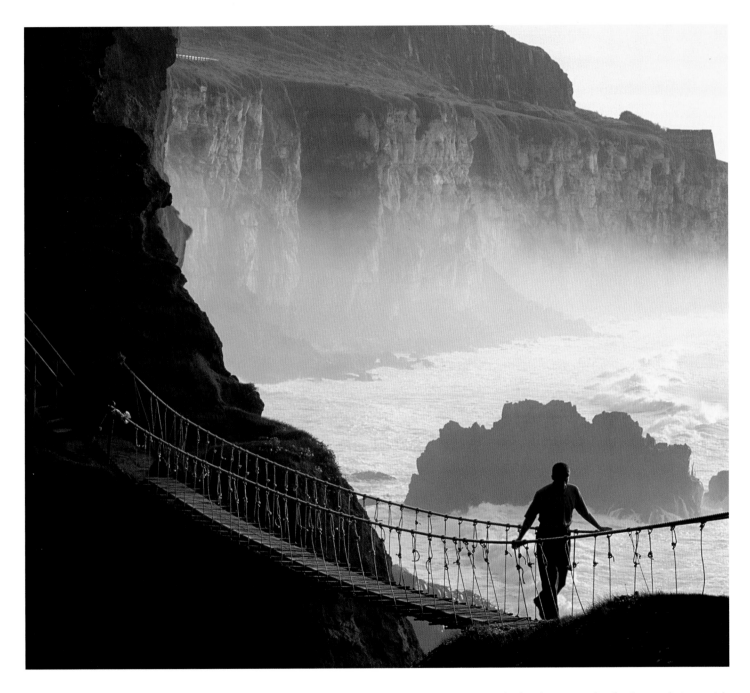

Carrick-a-Rede ("rock in the road") Rope Bridge near Ballintoy in County Antrim is a suspension bridge about sixty-five feet long and ninety-eight feet above the rocks, built by fishermen to connect the mainland to the tiny island of Carrick. Today, visitors are drawn here simply to take an exhilarating walk across the rope bridge, now under the auspices of the National Trust.

ABOVE: *In Ireland you are never more than sixty or seventy miles from the sea. That sea is a mood-maker, with the wind-driven clouds above adding to the ever-changing color of the water. Along the shore, you can find pebbles of many hues and sizes, rolled by the incessant movement of the waves, or even larger rocks which the tides have failed to wash away, visible here at dawn's light on an Ulster seaside.*

OPPOSITE: *Looking at the movement of water on rocks or a gentle shore is a fascinating occupation, the ebb and flow creating a motion-filled rhythmic pattern. There is something reassuring in realizing that we are looking at an age-old action that connects us with a past long before man ever appeared on the scene. Here, the sea and rocks are delicately bathed in a diffused early-morning light.*

FOLLOWING SPREAD: *The northwestern county of Donegal, with its stunning mountain scenery, is composed of some of Ireland's oldest rocks, dating back some six hundred million years. For the swimmer and strand-walker alike, the county has the most underrated sandy beaches in the country, such as here on the Rosguill Peninsula, where quartzite and granite form a bastion against the Atlantic breakers.*

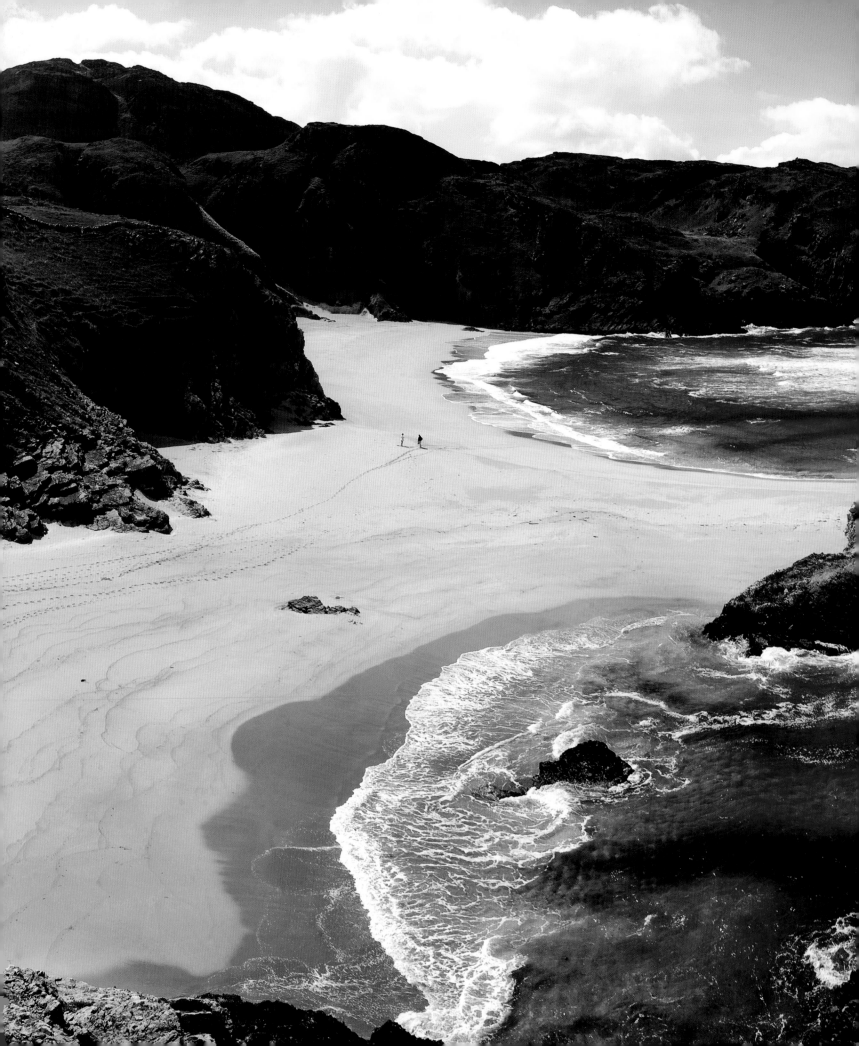

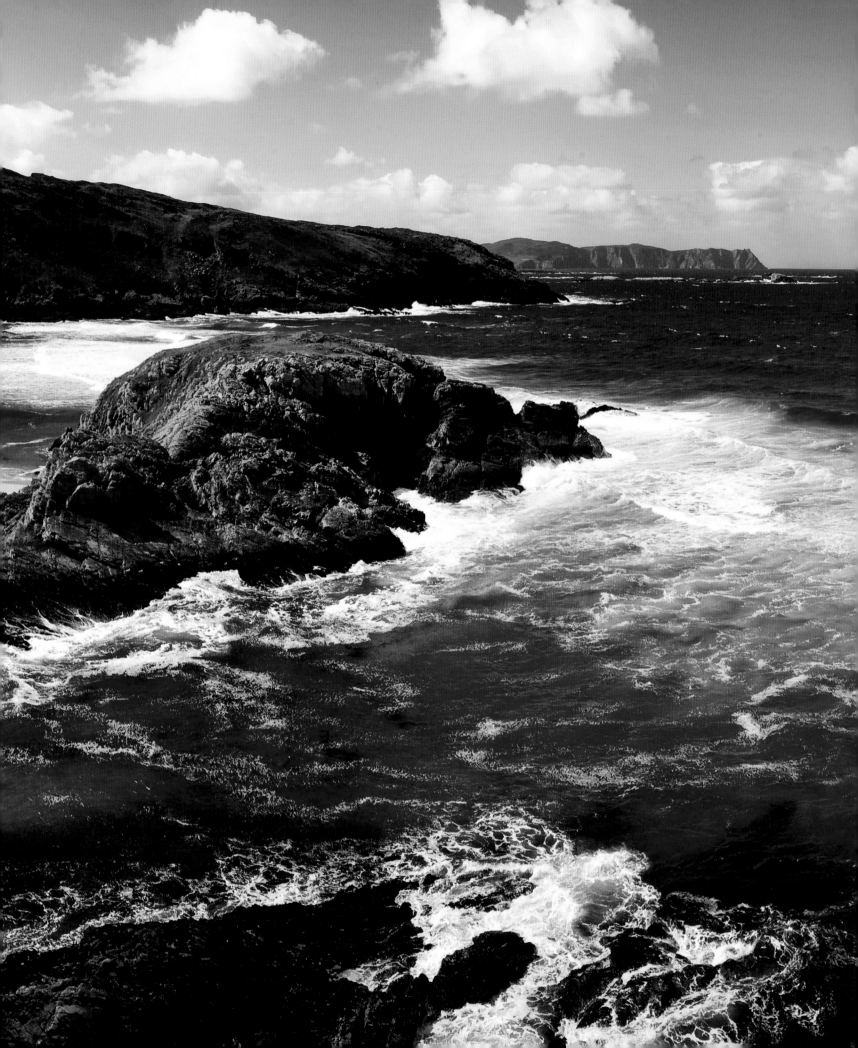

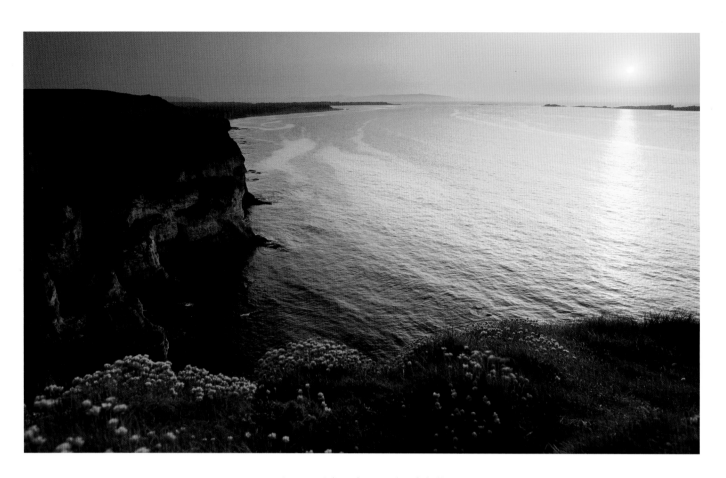

ABOVE: *The White Rocks of chalk on the north Antrim coast are Northern Ireland's answer to the Cliffs of Dover, boldly fighting for existence against the attrition of the sea constantly pounding at their base. It was here, at the foot of Dunluce Castle, that sailors of the Spanish Armada perished in 1588 as their ship was wrecked at Lacada Point just around the corner. The colorful sea pinks on the cliff-edge flourish in summer's warm sun and the natural moisture of the sea air.*

OPPOSITE: *Impressive cliffs of limestone, stratified and streaky layers of shale with the occasional dash of yellow sandstone near the top, form the extraordinary Cliffs of Moher on the Atlantic edge of County Clare. The cliffs provide a sheer-rock introduction to the the rockiest part of Ireland—the Burren.*

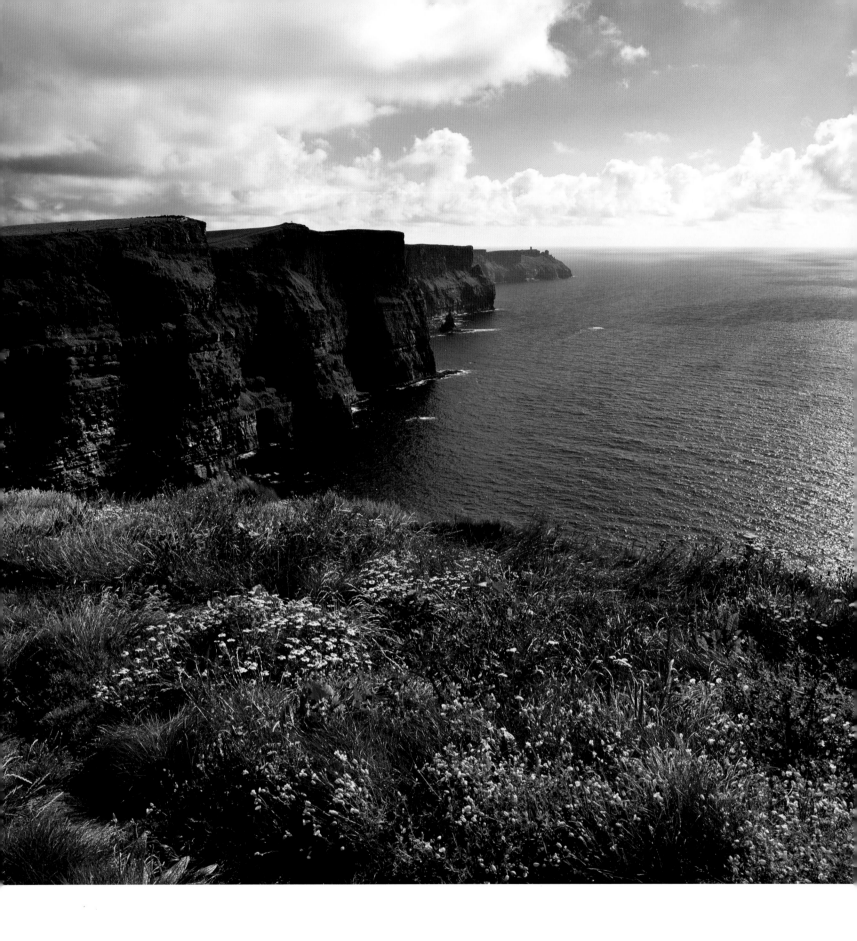

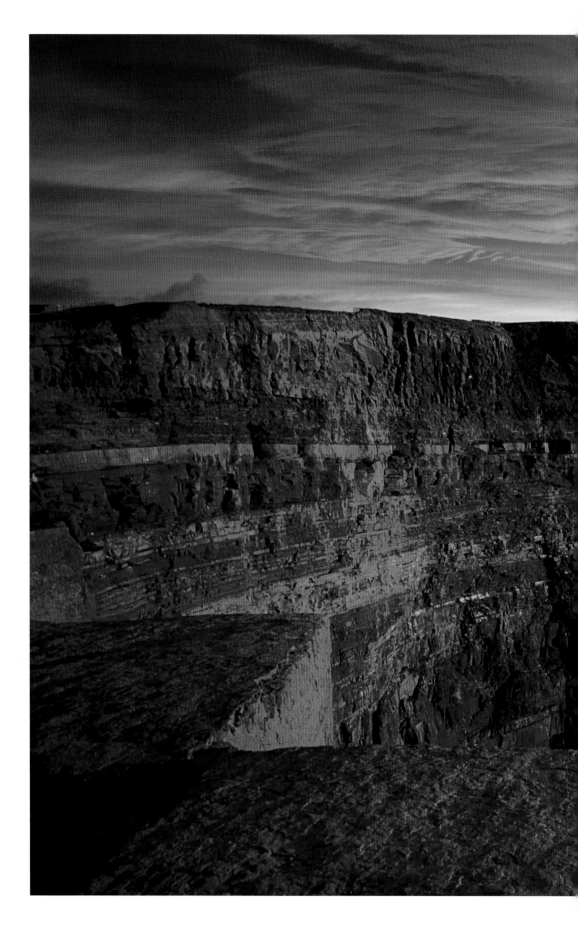

The series of dramatic headlands—the Cliffs of Moher—undulating one behind the other along a five-mile stretch of the Atlantic coast of County Clare are seen here in their late-afternoon splendor. Legends reign here, too, with tales of Maire Rua (Red Mary) O'Brien of Leamaneagh, who would send suitors (already deemed by her unqualified or unwanted) galloping off on a spirited horse that they were meant to tame as part of a test. The horse would race to the edge of the cliffs and toss each unsuspecting suitor to the waves below.

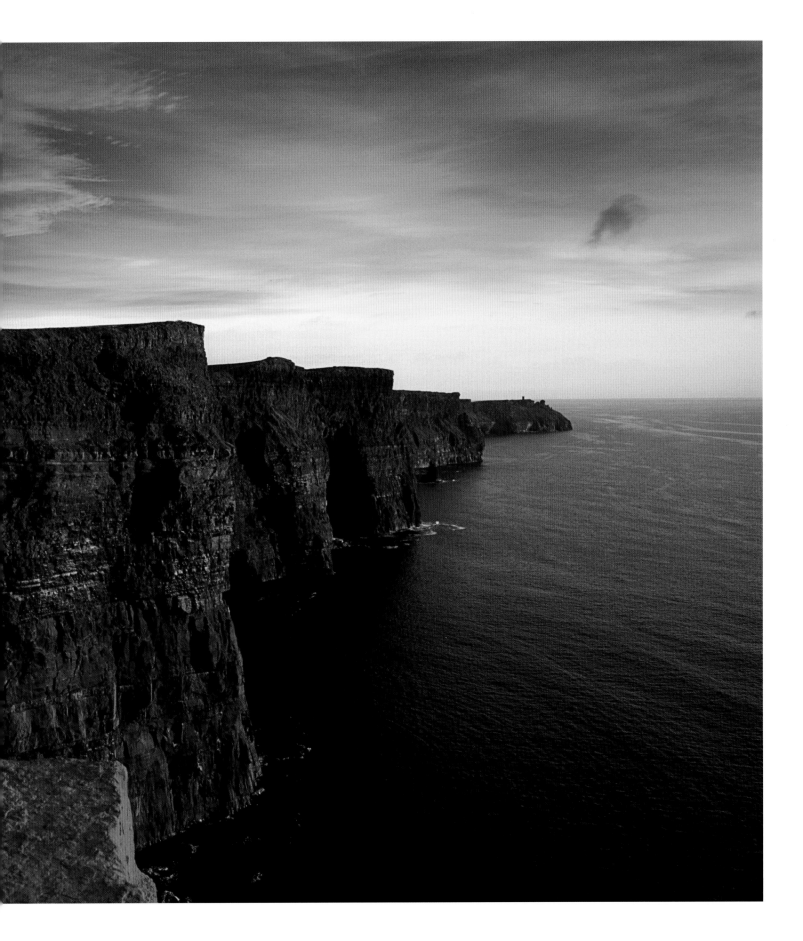

The rocky Burren is a unique area of limestone-covered mountains, tranquil valleys with quiet streams, and miles of natural grey walls constructed with stone from the surrounding acres. Exuberant flowers find tiny spaces in the cracks of the limestone hills to create a tapestry of color and a magical aura. Not only is the Burren remarkable for its flora, but it is home to an incredible number of butterflies: twenty-six of the country's thirty-three butterfly species have been found here.

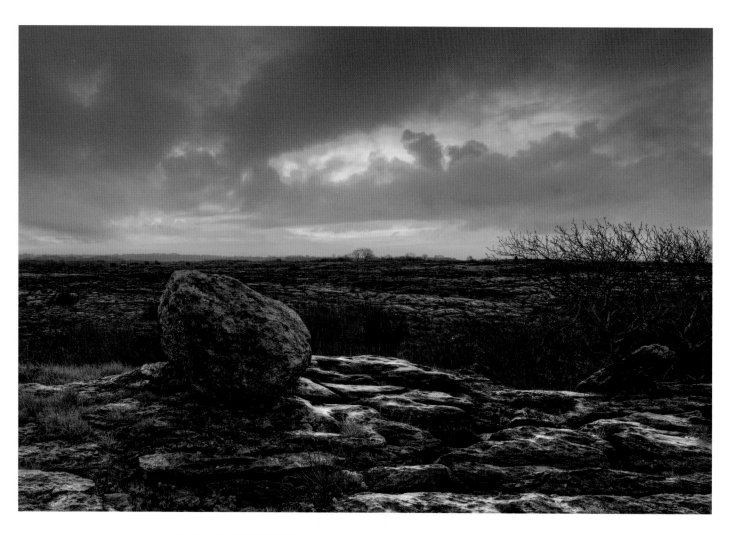

"Erratic" is a word often used to define a person's unusual behavior, but nature, too, has its erratics in unexpected places. These are large boulders, often of a different rock than that surrounding it. The explanation of this phenomenon is that the great blocks were gathered up elsewhere by glaciers during the last Ice Age and then deposited wherever the glaciers gradually melted, around twenty thousand years ago. There must have been quite a bit of sun to melt the glaciers over the lunar limestone of the Burren in north County Clare, where erratics are found in greatest abundance, sometimes by the sea, but also inland as seen here.

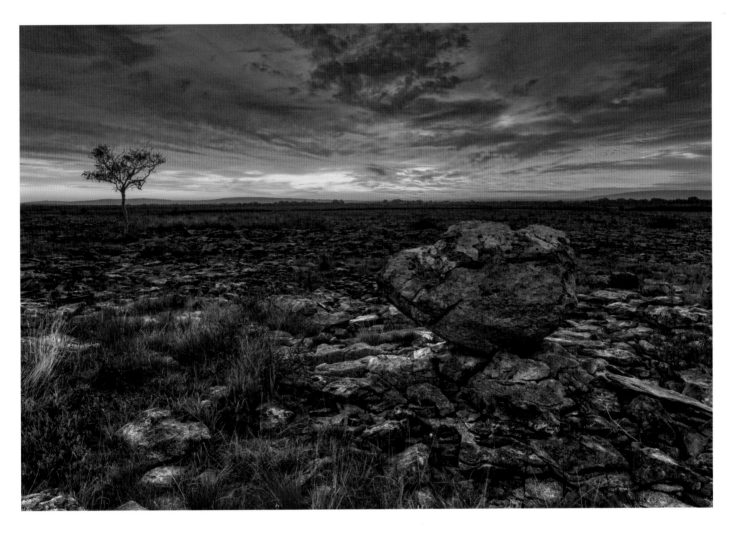

One of the most remarkable characteristics of the Burren is the way the color of the stone can change depending on the lighting conditions, and this can become particularly dramatic at dawn or sunset. The clouds add their own splash of color to the drama to make the Burren into the most extraordinary stony surface anywhere in Ireland. The lonesome tree or bush, resistant to wind and rain, adds to the eeriness and fascination of the area.

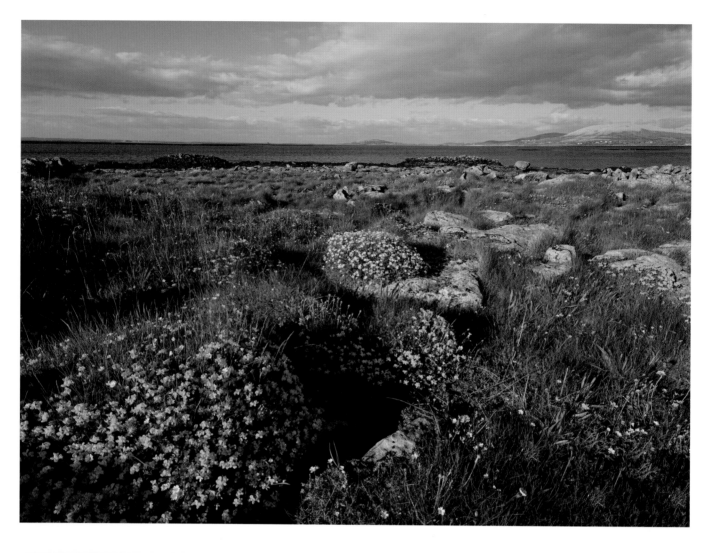

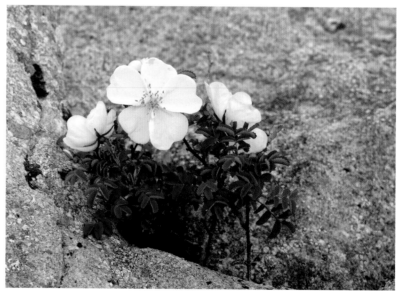

82	IRELAND: A LUMINOUS BEAUTY

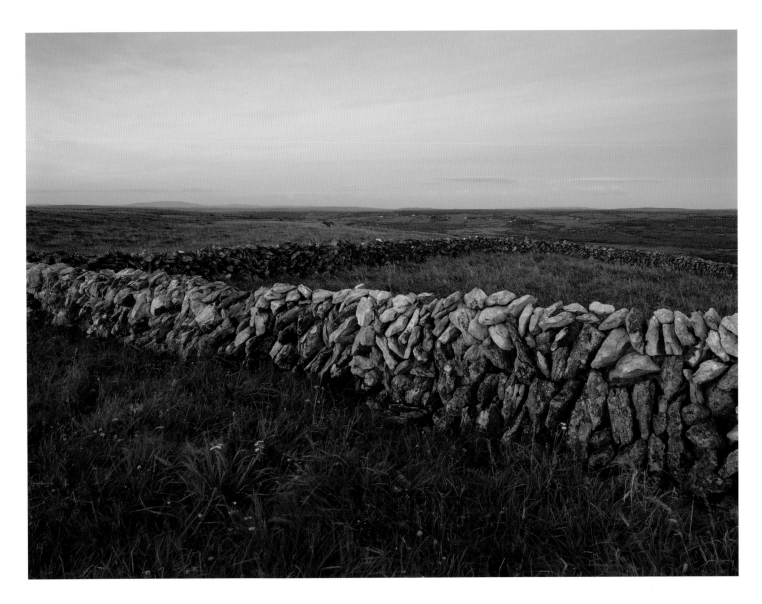

ABOVE: *Elegant stone walls push back time as they stretch across the land.*

OPPOSITE: *The sea does not prevent flora from flourishing by the Burren's shores—in fact, it encourages growth, but it is inland, in the sheltered cracks or grykes in the limestone surface, that we find the richest treasury of contrasting arctic and alpine flowers, such as the eight-leaved mountain avens (Dryas octopetala) and the five-leaved Bloody Cranesbill, a magenta member of the Geranium family.*

FOLLOWING SPREAD: *Meadows of soft green grass between the limestone hills of the Burren provide excellent winter grazing for cattle and sheep.*

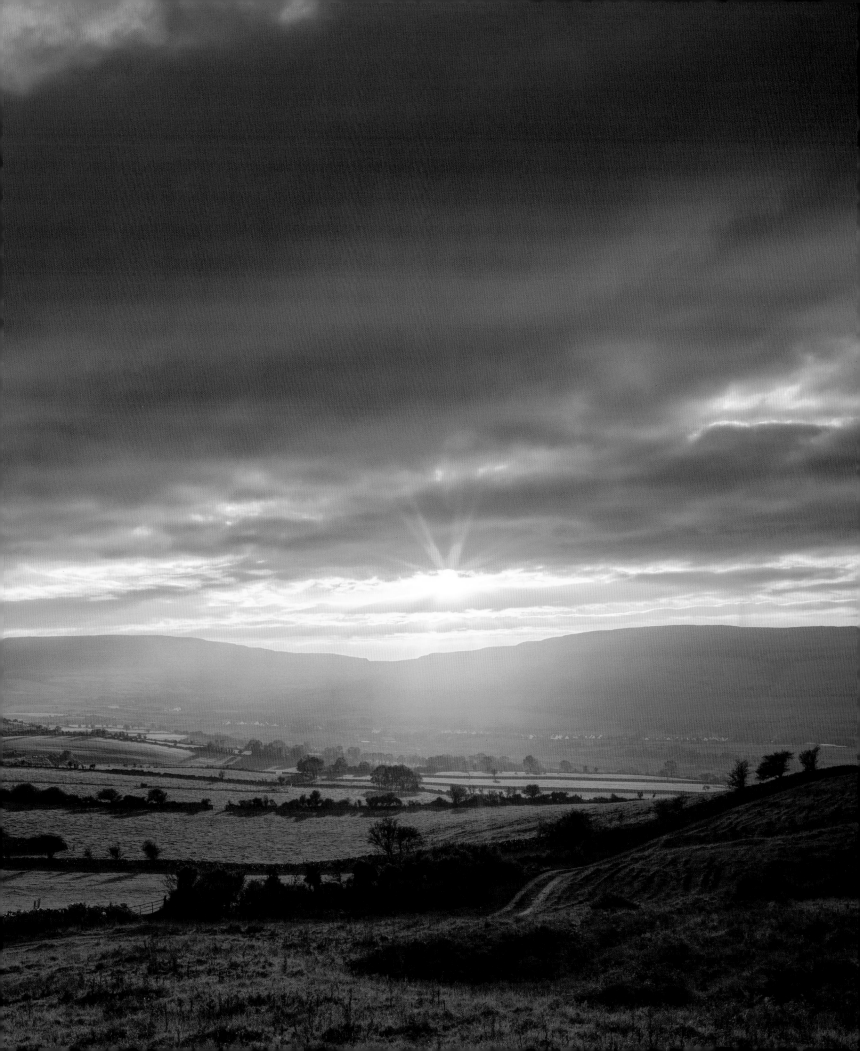

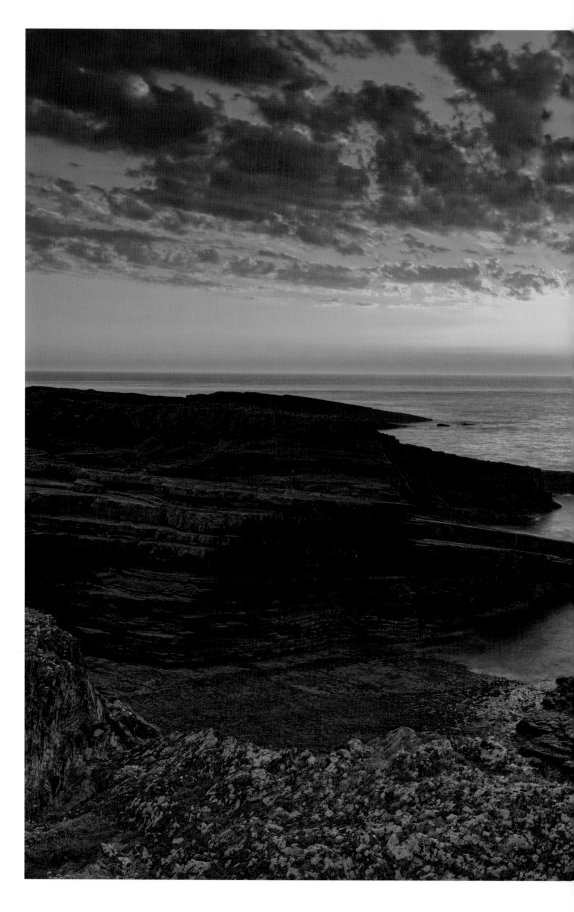

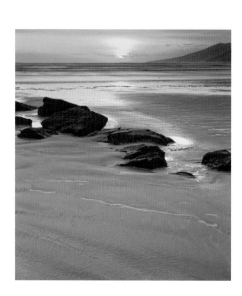

A setting sun soothes the mind, and it is always a mesmerizing time to watch the motion of the sea creeping up and down the beachhead, like the mythical Greek Sisyphus rolling his stone up a hill and then having it all roll back again. And that sea, twice a day, every day, brings surprises with it: nature's bounty in the form of pebbles and shells. The waves nibble tirelessly (and, in the long run, effectively) at the rocks they meet, layered like large discs, as in the Kerry scene with fantastic clouds (right), or a line of stepping stones fit for a giant (above).

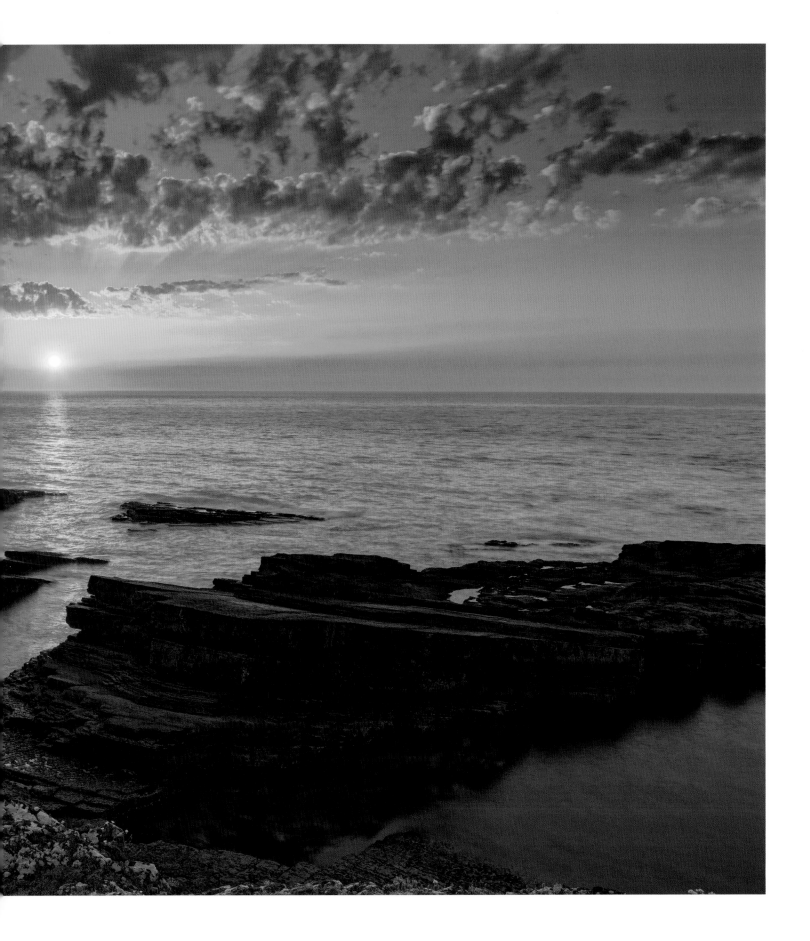

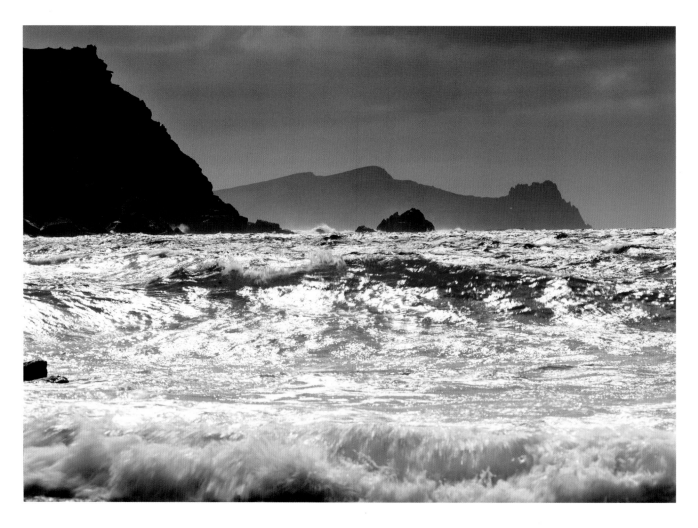

ABOVE: *Noonday horses of the sea with glistening light and texture race to the shore of Clogher Head. The view brings the eye across the waves to Inishtooskert, the northernmost of the Blasket Islands at the end of the Dingle Peninsula in County Kerry. Violent volcanic activity millions of years ago created this amazing rugged coastline. The Blasket Islands were inhabited until 1953, when the last twenty residents were brought to the mainland.*

OPPOSITE: *A wild storm on the coast of County Clare in Kilbaha Bay, near Loop Head brought waves that swept over a cliff more than twenty feet (six meters) high.*

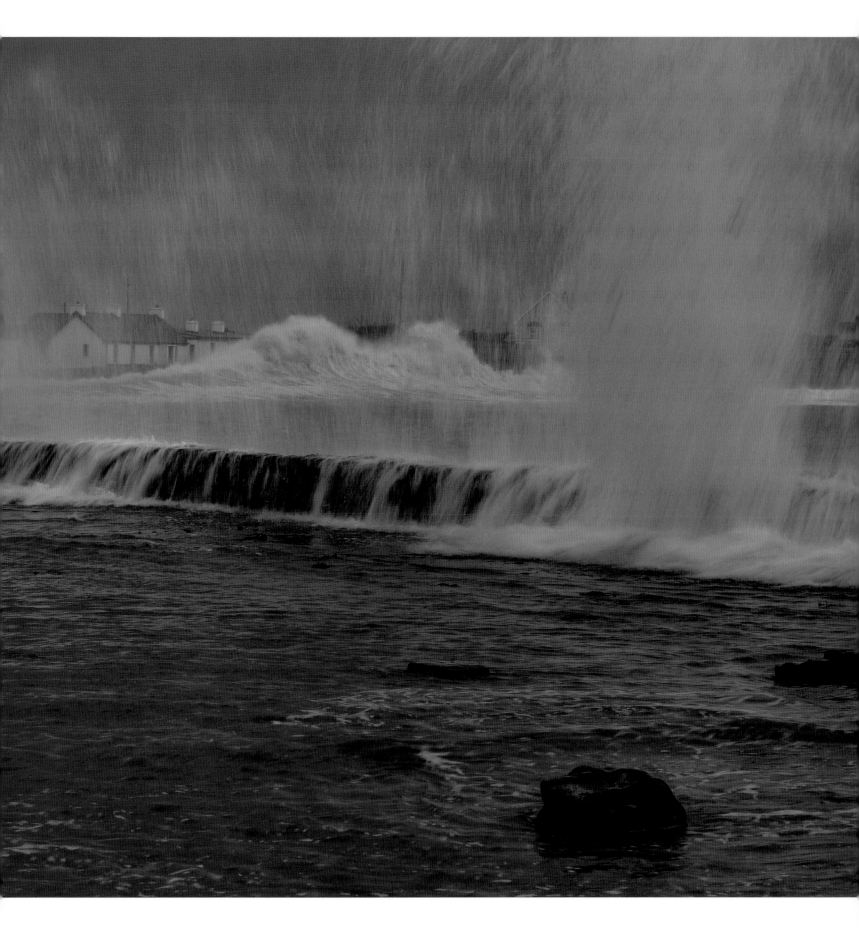

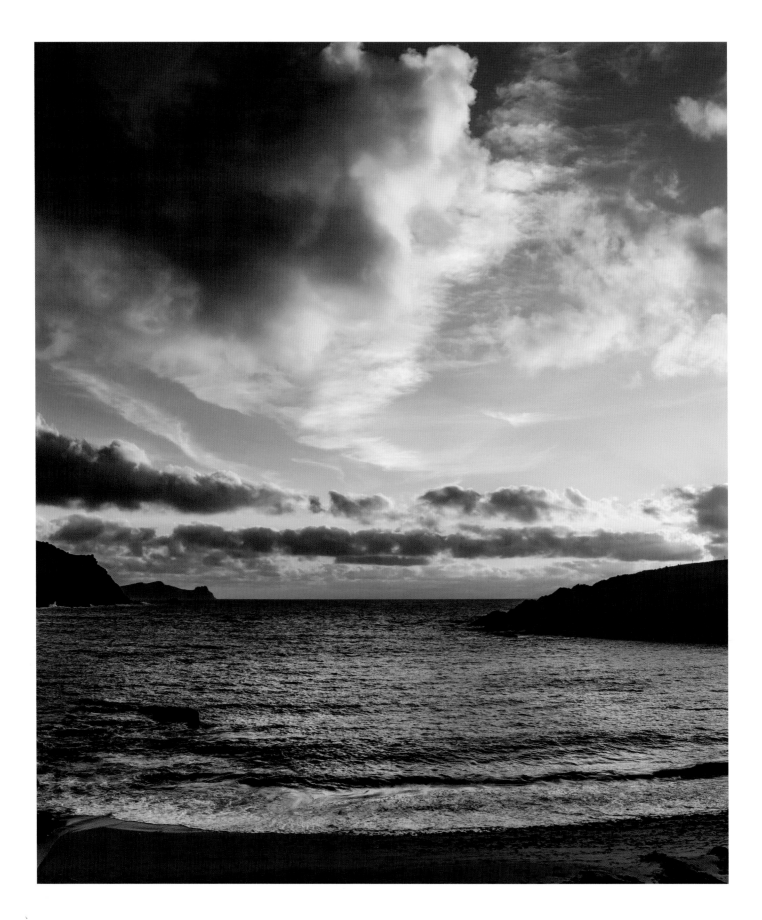

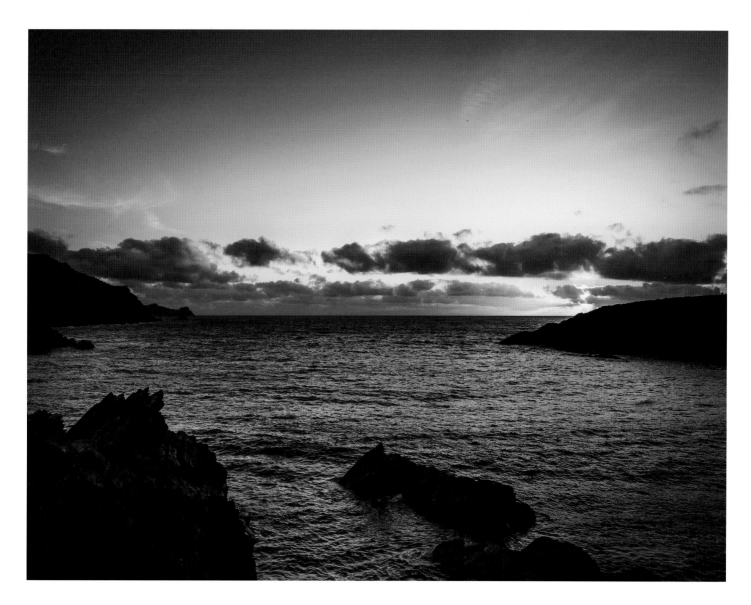

ABOVE AND OPPOSITE: *Two views of the same spot, with differences in color, light, and texture elicit different responses. In the enchanting early evening light (opposite), we can enjoy the Kerry landscape with amazing clouds of a kind that gave inspiration to the Irish artist Paul Henry when creating his paintings of the west of Ireland one hundred years ago. For every day, night must come, and the colorful clouds which brighten the evening when the sun is still shining become almost monochromatic, but elegantly so (above), with the onset of nightfall, bringing a time of quiet reflection. The summer's long evening light on the Dingle Peninsula on the Atlantic coast of Kerry means you have natural light to read your paper outdoors until eleven o'clock.*

FOLLOWING SPREAD: *Toormore in County Cork is near the town of Skull, a name not morbid but derived from the Irish word for "school." It is not far from the southern tip of Ireland, where narrow creeks separate long, thin fingers of land that stretch out into the Atlantic. A heavy bank of clouds highlighted with color escorts the setting sun. The area played an important role four thousand years ago when miners discovered copper lodes and began to exploit the ores which, with added tin, provided the material for bronze tools and weapons. The miners buried their dead in simple wedge-shaped stone tombs, one of which still survives nearby at a place named Altar.*

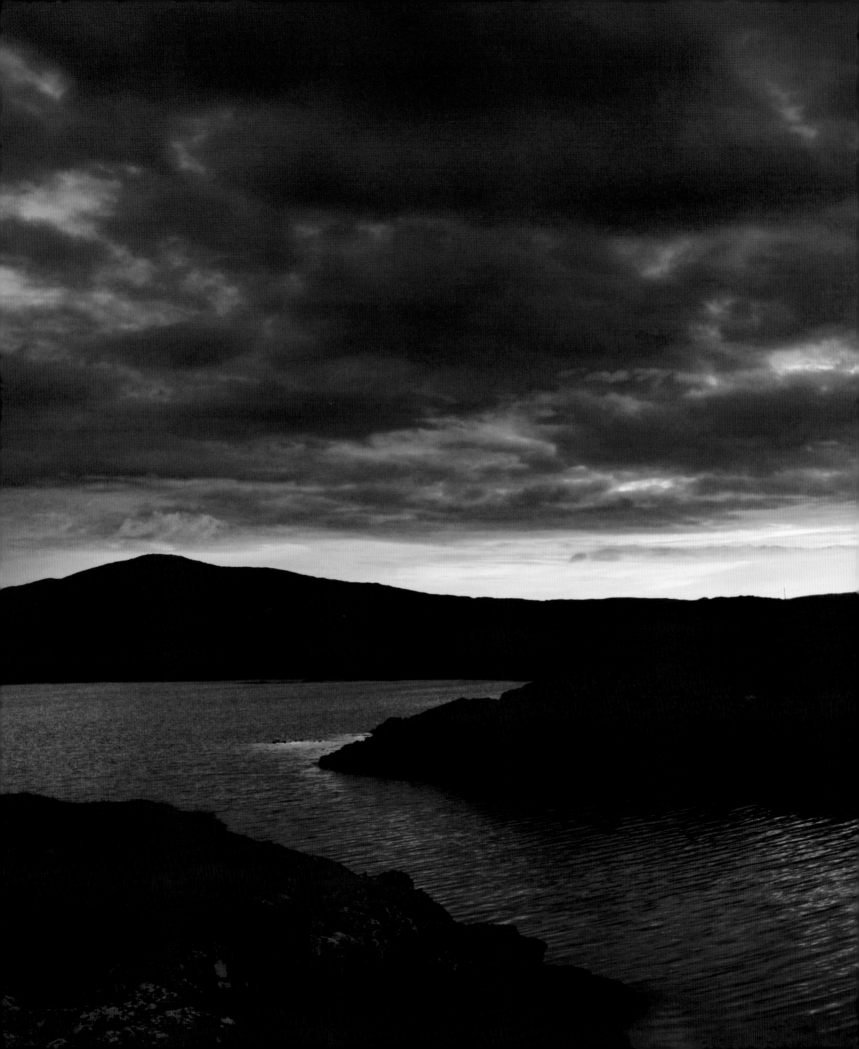

With not a whiff of land in sight, the coast of Waterford on the southeast coast of Ireland offers fascinating action in the waves creating parallel layers, each trying to overtake its neighbor as they tumble to the shore at Ballydowane. The cloud formations seem to mimic the waves in a tumbling contest of their own. Where do the waves stop and the clouds begin? The crests of the waves spew up to merge with the clouds suffused with offstage sunlight.

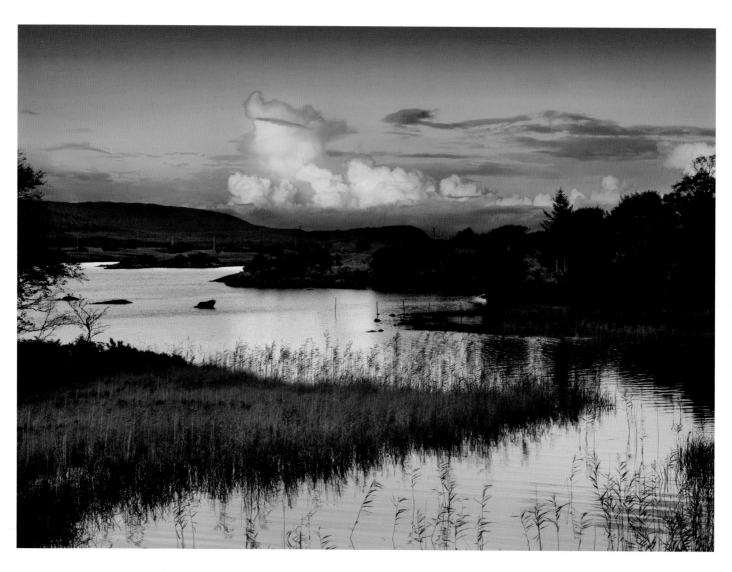

ABOVE: *In contrast to the restlessness of the sea in the previous pages, the lakes of Ireland, of which there are many, are calm with a peaceful stillness. The long and winding Derryclare Lough in Connemara twists itself along the southern flank of the Twelve Bens mountains, encouraging wood growth along its banks.*

OPPOSITE: *Equally contemplative is Lough Oughter in County Cavan, with its still waters reflecting the motion of late-afternoon clouds above. The stillness of the water is stirred up by the ever-changing sky of wind-blown clouds.*

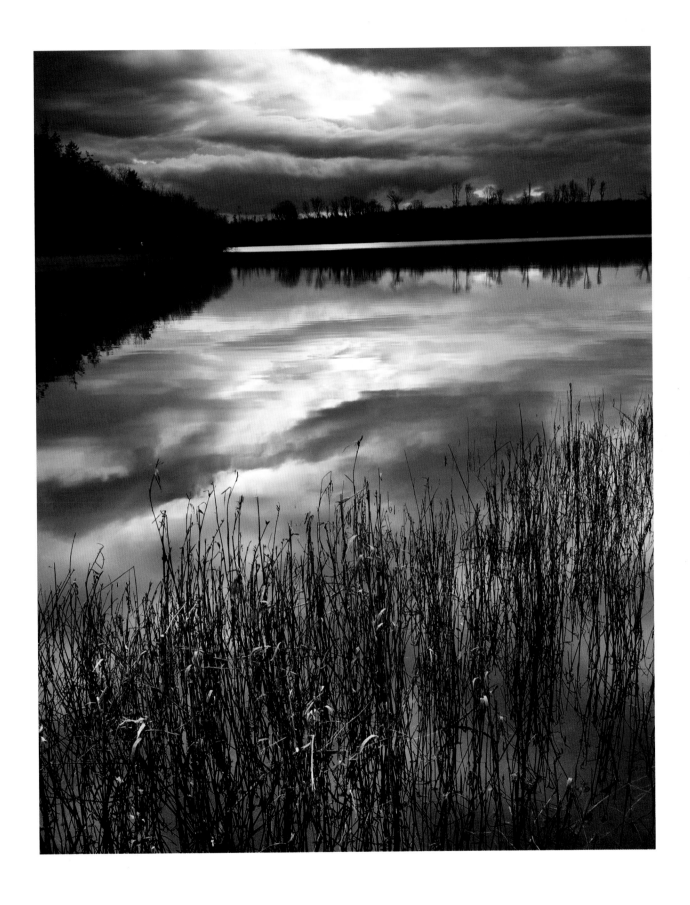

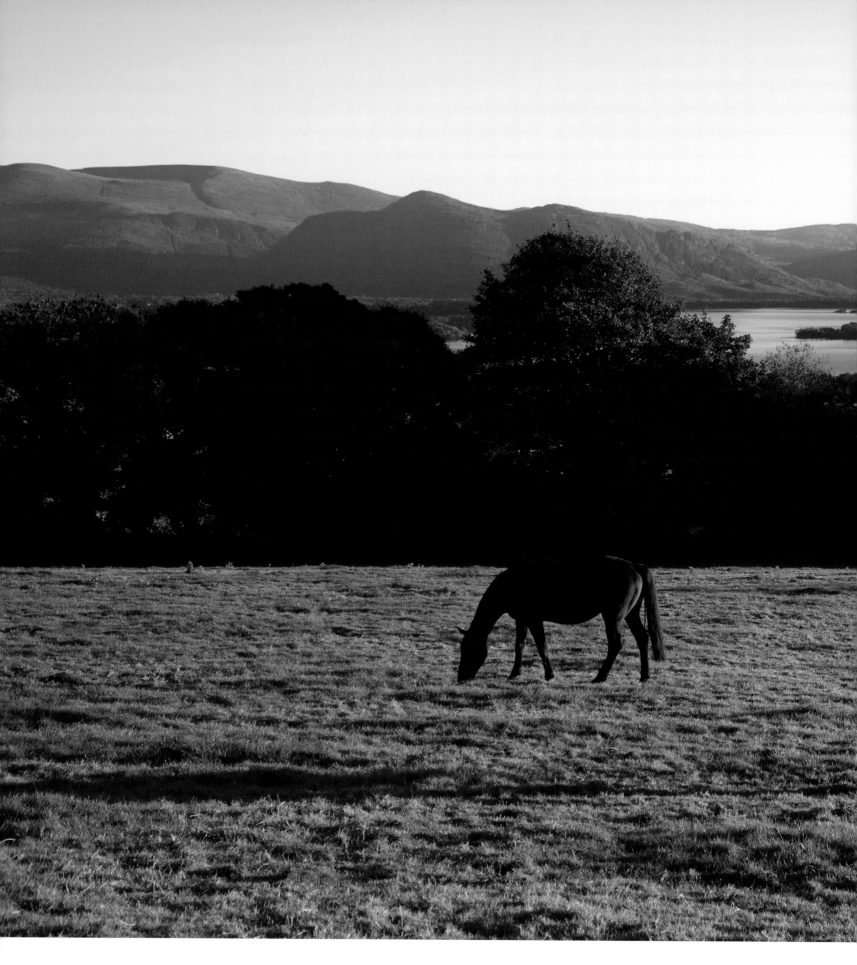

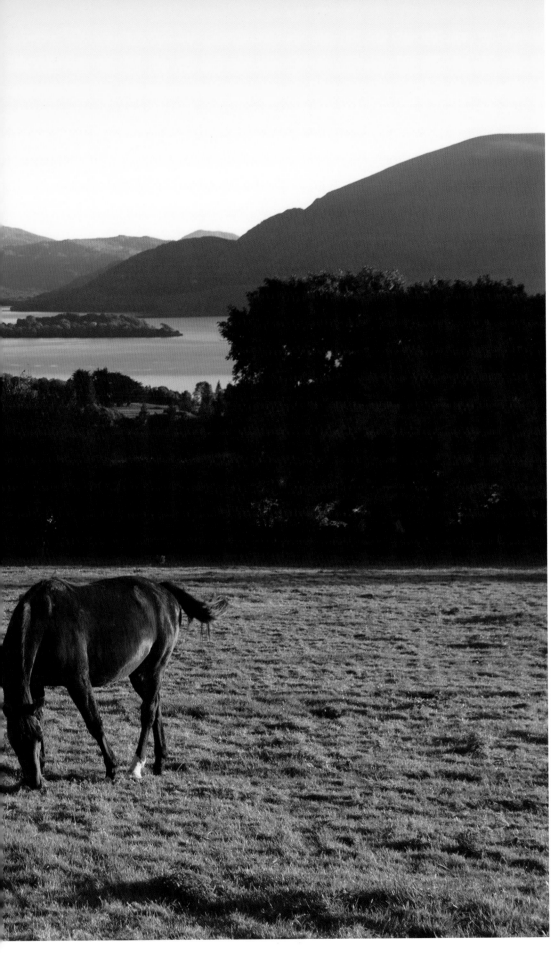

When the great Irish orator Edmund Burke spoke of the sublime and the beautiful in the eighteenth century, he could well have had the lakes of Killarney in mind. For it was then that the world began to appreciate just how stunning those lakes in County Kerry are, and they have remained a magnet for scenery-loving visitors ever since. Lough Leane, seen here in the evening sun from the heights of Aghadoe (one of many mellifluous Irish place-names), is the epitome of that sanctuary of peace that attracted Queen Victoria to come and admire it in 1861. When her descendant, Queen Elizabeth II, came to Ireland a century and a half later, it would have been more the horses to catch her eye.

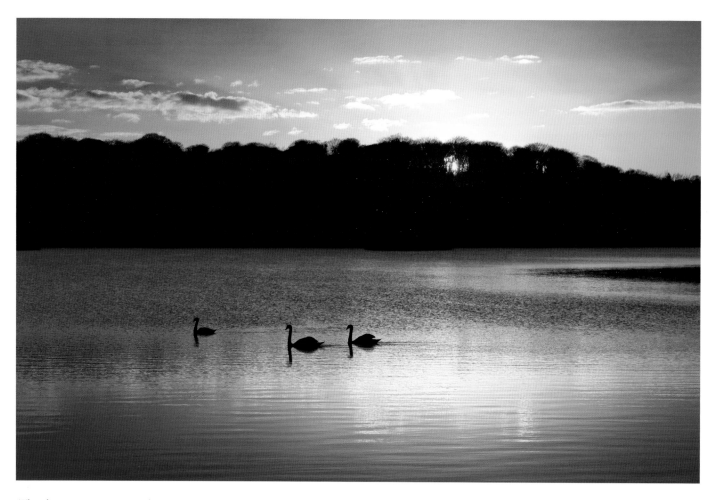

The elegant swans on Lough Gowna in County Longford bring to mind the tragic medieval Irish legend of the "Children of Lir." Lir was a mythical chieftain. His second wife, Aoife, was jealous of her four stepchildren, so she turned them into swans and cast them out over the waves where they would remain for nine hundred years, regaining their human form when they were baptized (at over nine hundred years old!), only to die shortly afterwards.

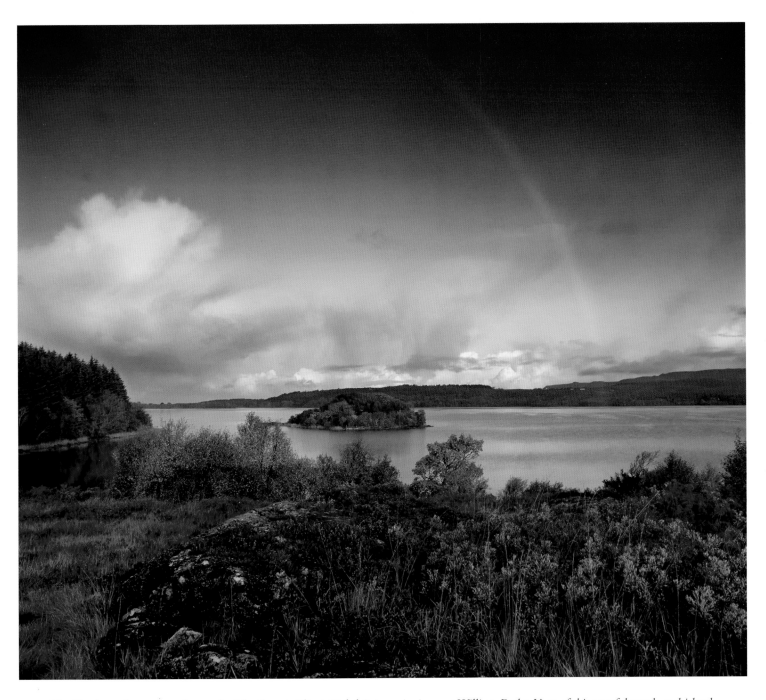

"I will arise and go now, and go to Innisfree" wrote Sligo's Nobel Prize–winning poet William Butler Yeats of this graceful wood- and island-studded lake: Lough Gill, uniting the counties Sligo and Leitrim.

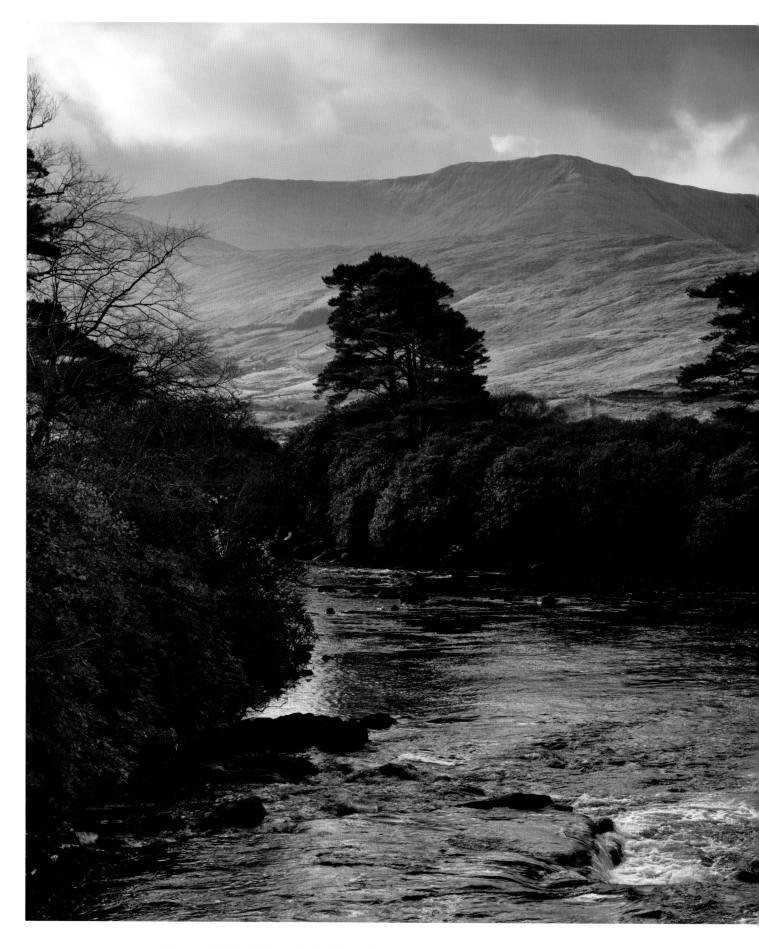

What one would expect in this scene of *Aasleigh Falls in Leenane, County Galway, is a fisherman trying his luck to entice a salmon onto his hook. Instead, there is peace, with nothing but the sound of water rustling over the rocks, the gentle rapids soon to tumble into a waterfall. Most remarkable here, really, is the contrast between the somber and richly wooded banks of the river keeping the flow within bounds, and the sunlight shining on the hillside beyond under the threatening storm clouds overhead.*

RIGHT: *There is something very painterly in the way that water can make such color and gain vigor as it falls and enchants us, as if trying to earn the epithet of Longfellow's Minnehaha, "Laughing Water." Murmuring along its path in a low but constant whirr, the stream never changes except to wear a hollow in a stone.*

OPPOSITE: *Beauty abounds around Killarney, no matter from which direction you come to the central feature, Lough Leane. Only a few miles from it, but over the massif of Shehy and Tomies mountains, is the Gap of Dunloe, just to the east of the Macgillycuddy's Reeks and Ireland's tallest mountain, Carrauntoohil (3,414 feet). Glacial activity millions of years ago gouged out the gap from the mountain sides, leaving in the glacier's wake the ragged assortment of rocks which the stream must navigate after it has passed beneath the single span of the nineteenth-century bridge. Vegetation here is sparse, but bushes, stunted trees, and ferns enliven the scene with their color.*

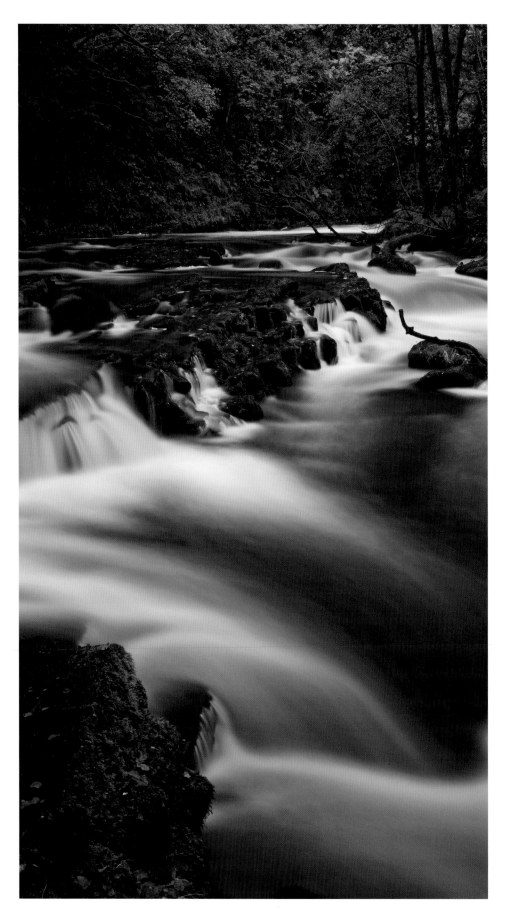

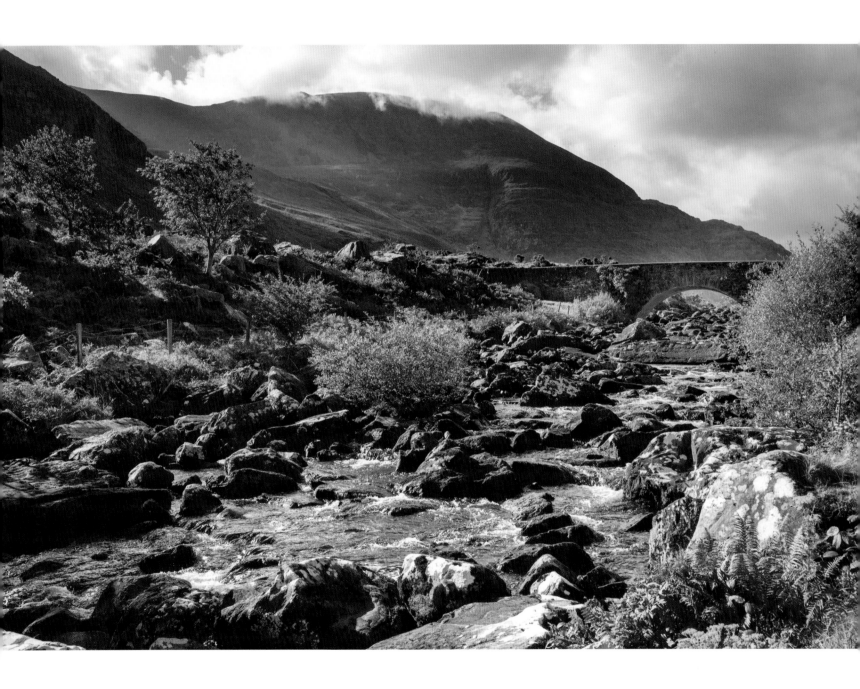

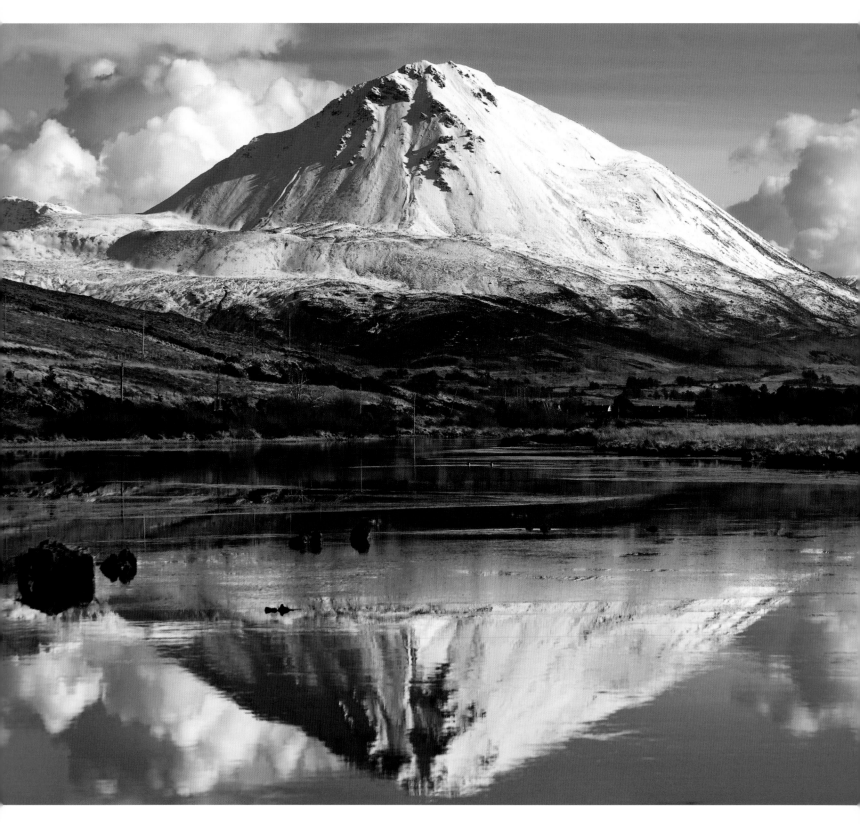

Errigal, at 2,466 feet, is County Donegal's highest mountain. It rises dramatically from the peaty lowlands around Gweedore to a quartzite peak, usually barren, but which takes on a new life with snow, giving it the appearance of an aging human face attempting to break out of its snowy mask. The reflection on the lake makes the whole scene even more dramatic, though obscuring the frost-shattered accumulation of loose stones (scree) which surrounds the base of the mountain.

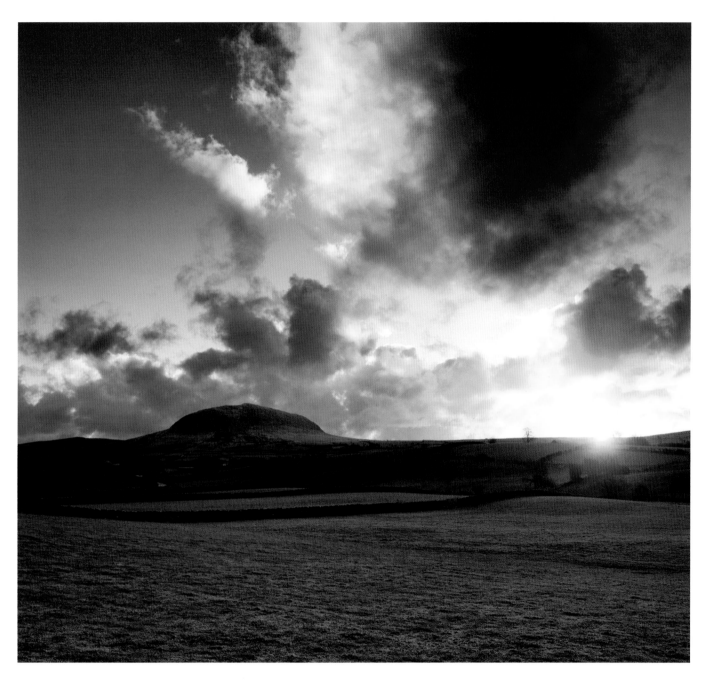

Like the Twelve Bens and Errigal, Slemish in County Antrim, at 1,437 feet, rises like an inverted broad-rimmed bowl from an otherwise flattish terrain. But here the geology is very different. Slemish is volcanic, perhaps the last remnant of a taller range of hills once present but worn away by river water, leaving it to lord over the smooth lava plateau that surrounds it. Slemish features very early in the history of Ireland, for it was there that St. Patrick was brought as a boy by his pirate captors to work as a slave herding the pigs of his master, Miliucc Moccu Buain. While Patrick "ate the bitter bread of bondage" (in the words of biographer J. E. Bury) for six years, he also matured spiritually by praying in the open air day or night, and he looked back later in life to see his years on Slemish as among the most important of his journey.

Hundreds of years ago, the Irish countryside was not enclosed as it is today. It was only in the eighteenth century that neat hedgerows began to be planted to divide up land between owners of different fields, but also—sometimes with the help of stone walls—to keep farm animals from straying. Such land divisions are seen neatly in this image of Glenelly Valley in County Tyrone, not only in the richer valley land with its trees creating property boundaries, but also up the mountainside. This was a feature common in nineteenth-century Ireland, when the population, double what it is now, was forced to divide up land within a single family and create what seem to us today senseless walls going up even over the tops of hills and ridges. The houses are fewer and better nowadays than they were then, and the land is ample enough to provide a living for modern farming families half way up the valley to the mountain ridge.

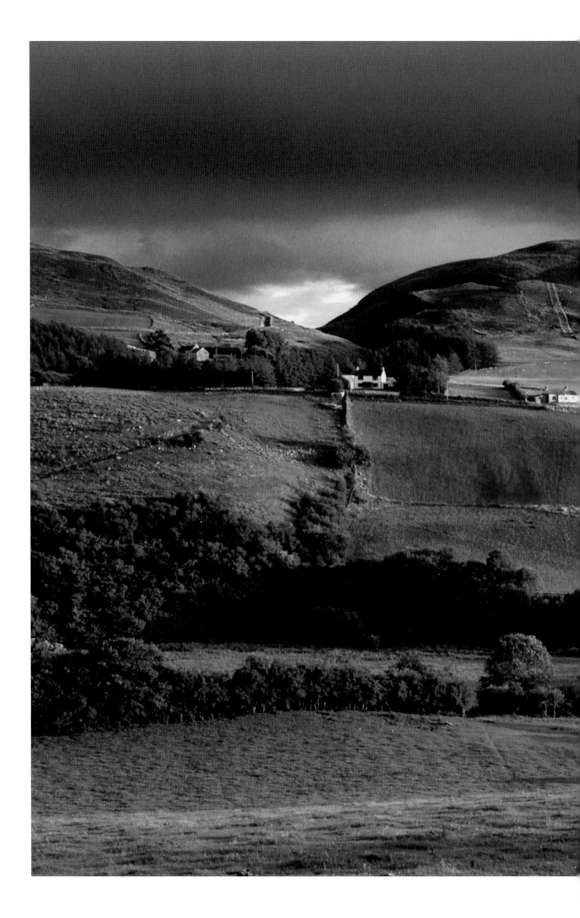

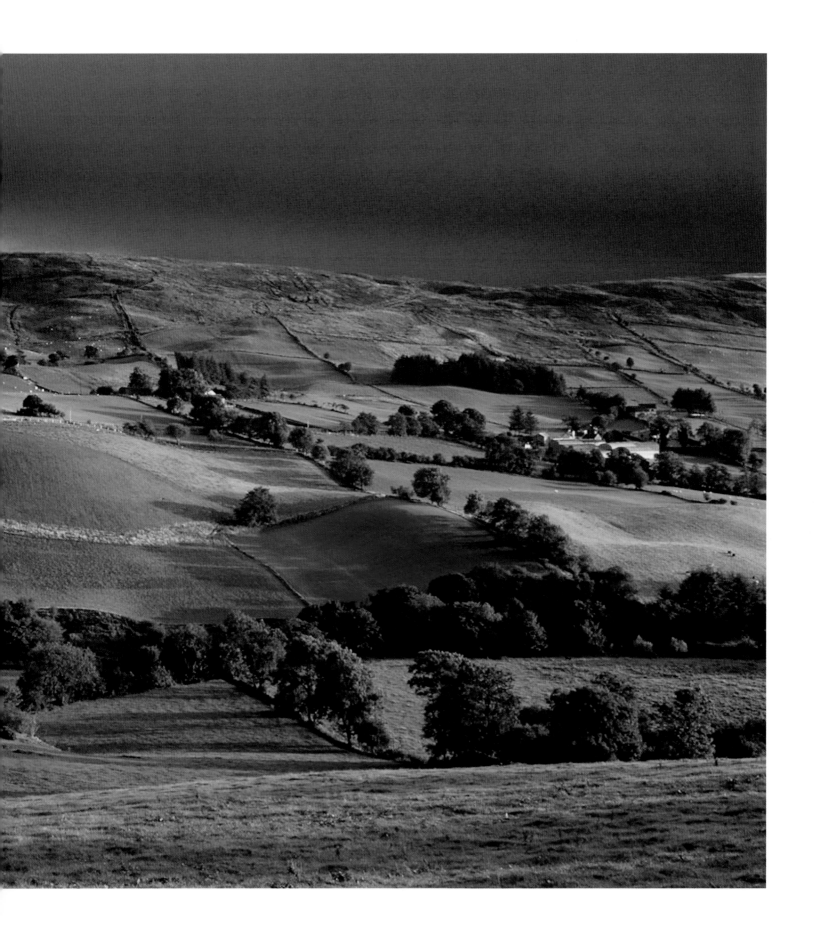

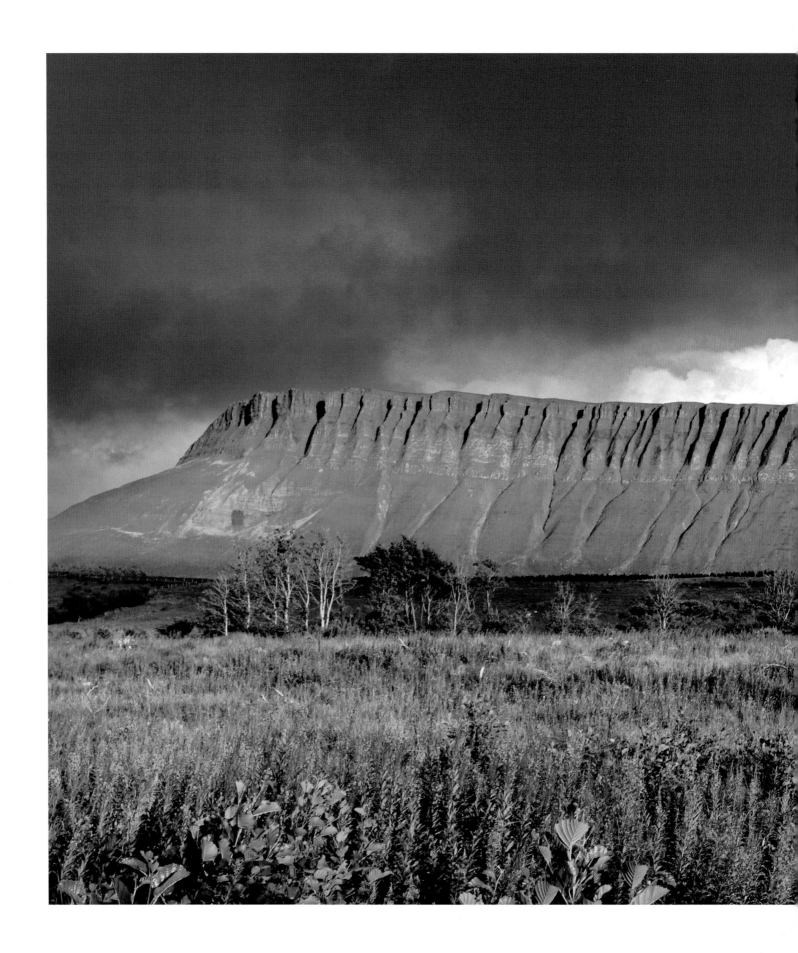

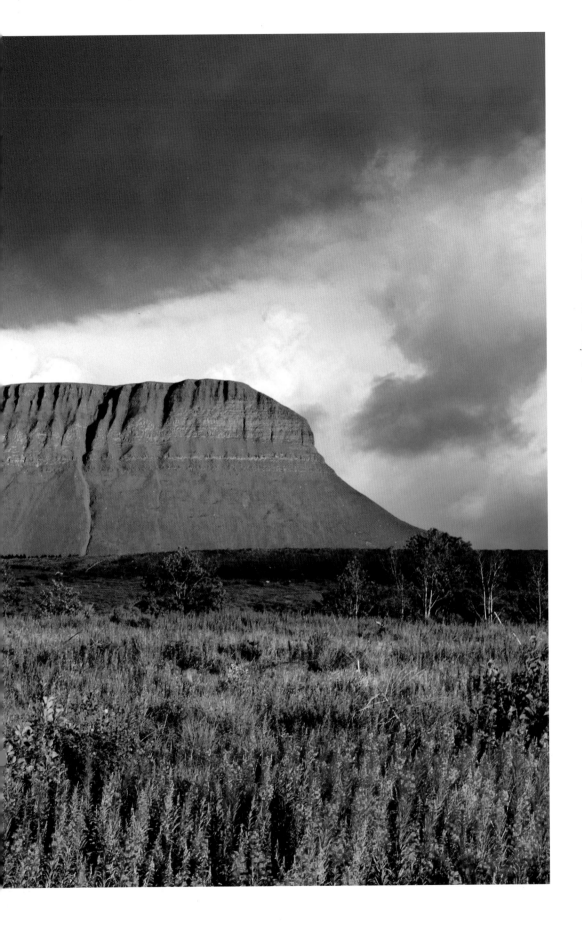

Together with Croagh Patrick in County Mayo, and perhaps also Skellig Michael in Kerry and the Sugar Loaf in County Wicklow, the most immediately recognizable hill in Ireland must be Benbulben in Sligo. It is a long, flat table, 1,730 feet high, that is really part of a limestone plateau, weathered on the sides and thus causing an accumulation of loose stones to fan out along the base. No matter from which side you approach, Benbulben is a great presence in the Sligo landscape, looking out over lowland to the Atlantic Ocean. It is no wonder, then, that it attracted storytellers and literati who were impressed by its dramatic shape. It is here that the famous love story of Diarmuid and Gráinne came to a sad end. Diarmuid Ó Duibhne, a handsome youth and one of the Fianna warriors, had eloped under the spell of the beautiful Gráinne who was, however, already betrothed to the aged hero Finn McCool (mac Cumhail). The pair were pursued as they raced widely throughout Ireland, building dolmens as their nocturnal resting places, until they came to Benbulben, where Diarmuid met his fate by being gored by a wild boar as Finn refused to come to his aid. The great literary figure associated with Benbulben is, of course, W. B. Yeats, who died in the south of France in 1939 but who wanted his body brought back to his home county to be buried "under bare Benbulben's head" at Drumcliff. The simple inscription on his gravestone reads:

> "Cast a cold eye
> on life, on death.
> Horseman, pass by!"

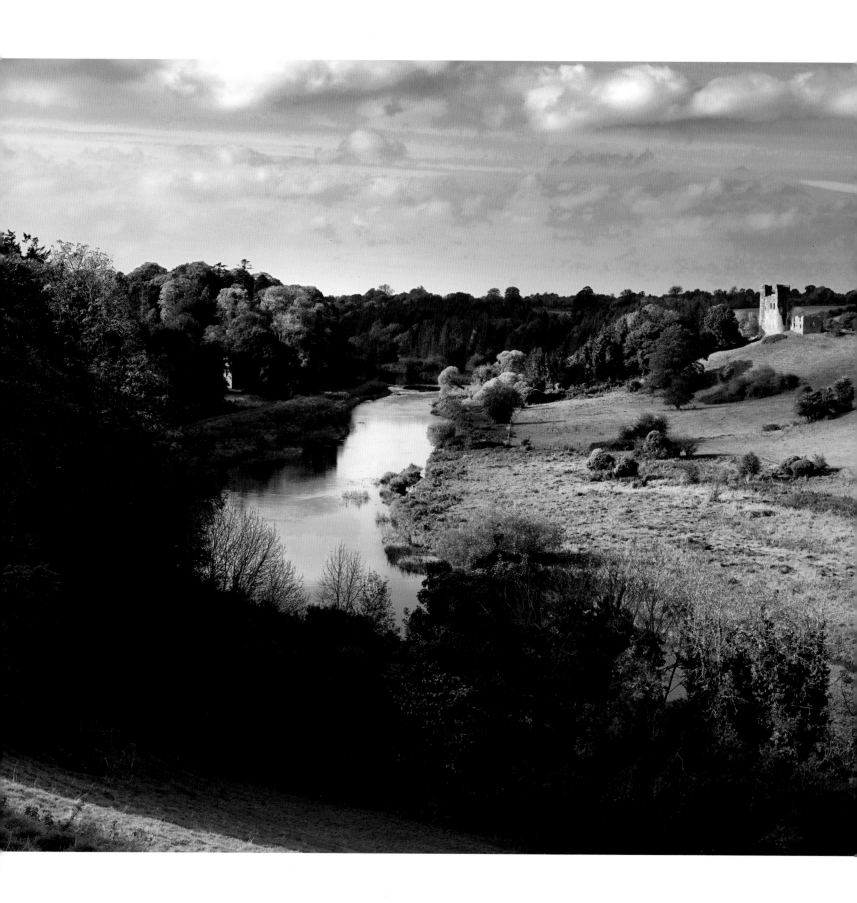

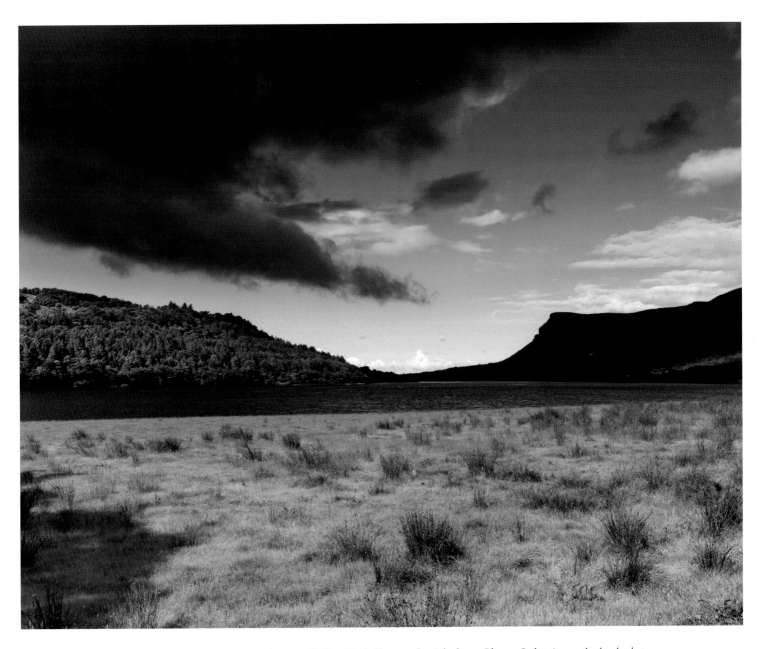

ABOVE: *Sprawling just in front of two mountain slopes, including Benbulben on the right here, Glencar Lake sits on the border between counties Leitrim and Sligo. The waterfall at Glencar features in Yeats's poem "The Stolen Child."*

OPPOSITE: *The river Boyne flows sluggishly through the rich farm land of County Meath, its progress charted over 150 years ago by Sir William Wilde, father of Oscar. For what might seem like a small, insignificant river, its fertile banks of luscious, iridescent green have been a focus for both peaceful and bellicose events for millennia: the great Boyne tombs of Knowth, Dowth, and Newgrange below Slane, Finn McCool catching the salmon of wisdom, and St. Patrick eyeing the king of Tara across the river. But the most significant historical event of all was the Battle of the Boyne, the only military action of European significance fought on Irish soil, when William of Orange defeated the English Stuart king, James II, in 1690. The medieval castle of Dunmoe on the right is a reminder that, being prime land, the whole Boyne Valley was always considered a prize worth fighting for throughout the centuries.*

Rolling hills with an amazing abundance of heather under a light-filled sunny sky in the gentle southeast County Wicklow, known as the "Garden of Ireland," offers stunning scenery. The jewel-toned foliage is complemented by a graceful blue sky.

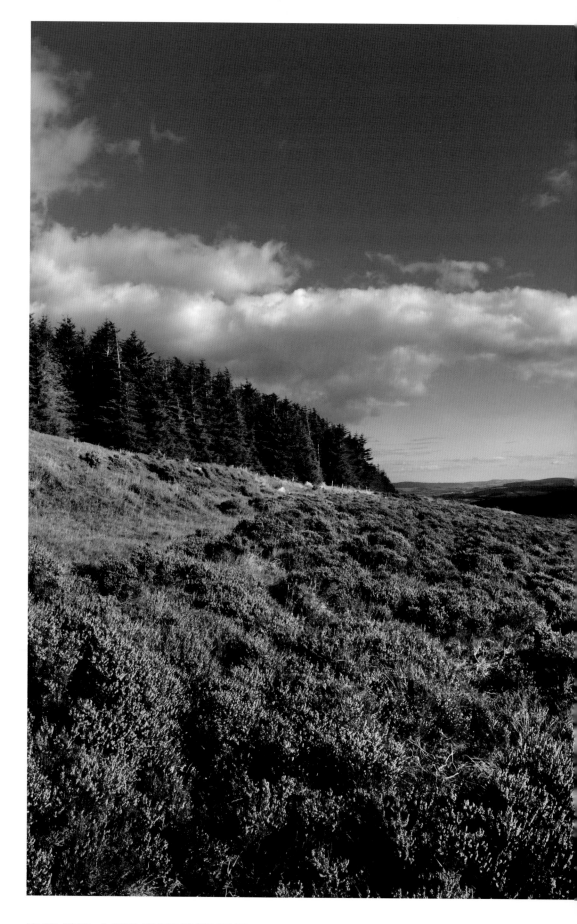

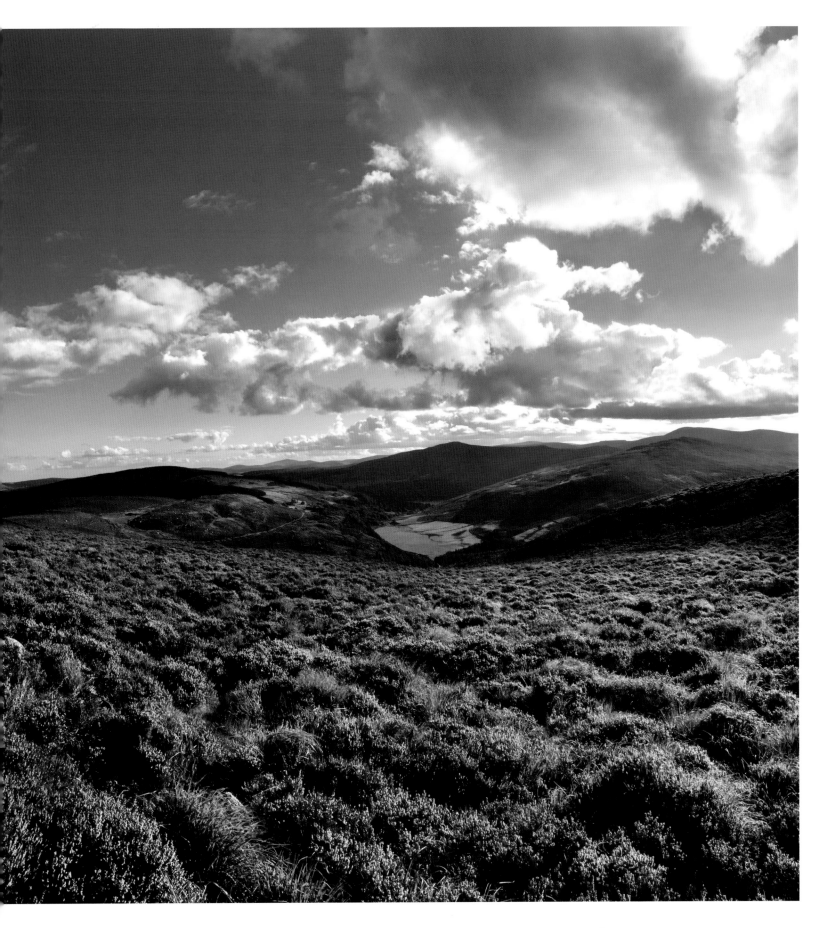

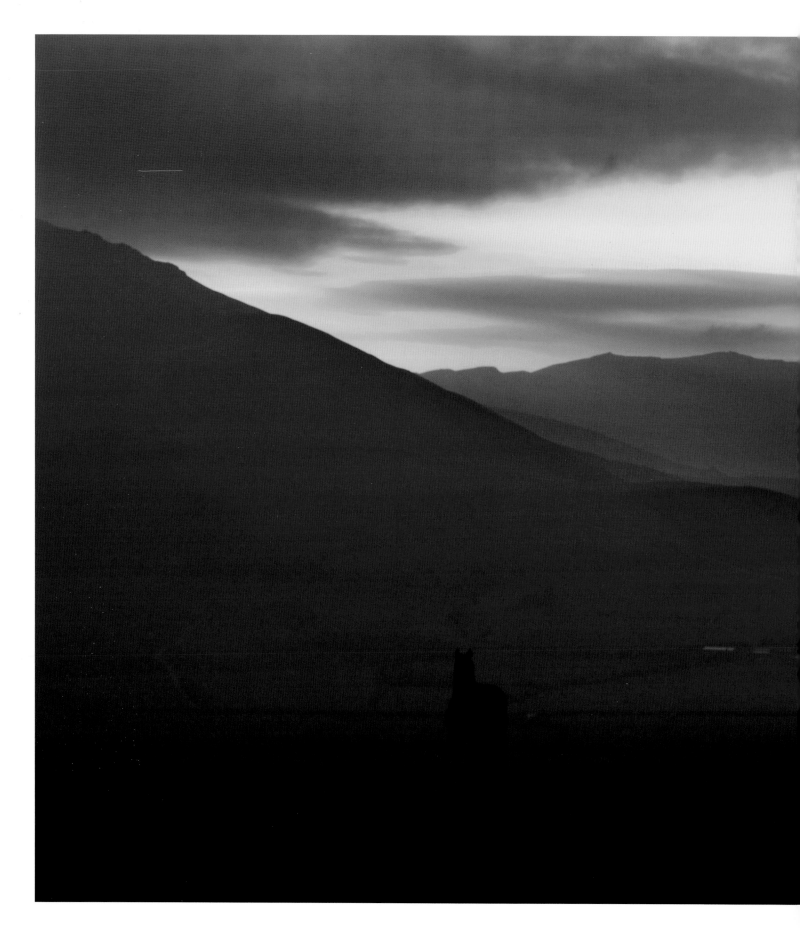

IRELAND: A LUMINOUS BEAUTY

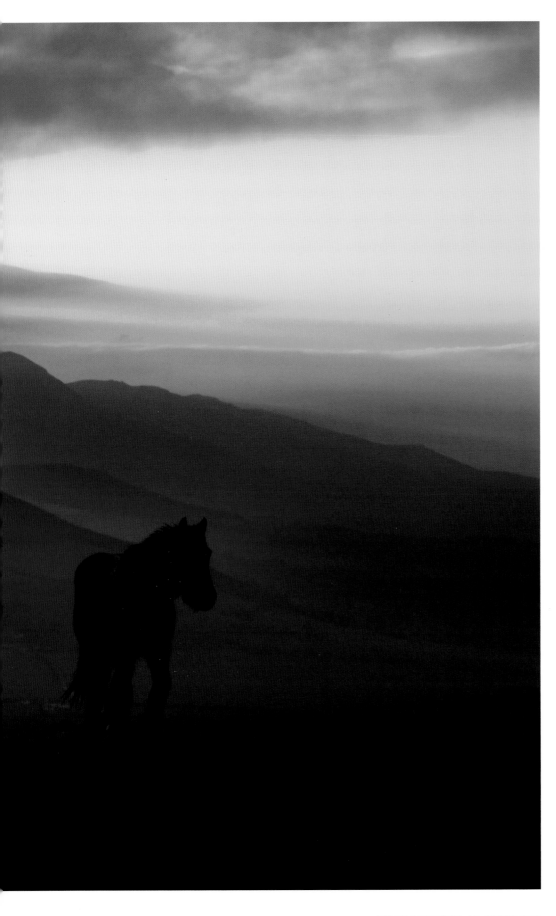

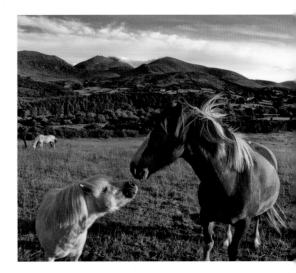

ABOVE: *Against the background of the Mourne Mountains, old and young greet one another. But who should blink first? The foal sniffs in uncertainty wondering how close to get. The adult stands still, not knowing what to think or do. They may leave us in doubt, but not about the beauty of the scene.*

LEFT: *The constantly shifting light and shadow play out at day's end as two horses head home on Croughaun Hill in County Waterford, with the blue-shadowed Comeragh Mountains and the sun's waning tones in the sky behind them.*

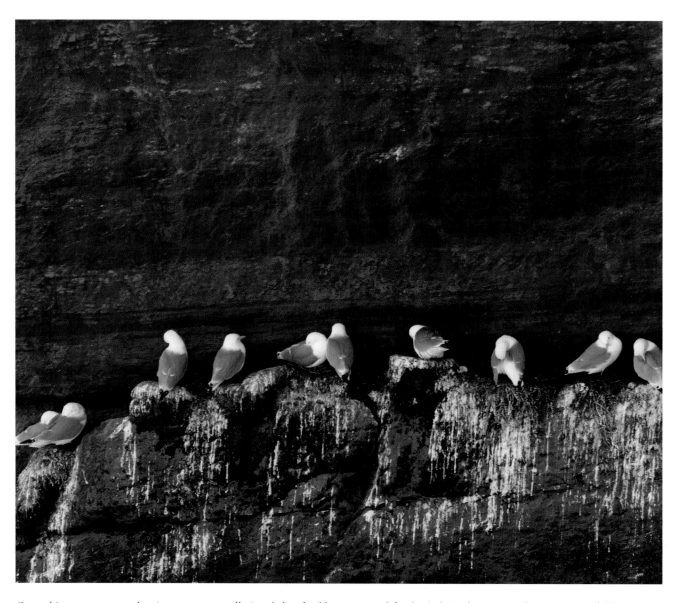

Squawking scavengers and serious squatters, gulls (symbolic of wild, unsurpassed freedom) claim their own real estate, a peaceful haven from the sea, on a ledge on Skellig Michael in County Kerry. They love to swoop on fishing boats in the hope of finding tasty morsels.

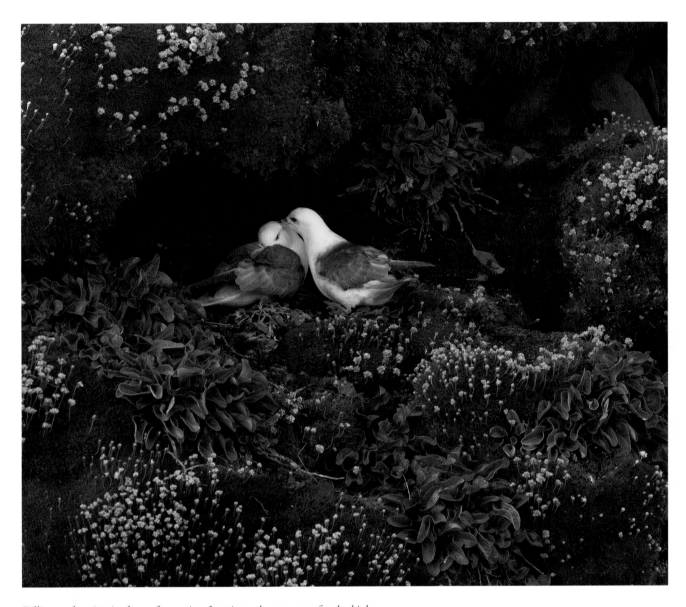

Billing and cooing in the perfect setting. Luminous beauty even for the birds.

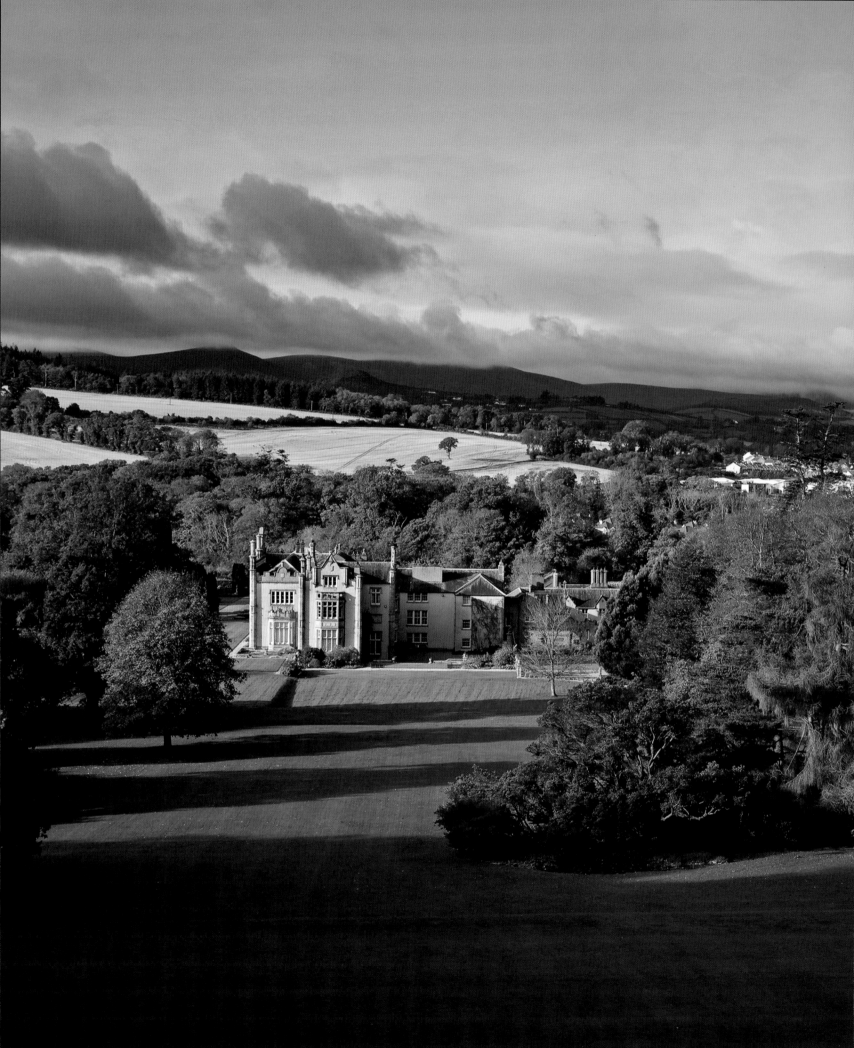

THE CULTIVATED WORLD
IMAGINATION AND STYLE

The Irish have responded to their spectacular, dramatic environment by transforming it into one that solidifies and enriches their own sense of place. The past is ever present in the landscape of Ireland, whispering a provocative story that gives material to her inhabitants to create interpretations of their world in any number of ways. From seeing the building of homes, development of towns and cities, art created through stories, poetry, music, sculpture, and, yes, even food, we discover the spirit that is Ireland, a journey of imagination and style.

The modern era really began in the seventeenth century. But it was no easy century; the wars of the medieval period still persisted, even bringing God into the fray through the Cromwellians, whose Christian brotherly love did not extend to Irish Catholics. Religion played a role at the end of the century too, when the Protestant William of Orange defeated the Catholic-sympathizing Stuart king, James II, in the Battle of the Boyne. Though not directly involved in either conflict, the dramatic castle of Dunluce in County Antrim is a reminder that people needed to entrench or fortify themselves against a potential enemy.

Though there was still religious discrimination, the eighteenth century brought a wave of culture in the fields of art and architecture as seen in the appearance of great mansions such as Castletown in County Kildare. No longer was it necessary to fortify; here, instead, was the urge to create beautiful things, often with a classical background. These great houses were the first exercise in gracious living in Ireland, at a time when literature in the English language first became an art through the pen of Jonathan Swift, dean of St. Patrick's Cathedral in Dublin. The love of learning that had so dignified and

ABOVE: *Swans flying in a great arc are the subject of a fine piece of sculpture by the Scottish artist Malcolm Robertson. Located by the sea at Ballycastle on the north coast of County Antrim, the piece recalls the tale of the children of Lir. Its title could just as easily apply to what humans also need: "A Leap of Faith."*

OPPOSITE: *County Wicklow is home to Kilruddery House, this stunning seventeenth-century home with meticulous, French-inspired gardens, caught here in a soft autumnal light. The house, built originally in 1627 for the 2nd Earl of Meath, was altered extensively in 1820 by architects Richard Morrison and his son William. In 1951 the house was reduced to a more manageable size. The present earl (the fifteenth) and countess have opened the house and extensive gardens to the public as a center for art and music. Films such as* My Left Foot, Dancing at Lughnasa, *and* Angela's Ashes *have been filmed here.*

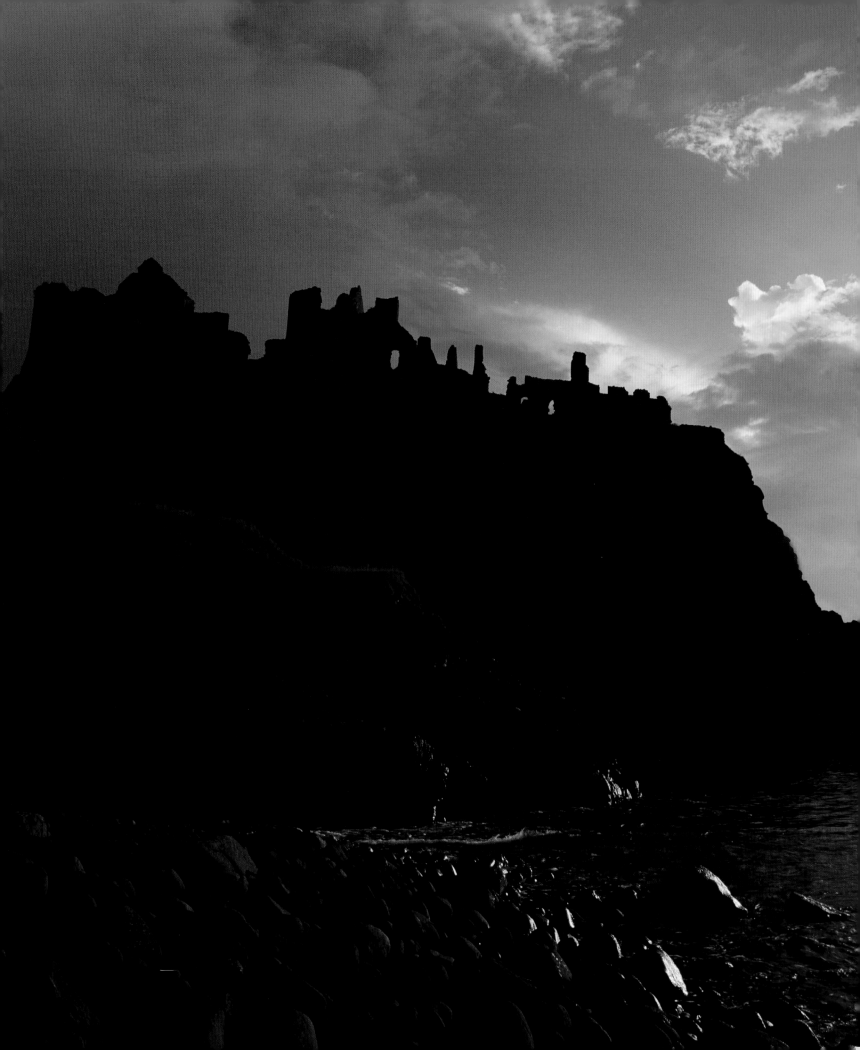

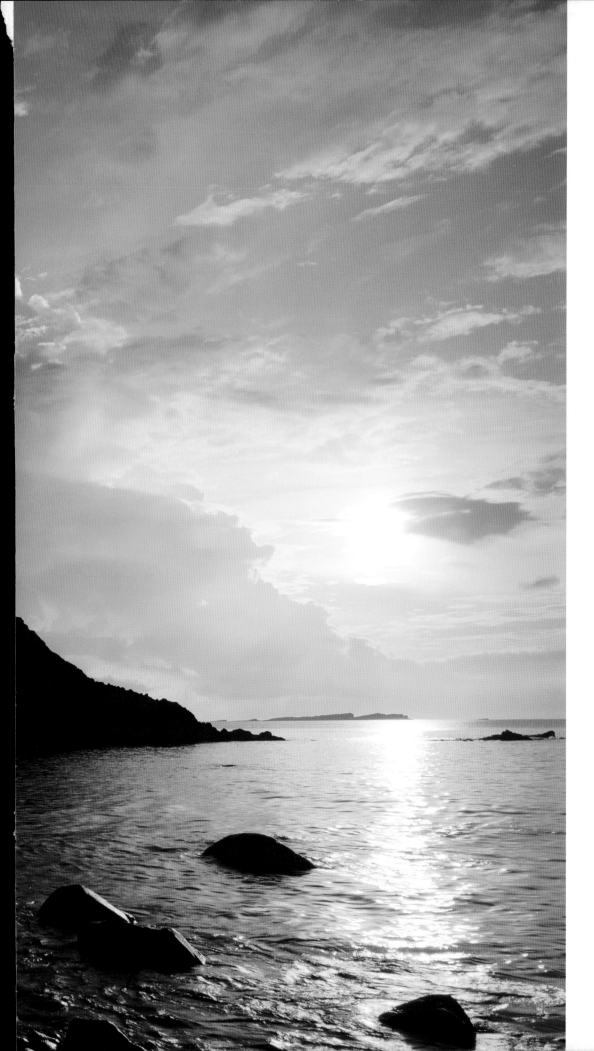

Dunluce, on the north coast of County Antrim, about five miles from Portrush, is one of the most spectacularly sited castles anywhere in Ireland. It sits on a narrow basalt outcrop, stretching out into the Atlantic. Ideally situated as a fortification, the castle was only approachable from land across a deep gully which once must have had a drawbridge over it. The buildings at the extreme right of the picture are part of the surrounds of a lower yard which partially collapsed into the sea in 1639, taking many of the serving staff to a watery grave.

123

The flamboyant statue by Rowan Gillespie of Sligo's Nobel Prize–winning poet W. B. Yeats was erected in 1989 to commemorate the fiftieth anniversary of his death. Cast on his clothing are excerpts from some of his most famous verses. Located at an important traffic intersection in the center of Sligo town, it was knocked down by a drunken driver in 2005, but, unlike Humpty Dumpty, the poet was successfully put back together again.

distinguished the monasteries of early medieval Ireland came forward again, and nowhere is that more realized than in the magnificent library of Trinity College, Dublin. Begun in 1712, the library holds some of the superb manuscripts of that earlier culture, including the Book of Durrow and the Book of Kells, creating an impressive link between old and new.

Some of the splendor of the Georgian era of the eighteenth century was, however, achieved by an upper stratum of society who cared little for their tenantry, whose dependence on the potato was to lead to Ireland's greatest catastrophe. This was the Famine of 1845-47, when a blight struck the only staple food of the poor, leading to the death of millions and the emigration of more, bringing the Irish gene pool to many countries across the globe.

Yet, despite the drain on human resources, the nineteenth century saw great additions to the structural heritage of the country. Most of Ireland's towns and villages are creations of the nineteenth century, when, more than ever before, the rural Irish people came to live together in communities, usually accompanied by one or more churches (one for each of the two major religions). Nevertheless, the old custom of the family occupying a single house in the countryside continued, as it does to this day. Pride in the home, large or small, brought gardens with flowers. Inspired by the colorful presence of flowers in the wild, which the Gulf Stream ensured, plentiful gardens of all kinds developed around people's homes. A fine example of horticultural splendor can be seen at Mount Stewart in County Down, where one woman, Edith, Lady Londonderry, was responsible for designing an extraordinary garden taking advantage of a mini-climate on the shores of Strangford Lough. In County Wicklow, a further link with the medieval past was forged with the revival of the Gothic style of architecture in Kilruddery House; the same can be said of Clifden Castle, now in ruined splendor near the Galway town of the same name. Despite the fascination with the ornate Gothic style, classicism still continued with the General Post Office in Dublin, the Crown Bar (formerly the Crown Liquor Saloon) in Belfast, and even into the twentieth century with Belfast's city hall. The General Post Office in Dublin, however, is known less for its architecture than for the Insurrection which took place there in 1916.

Various literary figures form the focus of one of Ireland's greatest pieces of twentieth-century stained glass, Harry Clarke's Geneva Window of 1929. Such artworks provide food for the soul, but food for the body is provided aplenty in modern-day Ireland at the lively English Market in Cork and in the number of cookery schools around the country. Modern Ireland is like a mosaic—a myriad of colorful pieces fitting neatly together.

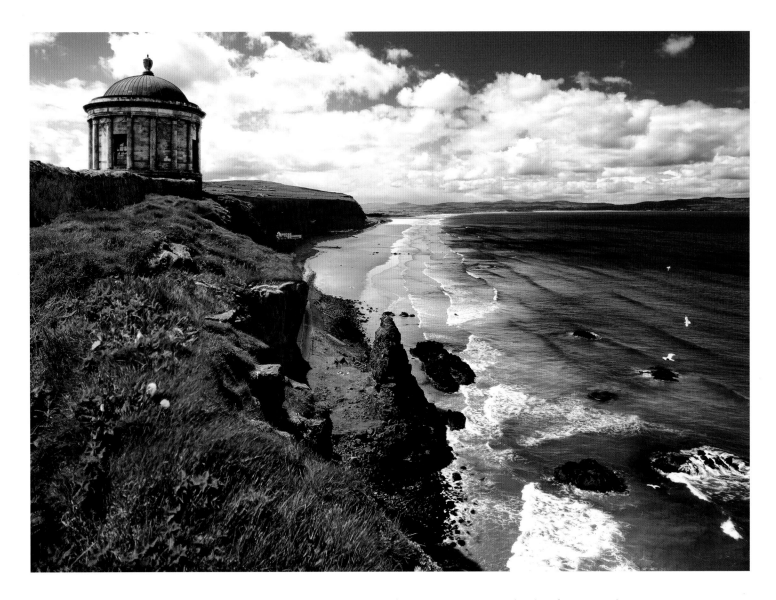

What a superb location for a "temple" overlooking the sea on the north coast of County Antrim. It was the idea of one extraordinary character, Frederick Augustus Hervey, 4th Earl of Bristol and bishop of Derry, commonly known as the Earl Bishop, who traveled widely on the European continent, where he gave his Bristol name to many a hotel. Gaining a taste for classical culture on his travels, the bishop commissioned the Cork architect Michael Shanahan to design a round-domed building modeled on the temples of Vesta in Tivoli and Rome as a suitable home for his library, where the books were cleaned four times a year. Unfortunately, those books were lost in a fire in 1803. The sixteen Corinthian columns which decorate the outside wall are not just mere decoration, but are hollowed out to function as drainpipes.

Completed in 1785, the "temple" gets its name from a Mrs. Frideswide Mussenden, a great beauty and cousin of the bishop, who was thought—probably wrongly—to have been having an affair with him, he aged fifty-two and she only twenty. She died before the building was completed, and so he dedicated the temple to her memory. It is now part of the National Trust.

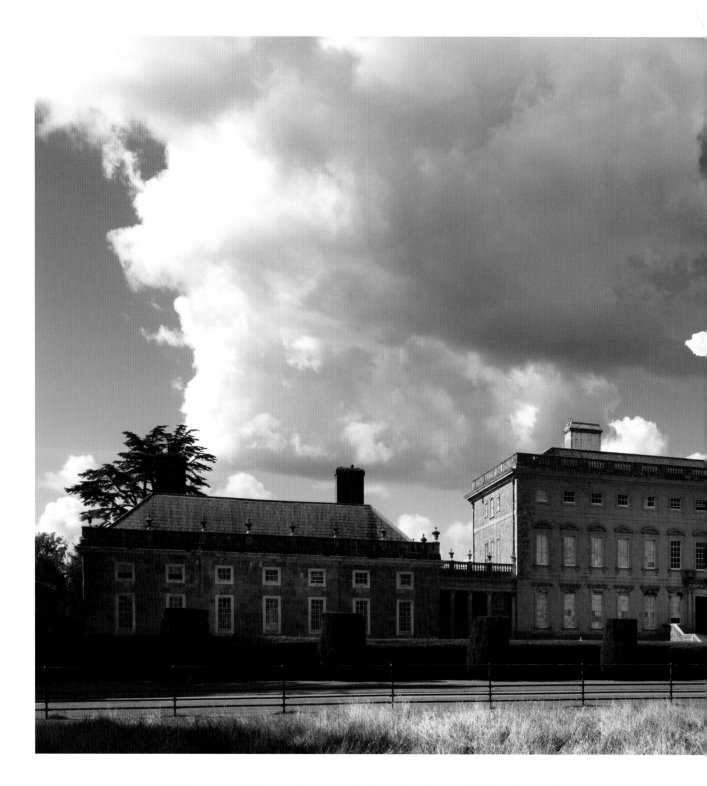

Castletown was the first great house in Ireland, its idea of a central block with wings being derived from a villa designed by the great sixteenth-century Italian architect Andrea Palladio, encompassing the best of classical and Renaissance architecture. It was built by William Conolly, speaker of the Irish House of Commons, and designed by another Italian architect, Alessandro Galilei, who was responsible for the façade of the Basilica of St. John Lateran in Rome. However, Ireland's first great architect, Edward Lovett Pearce, best known for his work on what is now the Bank of Ireland in

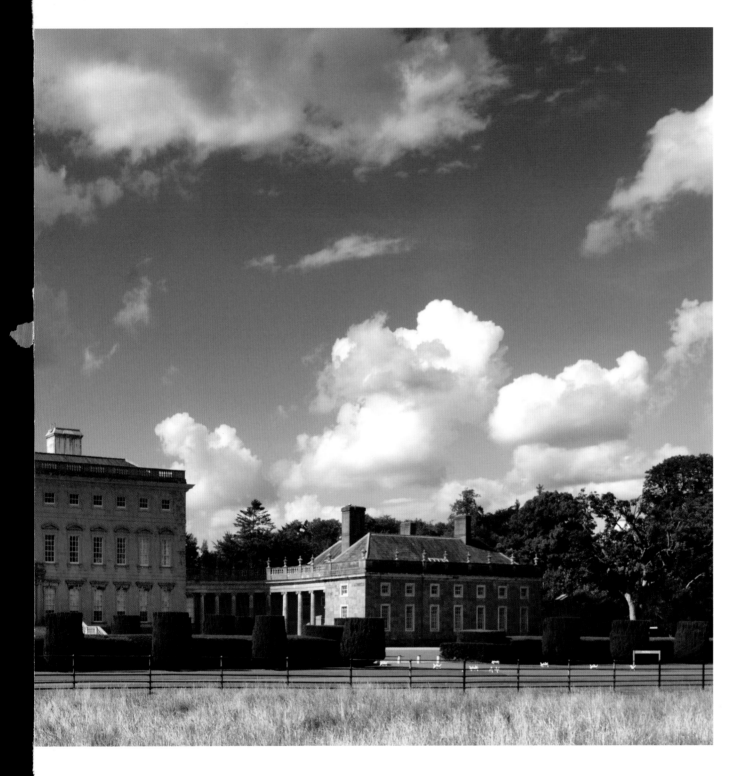

*Dublin's College Green, may also have had a hand in the project. The house dates from the
1720s but was not finished for decades, as the great staircase—decorated by the Francini brothers,
Swiss stuccodores—was not inserted until the 1750s at the earliest. When sold in the 1960s, the
house became the home of Desmond and Mariga Guinness's Irish Georgian Society, and is now
owned and run by the state.*

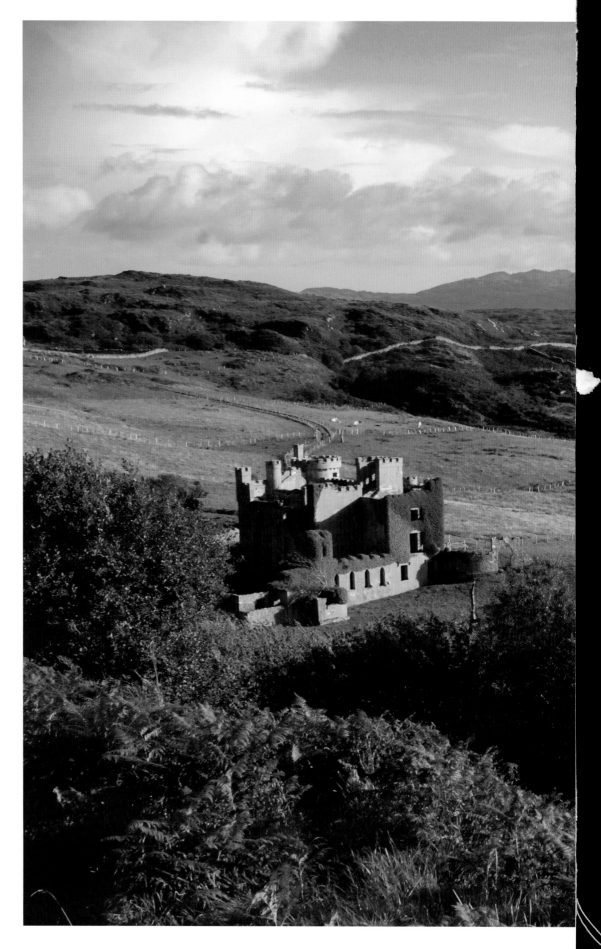

Ivied Clifden Castle looks like the ideal location for a love story, with owls too-whitting and too-whooing among the lofty towers, and it does have a certain romanticism to its story. It was built by John D'Arcy or Darcy around 1815, only two years after the more famous Mr. Darcy made his debut as the hero of Jane Austen's Pride and Prejudice. The Irish Darcy's first wife died before his castle was completed, but love triumphed once more when he married again in 1820. It was his second wife who helped him make the castle into what was probably regarded as the finest residence in Connemara at the time, a home full of guests and hospitality. It is a pity to see it now gone to ruin, but sic transit gloria mundi! The castle is only two miles from the town of Clifden, which Darcy had founded and nurtured to become what is now the heart of Connemara. It is a thriving center for swimming, fishing, and touring, and not far away once stood the now-vanished Marconi wireless station, Europe's first telegraphic link across the Atlantic.

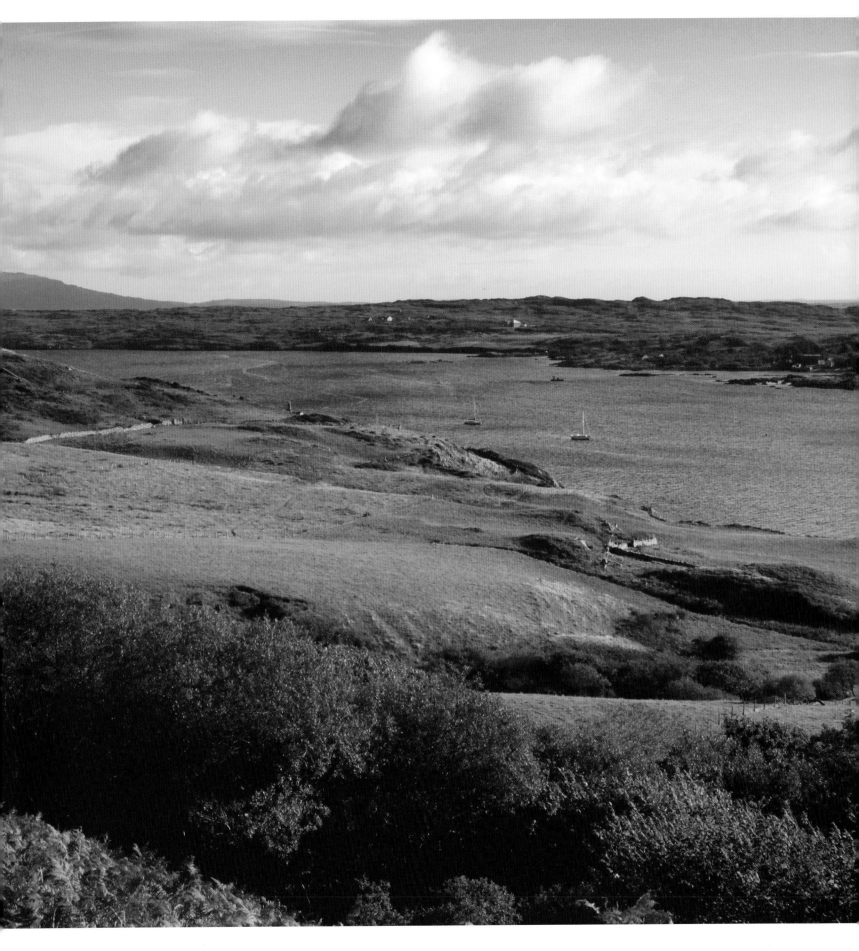

We all look to transform our environment by creating our own space in the natural world. And the Irish have made an art of it. A steady light beckoning from the interior of a cottage nestled against a hill contrasts with the roiling sky above, reflected in the gently meandering stream below. Light in the window of a home, here in County Waterford, was once a beacon for wandering storytellers in search of a warm fire, a meal, company, and a night's shelter in exchange for a lively retelling of their myths and tales.

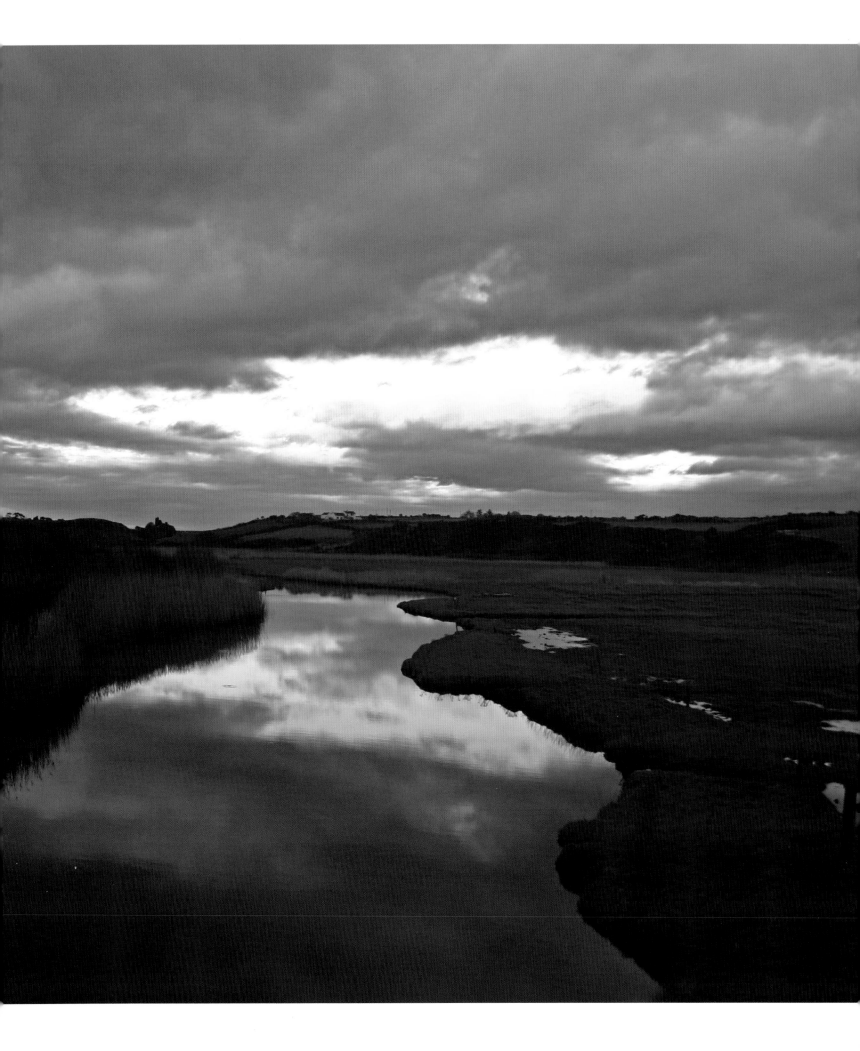

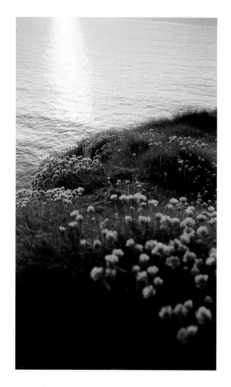

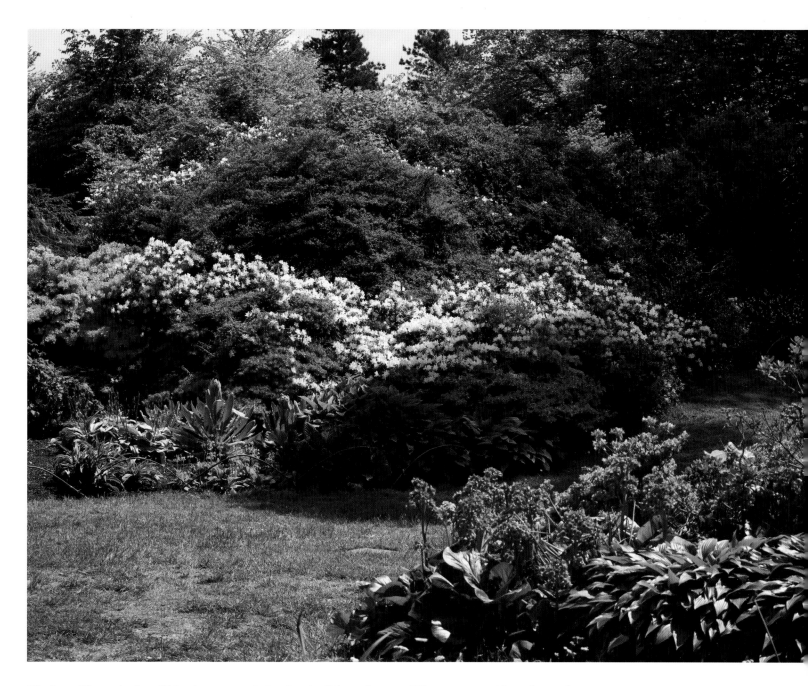

Blankets of flowers in the wild inspire an appreciation for color, light, and texture. When nature provides such stimulating originals as sea pinks (opposite, top left), which flourish undaunted on many exposed coastal sites, it doesn't take long to develop one's own world of flowers. So inspired, the wild flowers become less wild, moving from great pots with minigardens of color beside a painted door, to cascading flowers and greens in a bright window box, to a stage-crafted front doorway of hanging potted flowers, and finally to a sumptuous, elegant garden—this one (above) at Rowallane House in County Down—now in the hands of the National Trust.

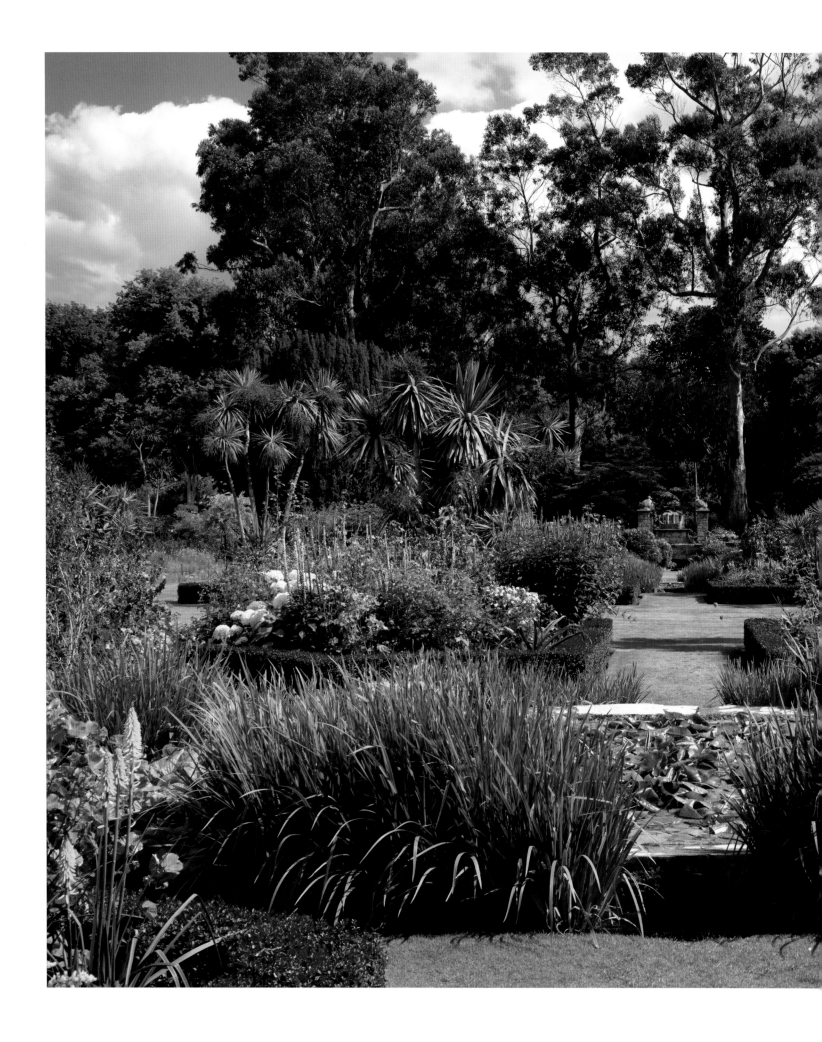

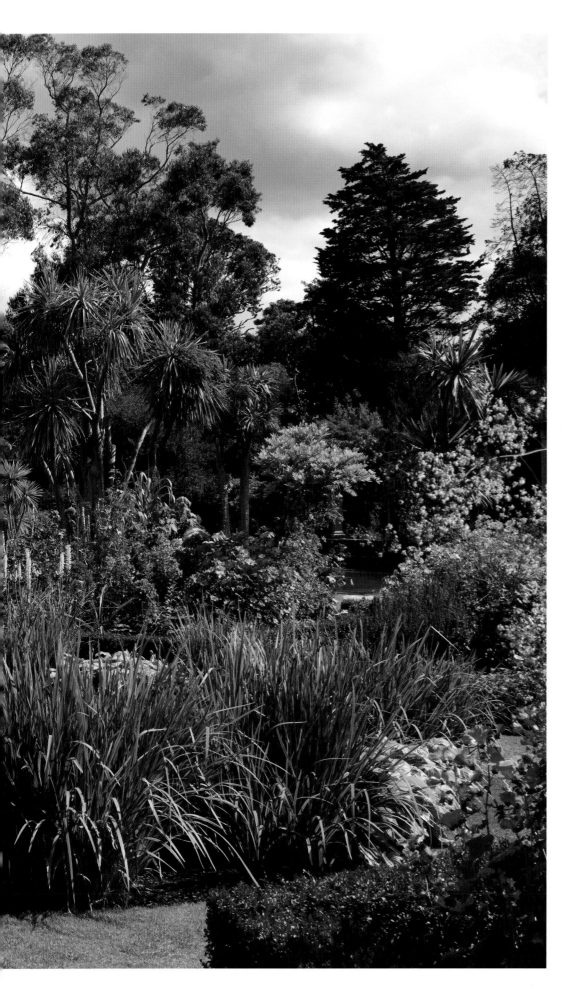

ABOVE: *The Red Hand in Mount Stewart gardens in County Down, demonstrating the owners' pride in belonging to Ulster, of which the Red Hand is the symbol.*

LEFT: *Mount Stewart on Strangford Lough has a miniclimate of its own, which enables the cultivation of plants that would normally be reserved for the greenhouse. The garden is attached to a large nineteenth-century house, which Edith, Lady Londonderry, found dark and damp when she arrived there in 1919 as the bride of the 7th Marquess of Londonderry. With the aid of soldiers demobilized after the First World War, she set about designing and creating an extraordinary garden with some assistance from Gertrude Jekyll, the legendary British horticulturist and garden designer. With energy and taste, she transformed what was an uninteresting landscape into a riot of color, in settings reminiscent of Italy and Spain, which she had read about in her extensive library. The plants were from exotic climes, and trees were imported from as far away as Tasmania and New Zealand. With a rose, the Dame Edith Helen, named after her, she gave the garden to the National Trust in 1957, two years before her death. Her marvelous work was continued by her daughter, Lady Mairi Bury, who died in 2009.*

135

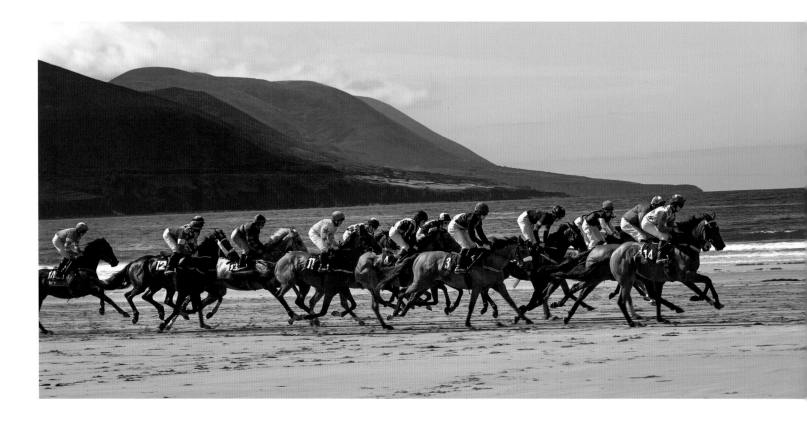

ABOVE: *Sometimes an environment is created to enrich one's sense of place, and at other times an environment is transformed into a meaningful place. Here, quirkily, a lone boat is secured to a window cut into a wall of granite. Why is it there?*

OPPOSITE, TOP: *Winning smiles abound: these charming lads proudly show off their catch. Angling in Ireland is a refined sport.*

OPPOSITE, BOTTOM: *Shunning the turf of traditional racing courses and transforming a natural environment, Glenbeigh Races takes over the beach at Rossbeigh Strand, County Kerry, every year. With six miles of golden sand, Glenbeigh is referred to as "the jewel in the crown of Kerry." The annual race is now one of the biggest in the country.*

Summer Cove overlooks the inlet leading up to the town of Kinsale, one of the most picturesque towns in County Cork. The site of a battle in 1601, disastrous for the Irish, Kinsale is now famous as a safe harbor for yachting, a gourmet capital, and a popular resort with a mild climate, particularly in the summer. Close to Summer Cove is the famous seventeenth-century star-shaped military outpost, Charles Fort.

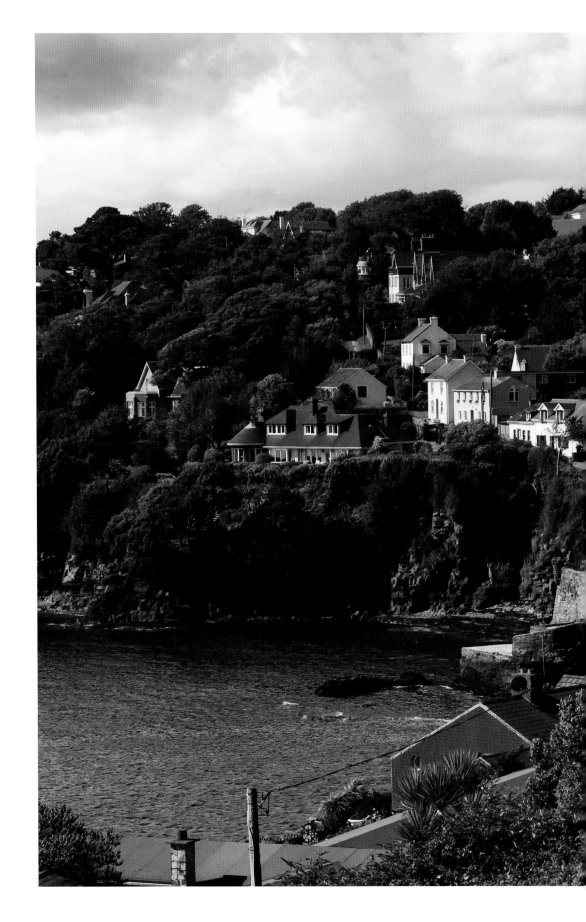

In the eighteenth century, Cork, the capital of Munster, had what was probably Ireland's greatest collection of markets for all sorts of items—butter, fish and meat, and many others. By 1790, the English Market had firmly established itself in the heart of the commercial center of the city. Sadly, a fire in 1980 gutted the old market building, but a speedy response by Cork Corporation enabled a new complex to replace it, which also included a fine restaurant on a first–floor gallery. It was probably its title that encouraged the authorities to bring the English queen, Elizabeth II, to the market in 2011, which brought a great smile to her face. The English Market is the place that has defined the artisan food movement in Ireland.

A FOOD LOVER'S CHOICE

As anyone visiting the English Market in Cork (opposite) over the years would have realized, the quality of Irish food has advanced in leaps and bounds over the last few decades, with splendid natural produce, meats, and native cheeses. Many restaurants in Ireland now compete favorably with the best worldwide. The population in general has become interested in improving the preparation and presentation of food, seen in the rise in popularity of high-level cookery schools in the country. One of the top sites is that designed by Kevin Dundon, a celebrity master chef who is often seen on Irish, British, and American television, and who passes on his skills at the Dunbrody Cookery School on the grounds of his elegant Dunbrody Country House Hotel near Arthurstown in County Wexford. Kevin has brought his engaging skills to the U.S. His Orlando, Florida-based Raglan Road Irish gastropub is a favorite of Disneyland visitors. The lovely Strawberry Pavlova (below) demonstrates Kevin's ethos of serving fresh, local food, prepared simply and served with style. Bon appetit!

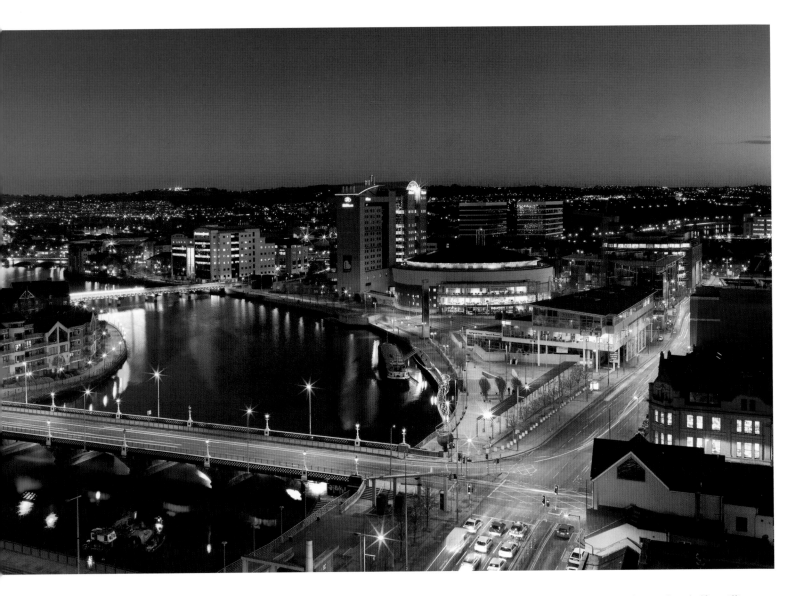

ABOVE: *Belfast has grown from a small market town into a thriving city with a population of more than half a million people. The famous Harland & Wolff shipyard built the Titanic. Paneling intended for its sister ship, the Britannic, ended up in the the Crown Liquor Saloon (now the Crown Bar).*

OPPOSITE TOP: *Belfast city hall in Donegall Square was the embodiment of the city's ambitions when it was built between 1896 and 1906, only a few years after it had achieved city status in 1888. Its shipyards and other industries were making it into the North's industrial capital, and seven years after the building opened its doors, Belfast saw the launch of its most famous ship, the Titanic. The city hall's architect was a Londoner, Sir Alfred Brumwell Thomas, and so it comes as no surprise to find him imitating here the dome of Christopher Wren's St. Paul's Cathedral in London, where British monarchs are crowned. The city hall is Belfast's greatest monument to the Victorian capital's enterprise and success. In the more than a century of its existence, it has been the scene of many events of political and social significance. One of the most popular is the annual lighting of the enormous Christmas tree (seen in the left background), given a more festive appearance when the surrounding park is covered in snow.*

OPPOSITE BOTTOM: *With its extraordinary tiled facade and ornate, atmospheric Victorian interior, preserved by the National Trust, the Crown Liquor Saloon (now the Crown Bar) is one of Belfast's gems, as well as its most famous pub.*

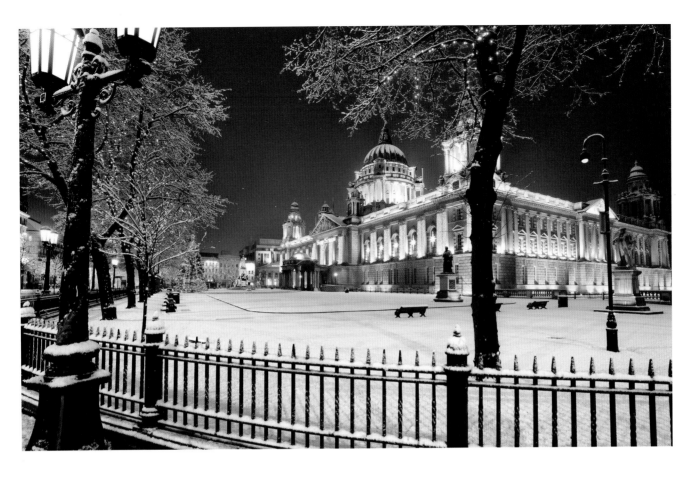

ABOVE: *Dublin's classic Georgian doorways share some well-proportioned architectural features like the door frame with Doric or Ionic column on each side, sometimes having a side-window, and frequently a graceful fanlight in the semi-circle above the door. The door color adds a graceful note to the often monotone streets.*

OPPOSITE TOP: *While Dublin Corporation officially calls this the Liffey Bridge because of the river flowing beneath it, it is known to every Dubliner as the "Halfpenny Bridge" because a halfpenny toll was extracted from pedestrians crossing the bridge after it was erected in 1816, but rescinded a century later after the lease ran out. It was originally called Wellington Bridge, named after the Dublin-born duke who had defeated Napoleon in the Battle of Waterloo only the year before, but he took no interest in the honor and the name never caught on. In 1912 the great art connoisseur Hugh Lane proposed that the bridge be replaced by a two-pavilion picture gallery spanning the river, to be designed by the famous architect Edwin Lutyens with the support of the poet William Butler Yeats and Lane's aunt, the renowned Lady Augusta Gregory. The project was dropped, however, when Lane drowned in the Lusitania disaster in 1915, and his paintings went to London instead. They are now shared in alternating exhibitions between Dublin and London, with half of the paintings exhibited in each capital.*

OPPOSITE BOTTOM: *The most exciting bridge to appear over the river Liffey in recent years is the Beckett Bridge in the Dublin Docklands, named after the Dublin-born author Samuel Beckett, who was awarded the Nobel Prize for literature in 1969. It was designed by the notable Spanish architect Santiago Calatrava, who created the James Joyce Bridge further upstream. It has been suggested that he got the idea for the design of the Beckett Bridge by tossing a coin which landed with the harp facing upward, so he put the instrument lying on its side. True or not, the bridge is a most impressive feature crossing Dublin's river, but also an appropriate one, as the harp has been the national emblem of Ireland for many centuries. Opened in 2009, the bridge—with a span of over 400 feet (123 meters)—is unusual in that it rotates horizontally to let ships pass.*

THE CULTIVATED WORLD 145

ABOVE: *For Irish people all over the world, the General Post Office on Dublin's O'Connell Street is synonymous with the Easter Rising of 1916, which, with martyrdom and loss of blood, eventually led to the creation of the Irish Free State six tumultuous years later. It was here, in front of this building, that Pádraig Pearse read the proclamation of the Irish Republic, which brought about Pearse's death and the destruction of much of the building's interior. The portico, crowned by Thomas Kirk's statues of Fidelity, Hibernia, and Mercury, is the backdrop for many commemorative and political rallies which have taken place since the Insurrection. Even before the destruction of O'Connell Street during the Easter Rising, the General Post Office was the only truly important building on the street, having been built between 1814 and 1818 to the design of the well-known architect Francis Johnston.*

OPPOSITE: *The interior of the Trinity College library, seen here, was designed to have only one low storey with a flat ceiling. But, in 1860, Deane and Woodward (the latter being Ireland's greatest nineteenth-century architect) removed the old ceiling and made the long room into a breathtaking two-storey space with a wooden barrel vault above, so that "what had been superb, they made into the sublime," in the words of Dr. Edward McParland, the College's architectural historian. The library is now Ireland's greatest interior space, housing what is known as "Brian Boru's harp," an instrument probably of the fifteenth century that is the model for the emblem of Ireland. The great room formerly housed the college's two great manuscripts, the Book of Durrow and the Book of Kells, but these have now been moved to a new location on the ground floor.*

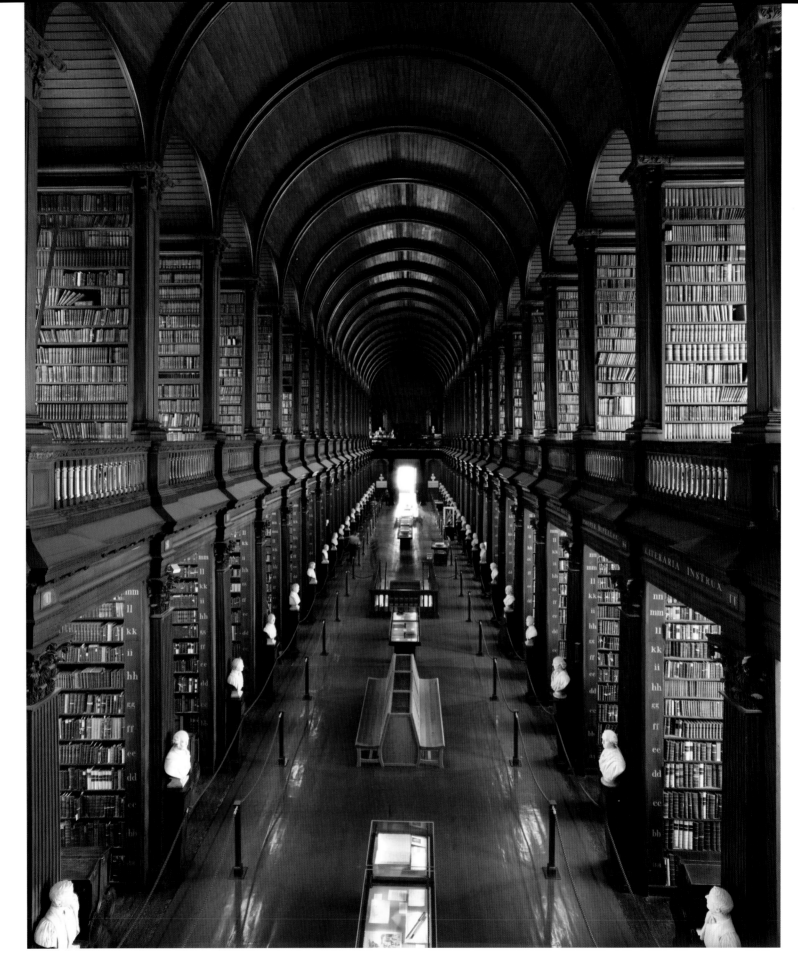

Harry Clarke's superb Geneva Window, completed in 1929, illustrates quotations from fifteen of Ireland's most celebrated authors: Pearse, Synge, Shaw, Lady Gregory, O'Sullivan, Stephens, O'Casey, AE (George Russell), Robinson, Yeats, Colum, O'Flaherty, Fitzmaurice, O'Kelly, and Joyce. The poetic lines illustrated in each panel are written at the bottom of the panel. Yeats assisted Harry Clarke in selecting writers for the project that combines theatrical fantasy and modern realism in its figures, coloring, and composition. Commissioned by the Irish government for the League of Nations in Geneva, the window was rejected because some of the authors' works were banned due to the prudery of the period, and the pictures were judged to be unrepresentative of the chaste, sober image of Ireland the government wanted to disseminate. Returned to the artist's family, the window stayed in Dublin until 1998, when it was acquired for the Wolfsonian Foundation in Florida.

Stained glass window, commissioned 1926, completed 1930 (never installed)
For the International Labor Building, League of Nations, Geneva
Harry Clarke (Irish, 1889–1931)
Clarke Studios, Dublin, maker
Stained glass, lead cames
71 ½ x 40 inches (181.6 x 101.6 centimeters)
The Wolfsonian–Florida International University
Miami Beach, Florida,
The Mitchell Wolfson, Jr. Collection
TD1988.34.1
Photo: Bruce White

Probably the longest-lasting tradition in Irish art and craft is the love of ornament in preference to the naturalistic representation of the human figure, comparable to the contrast between the arts of Islam and the ancient Greeks. Look at the Stone Age decorations at Newgrange and Knowth in the Boyne Valley, where we find circles, spirals, triangles and other geometric shapes. Look at the decoration of the Bronze Age gold in which, excluding the spiral, these design elements all recur again more than a thousand years later. When we come to the great illuminated manuscripts, the Book of Durrow and the Book of Kells of the period 650–850, we find imaginary animals prancing around and strands of interlacing ribbon. Where the human figure appears, as it must in depicting Christ or his evangelists for instance, it is the inherent stylization which stands out.

Kevin O'Dwyer, an award-winning contemporary silversmith, expresses Ireland's influence on him: "For over thirty years my artwork has explored the subtleties of ritual and imagination. Irish prehistoric art, Bronze Age artifacts, early monastic metalwork, twentieth-century design and architecture are my creative influences. Equipped with this visual vocabulary I create artifacts that often combine the

textured surfaces and flowing lines of our past with the strong and austere forms of modern architecture. The ultimate goal is to create a work of art that is timeless, thought-provoking, and responsive to the human spirit. . . ."

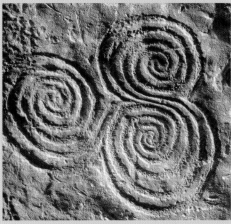

RIGHT: *The spiral carved on the burial chamber of the passage-grave at Newgrange provides design inspiration for art created five thousand years later.*

ABOVE: *The swirling spiral decorative element of Kevin O'Dwyer's late twentieth-century sterling silver sauce boat resonates with the Newgrange spiral of five thousand years earlier, demonstrating the long arm of Ireland's artistic design tradition, and what an inspiration ancient Irish art can be for imaginative craftsmen of any age.*

Mother and daughter, timeless figures, reflect the continuing luminous beauty of Ireland.